Masterpieces of American Modernism

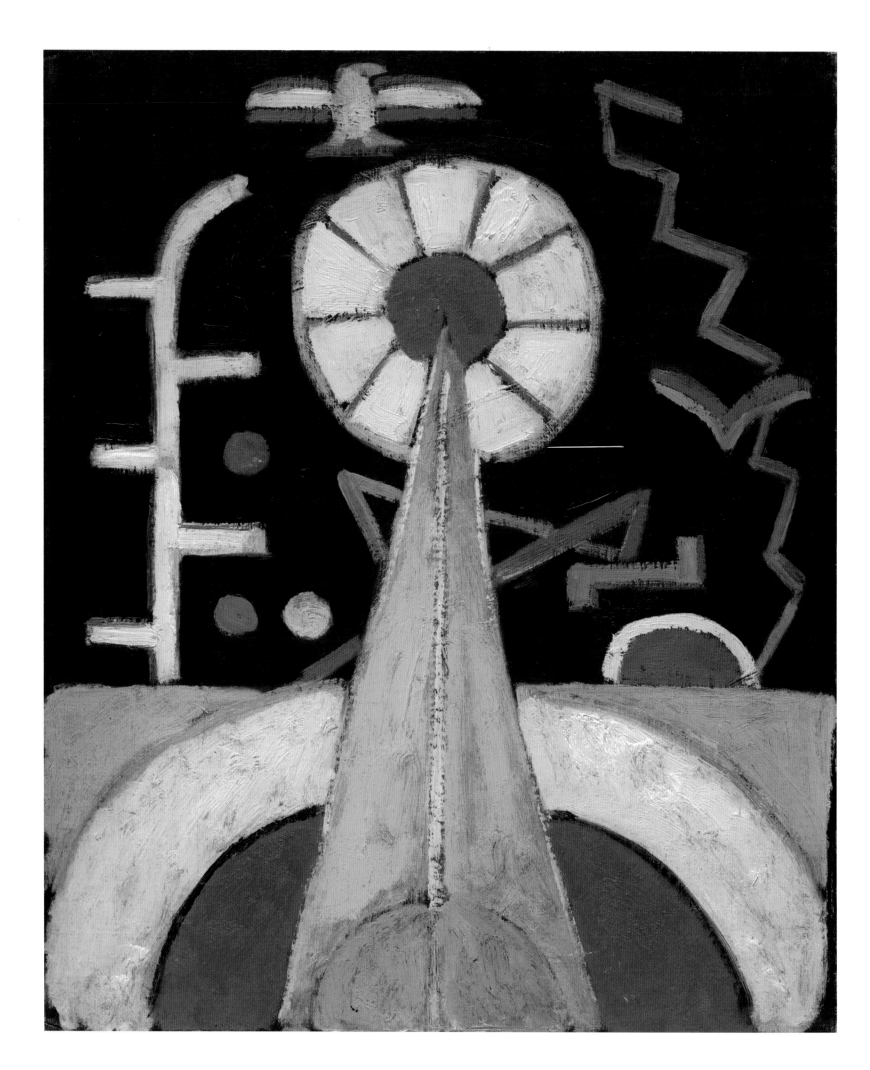

Masterpieces of American Modernism
From the Vilcek Collection

William C. Agee
and Lewis Kachur

With contributions by
Rick Kinsel and
Emily Schuchardt Navratil

VILCEK FOUNDATION

Preface

Jan and Marica Vilcek

How do two adoptive New Yorkers born in a small European country become passionate collectors of American modernist art? Not surprisingly, the two of us have different answers. One of us believes that it happened by design as both a final step in the process of our adjustment to the United States and a symbolic rejection of old values. The other thinks that it was largely a serendipitous development resulting from our exposure—at the right time and in the right place—to works from this fascinating period in American art.

Although our interpretations of why we began collecting may differ, we do agree on how we began. In the 1980s, we started paying short annual summer visits to Santa Fe, New Mexico. We became enthralled by the scenery, the climate, the sunsets, the opera, not to mention the mélange of Native American, Hispanic, and Anglo cultural influences. An additional Santa Fe allure, especially in the 1980s and 1990s, was the abundance of interesting art galleries, antique shops, and art fairs. Our friend Dr. Alvin Friedman-Kien, an avid art collector with a discerning eye for objects of many cultures and periods, took great pleasure in introducing us to the galleries of Santa Fe, including those that specialized in twentieth-century American art. One of these was the gallery run by Nat Owings, and it was there that we—hesitatingly to begin with—made our first acquisitions of American modernist works. Bringing these early acquisitions home to New York and living with them has turned our budding interest into an addiction.

Another person with an important role in shaping our collection was Rick Kinsel, a friend who is also Executive Director of the Vilcek Foundation. Rick's contributions were many. When we were unable to decide whether or not an object was worthy of acquisition, or when the two of us disagreed about the merits of a piece, we asked Rick for his opinion and, more often than not, we followed his advice. Rick was instrumental in helping to keep the collection focused and in convincing us to consider acquiring five works by Georgia O'Keeffe. Some years ago, we were fortunate to meet Emily Schuchardt Navratil, a young art history scholar whose major interest is American modernist art. Emily has taken on the task of cataloguing our collection, and, as a result, has uncovered many important facts that would have been missed without her talent for finding and interpreting archival materials, thus laying the groundwork for this publication.

Some time ago, we decided to make our entire collection of American modernist art, presented in this publication, a promised gift to the Vilcek Foundation. This decision, we hope, will go a long way toward keeping the collection intact for many years to come.

Toward an American Aesthetic

Rick Kinsel

Since 2001, Jan and Marica Vilcek have put together an extraordinary collection of American modernist art. How and why they have done so is a fascinating story, one that is intimately related not only to their immigration to the United States, but also to the aims of the Vilcek Foundation, which is dedicated to raising public awareness of the contributions to biomedical science, the arts, and the humanities made by immigrants living in America. As Executive Director of the Vilcek Foundation—to which this collection is a promised gift—as well as a member of its board, it is my great pleasure to introduce this catalogue by briefly describing the way in which the Vilceks came to collect American modernist paintings and sculpture, and my ongoing participation in the project. I do so partly out of pride in their achievement, and partly out of excitement that this collection will be placed on display in New York; but partly, also, out of a conviction that the Vilceks' endeavor furnishes us with yet more proof that immigrants from all nations are continually making substantial and enduring contributions to the cultural life of the United States.

Born and raised in Czechoslovakia, the Vilceks never imagined they would one day be living in New York. Jan Vilcek, on completing his medical studies in Bratislava, embarked on a career in medical research at the city's Institute of Virology. His wife, Marica, began her career as an art historian in the Department of Prints and Drawings at the Slovak National Gallery. Both Jan and Marica had a keen interest in the visual arts, and that interest was something they shared from their earliest years as a married couple.

At that time, however, the Vilceks' awareness of American art was very limited, for in the late 1950s and early 1960s, contemporary western European and American art was almost unknown in Czechoslovakia: libraries were not allowed to purchase books on the subject, nor were professors allowed to teach it in the universities. So far as the Czechoslovakian authorities were concerned, only the work of politically approved Czech, Slovak, Russian, and other eastern European artists producing art in the approved style of socialist realism was worthy of display. Of course, anyone passionate about art knew otherwise; and as a young curator, Marica was occasionally able to obtain books on Western contemporary art, which she shared with her friends and colleagues. Her first substantial encounter with paintings from American collections took place when her older brother, a physician and art collector who was then living in New York, sent her four reproductions printed by the Museum of Modern Art: one of a Jackson Pollock painting, one of a Jasper Johns painting, and two of paintings by Paul Klee. Reproductions of contemporary Western art were so rare in Czechoslovakia at that time that Marica treated them almost as originals, framing them and hanging them in her home.

Despite the restrictions imposed on personal freedom by the communist regime, the young Vilceks felt deeply connected to Czech and Slovak cultural and artistic life. They were particularly interested in the non-conformist contemporary art of their native land; and although their means were very limited, Marica nonetheless managed to acquire a few pieces of avant-garde Czech and Slovak art.

At the same time, the Vilceks were increasingly curious about contemporary art outside of Czechoslovakia, both in western Europe and in the United States, since the regime under which they lived was strongly opposed to it—and they, in turn, were passionately opposed to their government's interference in the visual arts. "When we were growing up in communist Czechoslovakia," recalls Jan, "modernist art, especially abstract art, was considered 'formalist Western art' by the authorities, and was virtually banned from public view. We were inundated instead with socialist realism, which we hated. Because of that, we longed to see modernist works, even if only in reproduction." Indeed, in common with Marica, Jan too had decorated his room in his parents' house with images of Western art—in his case, works by Picasso that he had cut out from a Polish magazine.

In 1964, just two years into their marriage, the Vilceks concluded that building a happy life for themselves in Czechoslovakia was not going to be possible. And so, while on a three-day visit to Vienna, they made the difficult decision not to return. With little more than a suitcase and a short list of personal and professional contacts, they made their way to West Germany, where they then waited three months to be granted the refugee status that would enable them to emigrate to the United States—where Marica's brother had offered to help them make a new start in New York.

The Vilceks' first few years in America were exciting but also difficult, both socially and personally. Fortunately Jan had received a job offer from New York University (NYU) School of Medicine, so he had work and an income at the time of his arrival. But the couple were cut off from the majority of their family and friends, and were confronted with not only a new language but also an entirely different kind of society, one about which they had been able to learn very little while living in Czechoslovakia. As Marica recalls, "My life, my interests, and my security were all turned upside down. My old language was useless, and there was so much here in New York that I did not understand. All my books were gone, as well as all the objects I had loved: all our possessions had stayed behind in the old world."

Glad as they may have been to have escaped life under communism, the Vilceks realized that they would now have to shift the center of their thinking permanently from Bratislava to New York, and, in essence, start again from the beginning. Jan had his work as a scientist and educator to give him a sense of purpose and belonging; Marica instinctively sensed that she needed to find work, too. So, even while struggling with a new language, she took an entry-level job as a clerk-typist at the Metropolitan Museum of Art.

The experience of working at the Metropolitan Museum would prove a transformative one for Marica—and, by extension, for her husband, too. In the late 1960s, the museum was still a relatively small institution, while the people who worked there were both warm and welcoming. Moreover, as she soon discovered, many of her colleagues were interested in collecting. Both the activity of collecting and the collectors themselves proved fascinating to Marica—as did, of course, the museum's own extraordinary holdings. Today, she describes her many years of living and working among the Metropolitan Museum's art collection as shaping both her personality and her taste.

There was also a social element to working at the museum. At weekends, the couple frequently attended its exhibitions, and in doing so developed a new sense of belonging. "Initially we had few friends here in New York," recalls Marica, "so it was comforting for us to spend our Sunday afternoons at the Metropolitan, surrounded by art objects and art lovers." More importantly, the museum was reconnecting the Vilceks to the world of art and culture that had been so central to their life in Czechoslovakia. They regularly attended exhibitions not only at the Metropolitan Museum, but also at the Museum of Modern Art, the Guggenheim Museum, and the Jewish Museum, among many other galleries and public art spaces.

As the Vilceks became financially more secure—Jan's biomedical research at NYU, including his contributions to the development of a drug for the treatment of inflammatory diseases, brought him financial success as well as professional acclaim—the couple came into increasing contact with individuals who both loved art and believed in the importance of collecting it. Perhaps as a result, the Vilceks too began to acquire works of art. According to Jan, their initial forays into collecting were focused simply on acquiring objects that they wanted to have in their home, regardless of period or style. Their first acquisitions included oriental carpets, African artifacts, medieval ivory carvings, and pre-Columbian art. While this last category would eventually become one of Jan's passions, his first pre-Columbian acquisition—*Olmec Mask Fragment with Engraved Headband* (1000–500 BC), purchased in 1993—was in fact made for him by his wife, as a birthday present. It remains a favorite piece of both Vilceks to this day.

During these initial ventures into the world of collecting, the Vilceks were encouraged by a colleague of Jan from NYU, the dermatologist, research physician, and AIDS expert Dr. Alvin Friedman-Kien. Jan describes Friedman-Kien as "a passionate, eclectic collector of a wide range of objects from many periods and cultures," adding that he is a man who "derives great pleasure from talking other people into acquiring art objects . . . He taught us many things about the process of acquiring

art. We spent innumerable hours with Alvin, being 'dragged' from one antique shop and gallery to the next. In the process we learned a great deal." Friedman-Kien's influence should not be underestimated: according to Jan, had he not befriended Alvin, he and Marica might never have become serious art collectors.

A handful of other collectors and curators also influenced the Vilceks. As a result, the couple began to notice and think about the visual power and formal innovations that are so characteristic of American paintings of the modernist era. They found themselves increasingly drawn to these pioneering works of American art, at once distinct from the modernist work created in Paris, and of such central importance to the history of twentieth-century American art.

One of the most admirable (and unusual) aspects of the Vilcek Collection is that the Vilceks assembled it with little outside assistance or professional help. They felt able to do so not only because of Marica's training as an art historian, but also because of her work at the Metropolitan Museum, where she had spent many years researching works of art on her own. I feel privileged, however, to have played a role in the choice of quite a few of the more important objects in Jan and Marica's collection; as a fellow art historian, I found working with them a great pleasure, even in our most challenging moments. The Vilceks insist upon giving me full credit, for example, for persuading them to reunite three important Stuart Davis still lifes from 1922 (pages 182–87). Shortly after they had acquired Davis's *Still Life with Dial*, an iconic work, I discovered two other Davis still lifes from the same year and of the same size. At first, the Vilceks were reluctant to purchase them, doubting the merits of owning three such closely related paintings. But with a good deal of argument I managed to persuade them otherwise, and today they agree that the three paintings are not only highly complementary, but also very fine when hung together as related works.

The Vilceks also give me credit for bringing to their attention five works of art by Georgia O'Keeffe (see pages 156–65). Although initially Jan did not want to add them to the collection, in time, and after much discussion, he finally decided to do so, and indeed his opinion of O'Keeffe has changed as a result. In this and many other instances, when Marica and Jan were thinking about acquiring some work or other but had not made a final decision, they would ask me informally for advice, and we would get together and discuss the pros and cons of the potential acquisition, sometimes at great length and with great passion. On some occasions I urged them very strongly to acquire the object; at other times, however, I tried to dissuade them. They usually listened to me, and they certainly took my opinions into account as they came to their final decision. To the credit of us all, we have somehow remained the best of friends throughout this long, challenging process.

The first of the Vilceks' American modernist acquisitions took place not in New York but in Santa Fe, New Mexico. The couple had begun visiting the galleries and museums of Santa Fe in 1990, and it was there, amid the magnificent landscape that had inspired so many of the great works of American modernism, that the Vilceks began to contemplate becoming serious collectors. This involved a great deal of reflection, however. "It took me a long time to recognize and understand the beauty and importance of American modernism," admits Marica. "It was not a simple process. I spent a great deal of time thinking and re-thinking my—and our—collecting preferences."

Both Marica and Jan trace the origin of their American modernist collection to their acquisition of Stuart Davis's *Tree* (1921; page 177), which they first encountered in the summer of 2001 at a gallery in Santa Fe. They returned to the gallery twelve months later, after becoming more familiar with the artist and the period, but it was not until the summer of 2003, after a further year "of doubt and discussion," as Marica puts it, before they were able to make the fateful decision to acquire Davis's painting. Indeed, Marica describes that moment as "the beginning of our firm, not always easy commitment to American modernism." In retrospect, however, there is a certain logic and inevitability to the Vilceks' decision to collect works of this period and movement, given their commitment both to their adopted home and to avant-garde visual arts: no other art movement of the twentieth century has demonstrated so firm a belief in the exquisiteness of the United States, nor in its creative independence from Europe and European traditions, even as it brought the dialogue of modernism into the American cultural scene.

When it comes to collecting and choosing what to acquire, the Vilceks enjoy making decisions together, even as they freely admit that they do not always agree. Their differences are partly based on temperament, for, as Marica notes, "Jan is more compulsive in acquiring objects, while I am more deliberate. I try to be sure that the object fits in, and that it will enhance the collection." Since I first began advising Marica, she has worked hard to shape the collection into one in which artists of a certain period explore modernist ideas in their own different ways. Jan, meanwhile, feels that Marica has helped to steady him over the years, keeping him from making too many rash acquisitions. He nonetheless feels that his own passion for collecting has kept them from being overly cautious, noting with a slight chuckle that "Without my enthusiasm, we probably would have failed to acquire many of the objects we own!" Asked if either of them has attempted to push the collection in a specific direction, perhaps by championing a particular artist, Marica says only that she has certainly worked hard to keep her husband focused on the American modernist period. "It was not an easy task," she concludes. "But in the end Jan and I were able to follow through and assemble a cohesive collection. This, despite our different temperaments, opinions, and inclinations."

Marica's work in the catalogue department of the Metropolitan Museum of Art has helped her enormously. Only through rigorous background research can one really begin to understand the significance of a particular artwork: provenance, exhibition history, and chronological place in the life of the artist must all be taken into account. Her love of research coincided with her desire to build a collection with only limited outside assistance; the result is a group of artworks that is at once deeply personal and scholarly.

One of Marica's tasks at the Metropolitan Museum was to complete the cataloguing of the Stieglitz Collection—a group of 131 works by American and European artists active in the first half of the twentieth century, collected by the photographer, gallery owner, and patron Alfred Stieglitz and donated to the museum in 1949—thus enabling her to immerse herself in the history of that period. "The catalogue department had several rare Stieglitz exhibition catalogues," she recalls, "while the museum's archives had additional Stieglitz catalogues, as well as notes and photographs that showed striking modern installations that he had organized. I had the opportunity to consult these materials for the Stieglitz project. At the time, I had no idea that one day we would be able to build an art collection of our own. But it's possible that certain ideas and images from the Stieglitz project were embedded in my brain as a result of my being so closely involved."

Many of the artists championed by Stieglitz throughout his career can be found within the Vilceks' collection. "While we have not consciously focused on acquiring works that reflect the Stieglitz aesthetic," notes Jan, "the recent Metropolitan Museum exhibition *Stieglitz and His Artists: Matisse to O'Keeffe* [2011–12] confirmed that, whether by chance or by design, we generally admire the artists he represented." At the same time, the Vilceks are not categorical in their love of Stieglitz and his circle: they do not yet own a single piece by John Marin, for example, even though they have had many opportunities to acquire his work. More significantly, the Vilcek Collection contains no photography, despite the fact that the history of American modernism is closely related to that of American photography, or that many leading photographers of the American modernist period were championed by Stieglitz, who was himself a very distinguished photographer. The decision not to collect photography was, according to Marica, a practical one. "I like photography," she notes, "and often go to see photography exhibitions at MoMA or the Metropolitan. For me, however, part of the pleasure of collecting is to live surrounded by objects. I don't like to keep objects in a closet, or in storage, or in boxes. Objects must be present. Unfortunately that's not possible with photographs, which should not be put on display for long periods of time, for reasons relating to conservation."

Interestingly, eight out of the twenty artists whose work makes up the collection—including Alexander Archipenko, Ralston Crawford, and Max Weber—were themselves immigrants to the United States. But the various artists' experiences of immigration were never something the Vilceks considered as they acquired works for their collection. "There was no conscious effort on our part to give preference to foreign-born artists," says Jan; rather, "We were looking for artists and works that in our opinion best reflected the modernist spirit, with some preference given to works inspired by the cubist aesthetic. The fact that eight out of the twenty artists were born outside America is a coincidence, but that fact helps to tie the collection to the current mission of the Vilcek Foundation." Marica agrees that the coincidence is a happy one, so far as the foundation is concerned: "It never dawned on me that the collection could be perceived as making a statement about immigration or emigration—and yet there is no reason why it could not."

The collection does, however, seem to underline the international influences that were exerted on the development of American modernism, as well as the influence American modernist art exerted on European modernism. As such, the collection can be regarded as one in which European and American modernism are in dialogue with each other. As Jan notes, "The European modernist influence has always been important to us, for many fine Czech and Slovak artists of the early twentieth century were also significantly influenced by the school of Paris." Moreover, these demonstrable connections between Europe and the United States underline yet again the importance of international influences to the shaping and enrichment of American culture, a central belief of the Vilcek Foundation.

It was Marica who expanded the collection to include sculpture. "I have always liked sculpture and three-dimensional objects," she explains. "I have a better memory for sculpture than I do for paintings. In the case of the José de Creeft and John Storrs sculptures [pages 112–25], I was attracted to their pared-down, geometric, and spatial architectural aesthetics, which reminded me of my interest in art deco furniture and design. The Georgia O'Keeffe sculpture [page 165] is a different story. I was intrigued by it, specifically by its minimalism."

Likewise, the precisionist, representational paintings of George Copeland Ault appealed personally to both the Vilceks. In acquiring examples of his work, the couple expanded the range of their American modernist collection. "I was attracted by Ault's *View from Brooklyn* [1927; page 173] from the first moment," Marica explains, "probably for personal reasons. The dark, empty windows; the lonely, beautiful landscape, void of human beings; and that phantasmagoric image of Manhattan in the background reminded me of my first days in New York. All windows seemed to be dark and empty, every space lonely, on those freezing February days in my new home. So it was a personal, not very logical attraction." Jan's response to the work was similar to that of his wife: "When we were offered *View from Brooklyn*, we did not know much about Ault, but the

work immediately appealed to me. It is one of my favorite works . . . I find it difficult to express what it is exactly that I find so appealing in the two Ault paintings [we own], but it includes the subject matter; some characteristic details, such as the empty, dark windows; an emphasis on architecture; the absence of human figures; the somber mood; the brushwork. I could go on."

As a husband-and-wife team, the Vilceks took a special interest in the combined works of Arthur Dove and Helen Torr, the husband-and-wife artists who lived and worked together on Long Island's North Shore. Jan greatly admires the work of Dove, and considers two Dove oils in the collection, *Untitled* (c. 1929; page 81) and *Below the Flood Gates—Huntington Harbor* (1930; page 87), to be among its most important works. "The fact that Helen Torr was Dove's wife played a role in our acquisition of her small painting [page 137]," he admits. "But we do like it regardless."

There are, in fact, relatively few women among the artists currently included in the collection: only Georgia O'Keeffe and Helen Torr. To Marica's way of thinking, however, "gender does not make a difference. It never occurred to me to collect more—or fewer—female artists. I realize that quite a few women achieved renown during this period and left their mark on American modernism. But when I look at or think about a painting, I don't think about whether the artist was male or female; often, I don't even think about the name of the artist. My guideline is, does the work show strength and depth, regardless of gender?" Jan, meanwhile, puts it another way, noting simply that, "We would not mind adding more American modernist women artists, but there are not many that come to mind."

When asked how the collection has evolved over time, Jan responds by saying that, in his opinion, the most important acquisitions since the purchase of Stuart Davis's *Tree* have been those of two works on paper by Marsden Hartley from around 1913–14, *Symbol IV* and *Symbol V* (pages 58–59). "Then came Hartley's *Atlantic Window in the New England Character* [c. 1917; page 63], followed by the several works by Dove. And, of course, the many important works by Davis." All of which raises the question of whether the Vilceks now consider their collection, a seemingly near-perfect articulation of the American modernist aesthetic, to be complete. "For me it is important to continue," states Marica. "Collecting, and improving the collection, is an intellectual exercise, and I think that as long as Jan and I are able to do so, we should try to improve it, and to fill in the gaps. New objects continually appear on the market, and values and opinions constantly change. I don't want to predict how the collection will evolve in the future, but I do hope we will continue to acquire works that will enable scholars, students, and art lovers to come to a better understanding of American modernism." Her husband is entirely in agreement with her on this point, merely noting with delight that, "There is no such thing as a complete collection!"

Even as the Vilceks continue to add to and refine their collection of American modernist art, however, they are strongly aware that what they have collected and how they have done so is part of a long-standing American tradition of recent immigrants giving back to the country that has given them the opportunity to succeed. Since arriving in the United States with very little, the Vilceks have enjoyed great professional success, material prosperity, and public recognition—most recently with Marica being named an honorary trustee of the Metropolitan Museum of Art, and Jan being named a trustee of NYU Langone Medical Center and receiving from President Obama the National Medal of Technology and Innovation, the highest honor bestowed by the US Government on scientists, engineers, and inventors. In establishing a private foundation to aid young immigrant artists and scientists, in creating a collection of American paintings that showcase American innovation and ingenuity, and, finally, in making that collection a promised gift to that foundation, they have proven themselves to be exemplary civic-minded Americans. "For me," observes Marica, "it brings to a conclusion my long effort to 'shift my center of the universe' from the old world of Bratislava to the new world of New York. I feel the collection completes my adjustment to this country: it is the final stage of my immigration and integration." Watching and helping the Vilceks create this extraordinary collection of paintings and sculpture has been the greatest of privileges; and it is with the greatest of pleasure that we shall present these works to the public at the Vilcek Foundation Headquarters in New York.

Perspectives on Modern Art in America

William C. Agee

The Vilcek Collection may well remind us of no less a venerable institution than the Phillips Collection. Located in Washington, D.C., the Phillips is now a large museum complex, but think back to 1921, when the art collector and critic Duncan Phillips opened it as the first museum of modern art in the United States. Established in his own home, it provided an intimate and intense experience for the visitor, who for years would feel as if he or she had been an invited guest.[1] That is how we are likely to experience the Vilcek Collection, soon to be installed in a former New York town house, with the focus solely on modern art in America.

The similarities abound. There is the quality of the collection, be the works large or small, or by well- or lesser-known artists. There are famous works and new surprises, even to specialists. The sense of exploration and discovery is everywhere; the collection demands and welcomes sustained engagement, just as the Phillips does. It has been carefully and well studied, deliberately and methodically considered, as was the Phillips by Duncan himself—often to the consternation of dealers and artists, Alfred Stieglitz and Arthur Dove among them. Moreover, the Vilcek Collection comes to the public at a crucial time for American modernism, for no other venue in New York has this art on view in any depth, if at all. The idea of seeing a few artists in groups of works has rarely even been considered, let alone fulfilled, in the United States.

A parallel aim exists only in Marfa, Texas, at the Chinati Foundation, where the artist Donald Judd carried out his dream of showing good art in this way. In common with Phillips, the Vilceks have collected with open minds and eyes, concentrating on the work of the most accomplished American artists, such as Dove, Marsden Hartley, Stuart Davis, and others, whose art the Vilcek Collection will enable us to study extensively. Phillips called such groupings of works by specific artists "units," providing new insights into the nature of the artists' achievements, as do the Vilcek holdings. Revelations continue to appear, both in the artists' own developments and through their interconnections with others. The Vilceks have looked with care and concern for additional first-rate artists, among them Andrew Dasburg and Ralston Crawford, who are less heralded, perhaps, but no less deserving of our attention. Social themes and patterns also present themselves, such as the impact immigration has had on the United States—a topic, of course, to which the Vilceks have a special connection.

———

The unit of paintings and drawings by Stuart Davis, the largest such group in the world, is especially instructive. Starting in 1921, it covers more than forty years of Davis's life and art, up to his death in 1964, thus enabling us to study a towering figure in American art in virtually all his myriad styles. From 1910, Davis affected the American art of every decade

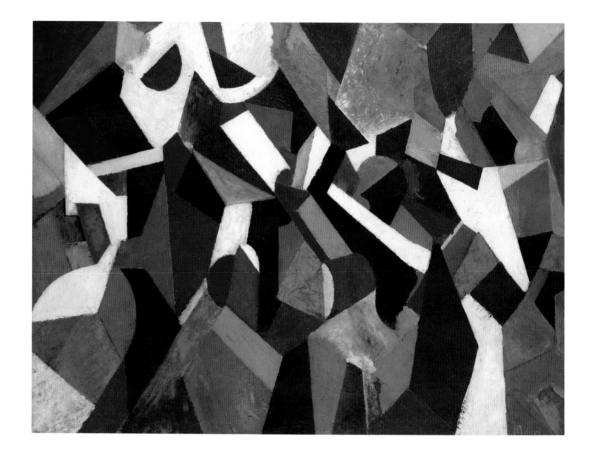

in which he lived. In the textbooks, however, he is identified only as a modernist of the 1920s, in brief passages accompanied by one or two illustrations. His career invariably stops there, never to be heard of again. This reflects the way in which we teach the history of modern art: as a series of avant-garde breakthroughs by young artists, one after the other. There is some truth to this, of course, but we fail to account for the artists' ongoing careers, which are often long and productive, well into old age, thus robbing ourselves of a sense of the multilayered richness of their work. In the Vilcek Collection, this tendency to focus on an artist's early period is put to rest, for we see Davis, as well as Hartley and Dove, as having been a major artist of startling innovation throughout his life—and in the history of the United States.

Indeed, Davis was as important to post-1945 art, long considered the exclusive domain of abstract expressionism, as he was to the art of thirty years earlier. After 1945, he was respected as a kind of elder statesman, but as one whose time had passed, his hard-edge art thought to belong to an earlier era. Not true, however, for a more geometric art—a mode seen vividly in the Vilcek Collection—continued to flourish after 1945, as highlighted by Davis's later paintings, as well as by Crawford and Georgia O'Keeffe. In the rush to proclaim the triumph of American art via abstract expressionism, artists and writers alike cast off earlier American art, virtually

erasing it from people's memories.[2] After 1945, critics and artists sought a more upscale pedigree, one located in French art, which was certainly deserving of their attention, but not at the expense of their more humble roots in American modernism. American art was far more complex in the postwar years than many have wanted to understand, but the Vilcek Collection forces us to reconsider this myopic point of view.

Davis was thought of, when he was at all, as an artist separate and apart from the so-called mainstream of abstract expressionism. However, in *Town and Country* (1959; page 215), a small but potent work, Davis took abstract expressionism head on, by doing his own version of a work by Willem de Kooning from the previous year, *Suburb in Havana* (opposite). Davis greatly admired de Kooning, which is unsurprising, since they had been friends and colleagues as early as the late 1920s, as part of the Four Musketeers group based around John Graham and including Arshile Gorky.[3] (De Kooning later called his fellow Musketeers the "smartest guys around."[4]) Davis and de Kooning fed off each other, and together spread a wide net of influence in the 1930s and 1940s. As different as their work was, they helped to form, with such other artists as Adolph Gottlieb and Jackson Pollock, a vital early chapter of the New York school. Understanding this should help to defuse the "Big Bang" theory of American art: that it was born only after 1945, with no earlier history.

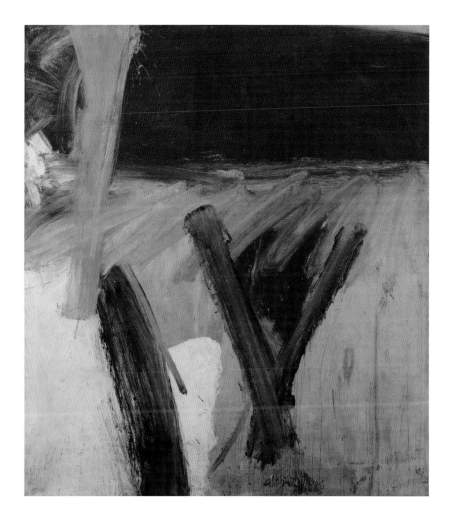

Without doubt, Davis challenged de Kooning in *Town and Country*, just as he had earlier challenged Pollock, Henri Matisse, and Piet Mondrian by doing his own, "improved" versions of their pictorial formats. Rather than use the same dense painterly surfaces as de Kooning, Davis adopted a more distilled, clarified style, using sharper lines and enclosed forms. It is like a hard-edge de Kooning, yet very much Davis's own creation, as if Davis were instructing de Kooning on a new and improved way to do his own painting.

Much has been made of the use of black and white in American art after 1945. Indeed, it was a hallmark of such earlier artists as Kazimir Malevich, and later of Picasso, and then of de Kooning, Robert Motherwell, Franz Kline, Clyfford Still, Pollock (in 1951–52), and Frank Stella (1958–59). However, its source should be traced to Davis's linear black-and-white paintings of the early 1930s, radical works even though they are still not well known. In *Ship's Rigging (Coordinates II)* (1932; page 199) and *Drugstore Reflection* (c. 1932; page 203), Davis uses black and white in a new and productive interpretation of the cubist grid, just one of his several original contributions to international cubism. Davis, in common with all who worked in a cubist vocabulary, owed much to Picasso and Georges Braque, but by 1927, at least, he had turned cubism into his own personal pictorial idiom. (By then, he was no longer a "disciple" of Picasso, a call we still hear from the

original "triumphalist" historians, those, such as the critic Irving Sandler, who dubbed abstract expressionism the triumph of American art.[5]) We can see Davis's debt to the cubist pioneers in his tree and garden paintings of the early 1920s (pages 176–79), fascinating, elusive, and mysterious works that surprise all who see them. They mark the start of a second wave of cubism in the United States, and thus are pivotal. This second burst of cubist art came after the first of 1912–14 had run its course, and was brought to a peak by Davis in the late 1920s and early 1930s. The garden pictures are intriguing to the modern viewer, and were no less so to Davis, who turned to them as sources for several important paintings completed post-1940. After that year, Davis almost always used existing formats for new compositions, updating them to reflect his current concerns.

Davis's stamp of originality in the cubist mode is evident in the set of four large, and large-scaled, still lifes of 1922, three of which are in the Vilcek Collection (see pages 182–87). These paintings tell us he had been looking at Braque's still lifes—specifically his "Guéridons," named after the round-topped pedestal table on which Braque arranged his subject matter—but their sheer ambition and pictorial drive take them to a new level. They are material evidence of the young artist's increasing confidence (and, we may say, of America's), proclaimed when he announced to himself that year that the United States

has had her inventors and scientists, and "now she will have her artist."[6] How right he was. Even in the still lifes of 1922, however, Davis added something new to the cubist lexicon, namely, the suggestion that these tables and their accumulated objects do not stand isolated. In at least one, *Still Life, Red*, they are, rather, set in a room that looks out on to the city, Davis's urban habitat. This format is essentially a new cubist mode. It has objects on a table, in a room, in a building, in a city—an expansive view of the world, a sense of American possibilities, so typical of Davis and his art. This theme was continued and enlarged, and made more visible (although it was missed for years), in the *Egg Beater* series (1927–28). There is nothing else like it in international cubism.

Davis loved to challenge existing modes, to make something new of them, as is evident in *Music Hall*, a Paris scene from 1930 (page 197). Davis had lived in the City of Light for more than a year, and, as an inveterate tourist, had spent much of his time wandering the endlessly fascinating streets. As an artist, he had taken corny and clichéd views of Paris and turned them into serious and challenging art, the kind of twist he loved. These paintings are often thought of as a "retreat" from the lean and distilled *Egg Beater* works, but this is to underestimate their complexity. They are more figurative, certainly, but Davis's art was *always* figurative, to a greater or lesser degree. That is why, in part, he insisted that he was a realist artist who painted what he saw and experienced, even as he said he used the more universal, modern language of cubism. In the Paris views, Davis extended his cubist practice by using broad, stage curtain–like forms to define the composition. By painting these forms in varying textures and densities, he gave each its own pictorial identity, creating, one might say, something like an urban still life. Davis's use of texture also added something new to the international cubist vocabulary, and shows us his deft and sensitive touch as a painter. This is important because Davis insisted on clear, firm lines, a sharpness that in reproduction can often look flat, with little material body. But Davis loved paint, its sheer color and density, its physicality and texture, and makes this love evident in all his paintings. One may call this a type of American materialism: the love of the palpable poetry of the things and places around us, a celebration of our senses, and thus of our lives. Such poetry is made evident in the colors—the blues and pinks in the case of *Music Hall*; how did he even think of such hues?—that heighten the physical presence of the paintings. Davis, it should be noted, was a great colorist, although the works in the Vilcek Collection point more to his insistence on drawing.

Davis's art and approach were important examples to younger artists seeking a new clarity, an impetus in their move toward an abstracting type of painting. This can be seen as part of a long tradition of artists looking for a new directness, with as little as possible

David Smith
(1906–1965)
The Banquet
1951
Steel
53⅛ x 83 x 13½ in. (134.6 x 210.8 x 34.3 cm)
KYKUIT (JOHN D. ROCKEFELLER ESTATE),
SLEEPY HOLLOW, NEW YORK

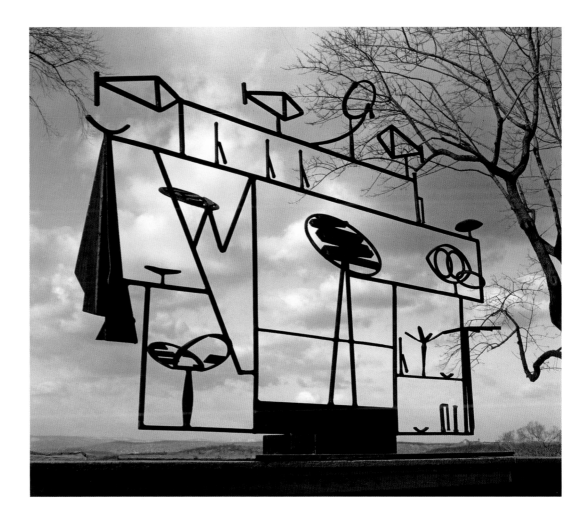

between the work and the viewer—a kind of pictorial quickness, essential to modernity. It begins with Caravaggio, and extends to Renoir and Cézanne, who wanted to make something solid of impressionism, as did Seurat; likewise, collage and synthetic cubism can be seen as attempts to clarify painterly the cubism of 1911–12, and precisionism and De Stijl as means of achieving a new and more resonant openness.

In the 1930s, Davis, along with Alfred H. Maurer, John Marin, Hans Hofmann, and Josef Albers, among others, extended cubism into new pictorial realms.[7] These same artists continued a larger size and scale of cubism after 1945, thus disproving the claim that cubism had died with the coming of abstract expressionism. Indeed, Davis reinvigorated the spare linear cubism of his black-and-white works of 1932 in later variations, full-scale paintings consisting solely of black lines, such as *Untitled (Black and White Variation on Windshield Mirror)* (c. 1954–64; page 205) and the maze-like *Letter and His Ecol (Black and White Version)* (1962–64; page 217). These works were once thought to be preparatory drawings, but we now know that they are indeed fully finished paintings.[8] Once again, Davis had looked to his earlier work for ideas to develop further. He may have been inspired to do so by Pollock's black-and-white paintings of 1951–52, which had impressed Davis when they were shown at the Sidney Janis Gallery in New York in November 1952.[9] In this series, Pollock resorted mostly to pure drawing, which would have

struck Davis, who constantly insisted that drawing not only was the basis of his art, but also *was* his art. In *Untitled* and *Letter and His Ecol*, Davis challenges Pollock in terms of overall complexity, for Davis's paintings are every bit as complex as Pollock's. But, in the kind of painterly exchange on which artists have thrived since time immemorial, Davis "corrects" the Pollocks, as it were, by achieving equal complexity with clear and sharply defined lines. Another such exchange can be seen between the open networks of steel created by David Smith between 1950 and 1954, among them *The Letter* (1950; Munson-Williams-Proctor Arts Institute, Utica, New York) and *The Banquet* (1951; above), and Davis's black-and-white open linear scaffolds of the 1930s, including *Ship's Rigging* and *Drugstore Reflection*. We should not be surprised to learn that, together with Davis, Smith was an active and respected member of the group of artists around John Graham in the 1930s. Davis alone tells us that modern art was alive and well in that decade, even though the textbooks dwell only on the dreary art of social realism and the American scene of the time.

———

In its clear, open forms, Davis's *Town and Country* appeared as a tonic, a refreshing counterpoint to the art of late 1950s America. In 1959, younger American artists were searching for new ways of making art that could embody the scale and power of abstract

Georgia O'Keeffe
(1887–1986)
Black Place II
1944
Oil on canvas
23⅞ x 30 in. (60.8 x 76.1 cm)
THE METROPOLITAN MUSEUM OF ART,
NEW YORK

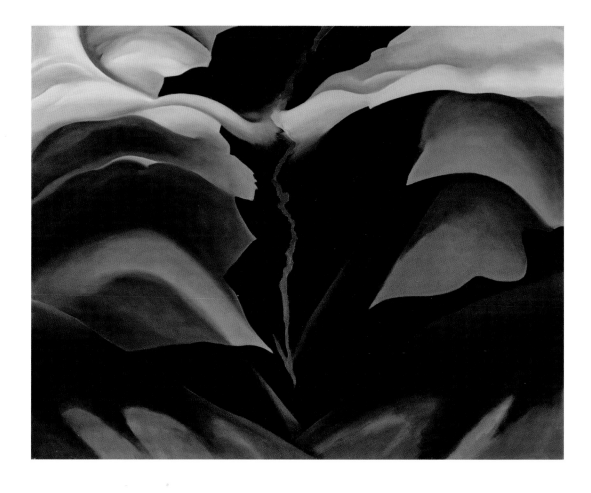

expressionism but without its overworked surfaces. Davis had provided such a possible new direction—in depth—in 1957, when his retrospective was presented in Minneapolis and New York.[10] It was a revelation, opening up new paths for young artists in the aftermath of Pollock's death in 1956. If the abstract expressionists had turned their backs on Davis (in reality they had not, but they would never admit it), then such artists as Donald Judd openly embraced his art. In 1962, on the occasion of what would be Davis's last solo show before his death two years later, Judd, then also writing monthly criticism, memorably proclaimed:

There should be applause. Davis, at sixty-seven, is still a hot shot. Persistent painters are scarce; painters with only a decade or less of good work are numerous . . . The present exhibit of paintings done between 1958 and 1962 is first-rate. That makes forty-six years. The "amazing continuity" of Davis's work does not seem to have been kept with blinders, in fact, could not have been. Neither has Davis been startled into compromises with newer developments. Some older artists abandoned developed styles for one of the various ideas included under "Abstract Expressionism," spoiling both. Davis must also have faced the fact of increased power and different meanings. Instead of compromising, he kept all that he had learned and invented and, taking the new power into account, benefited. His painting, certainly not by coincidence, gained in scale, clarity and power after 1945, and gained further after 1950. Tournos, Visa, Memo, Cliché, Owh! In San Paó are all instances. It takes a lot not to be smashed by new developments and a lot to face power and learn from it . . . Perhaps Davis should again increase the scale and add wilder notes . . . Someone at the show thought Davis should just write his name across a canvas billboard size. A change is that some of the paintings are hotter and therefore more dense . . . it is all subtle and complex.[11]

Judd's words show us that younger artists, able to get past the angst and rhetoric of abstract expressionism, could understand and admire the continuity between early and later modernism in the United States. American art, of all periods, comes from one nation, one culture, one society composed of many elements, and cannot be broken down into the categories of pre- and post-1945, as though it had come from two different cultures and countries. Continuity exists between the early and later work of not only Davis but also Georgia O'Keeffe and Ralston Crawford. O'Keeffe's *In the Patio IX* (1950; page 163) is as strong as any of her earlier works, although in common with Davis only her early work is deemed worthy of consideration. The artist behind the painting is still the real O'Keeffe, but at another stage in her life and art, older but with her roots still evident. With *In the Patio IX*, she continued her fascination with the cosmic, with a higher order, the heavens and clouds above, which her husband, Alfred Stieglitz, had famously explored in the 1920s, as had her dear

Winslow Homer
(1836–1910)
Kissing the Moon
1904
Oil on canvas
30¼ x 40⅜ in. (76.8 x 102.6 cm)

ADDISON GALLERY OF AMERICAN ART,
ANDOVER, MASSACHUSETTS

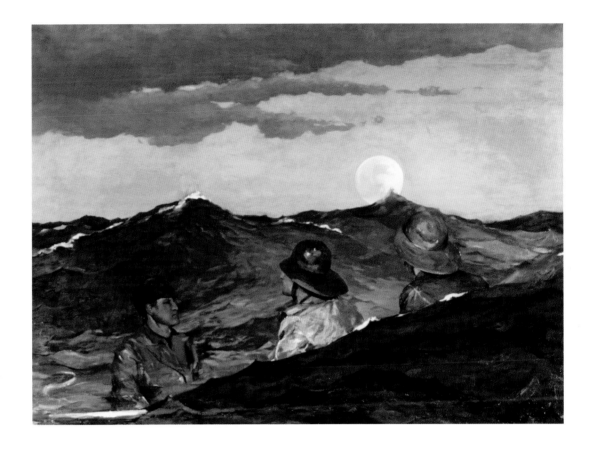

friend Arthur Dove, then and later. At first, this writer thought it was a painting about aviation: a supersonic black airplane, seen from above, approaching the edge, the curvature of the world. In effect, it is about aviation, only with the view reversed. It is as though O'Keeffe is projecting herself—and us—from inside the patio to the far reaches of outer space, from the intimacy of her house in New Mexico to the vastness of the sky above, a recurring motif in her work since the *Music* series of about 1919. As so many American artists have done, she sought a higher order, a greater power, a transcendental view of the world, of man in direct contact with God, that has its roots in Ralph Waldo Emerson and Henry Thoreau. *In the Patio IX* is strong and clear and firm, as though she had recharged her artistic and emotional batteries.

By all appearances, she had. O'Keeffe's creativity had begun to run dry by the late 1930s, as if she were exhausted by her life and circumstances. Little wonder, since Stieglitz, that giant of American art, by any standard a handful, was failing as he approached the end of his life. The hardships of old age and of a difficult marriage were surely an enormous strain on her, too. Her mood, her state of mind, virtually cries out to us in *Black Place II* (1945; page 161), painted a year before Stieglitz's death. The location, a canyon in New Mexico, just one of the many glorious places to be found in a state well termed the "Land of Enchantment," was dear to O'Keeffe, and she visited and painted it often. The version held by the

Metropolitan Museum of Art in New York (1944; opposite) is filled with foreboding and anxiety, supercharged with emotion. The canyon is seen from above, as if the gods themselves were showering their anger on the world, the Earth rent asunder from on high by a bolt of lightning hurled by Zeus. O'Keeffe seems furious at the Second World War and its upheavals, and also at her perilous fate, as her husband rapidly deteriorates in old age, soon to face the blackest place of all. The version in the Vilcek Collection is less tumultuous, softened even, but still pervaded by a deep sense of uncertainty and trepidation. O'Keeffe unleashes years of tension and frustration: her art had come alive again.

By 1950, with *In the Patio IX*, it appears as though O'Keeffe has made her peace with the world. She is in recovery, as it were, and is able to find a new sense of serenity: her husband's estate has been settled, and she has recently moved permanently into her house in New Mexico, the land she has loved for so long. Her serenity is clear, and she looks forward to a long future, to life in a new world—the postwar world in which both her and the United States find a new burst of energy. She sees new vistas, even the space age, as had Winslow Homer in *Kissing the Moon* (1904; above), painted the year after the Wright brothers' first successful flight.

Also by 1950, Stuart Davis had succeeded in his battle with alcoholism, which had almost killed him in the late 1940s. He, too, had made a fresh start, with

a new, dynamic style of ever more intense color and broad planes that spoke of a new, reinvented cubism, and even of Matisse. In his key pictures of 1950–51, *Little Giant Still Life* (1950; Virginia Museum of Fine Arts, Richmond) and *Visa* (1951; opposite), Davis proclaims himself still champion, despite the rise of abstract expressionism. The word "champion" is surely a reference to the movie of the same name about the boxer Michael "Midge" Kelly (played by a young Kirk Douglas), then opening in bright lights on Broadway, for Davis was a serious fan of the sport.[12] In *Visa*, he includes the words "amazing continuity," referring to his longevity as an artist even after 1945, something we ignore at our peril. In the same vein, the art of Charles Sheeler had also undergone a remarkable regeneration in the years just after the Second World War. The year 1950 was particularly important in the development of American modernism: Josef Albers introduced his famous *Homage to the Square* series, while late that year, Pollock did a painting on glass, filmed from underneath, so that his brushstrokes looked like cosmic drawing suspended in the vast blue sky above.

Ralston Crawford was a close friend of Davis, and one of the key artists who worked in a hard-edge style throughout his life. Crawford, the son of a ship's captain, was an inveterate traveler, constantly seeking new pictorial challenges and stimulation the world over. He was especially drawn to the buildings of America and its engineering marvels, as indicated by his abstractions of the bridge between St. Petersburg and Tampa in Florida (see, for example, page 225) and of New York's Rockefeller Center (1939; page 223), one of the monumental accomplishments of the 1930s. Crawford's *Rockefeller Center* reminds us of Davis's use of lean geometries based on the masts of boats docked in Gloucester, Massachusetts; here, however, Crawford applies such geometries to views of the modern city.

Crawford is best known and largely favored for the more figurative, illusionist paintings of bridges and buildings that he produced in the 1930s. But in common with Davis, much of his best work was done after 1940. With such paintings as *Construction #7* (c. 1958; page 231), Crawford surely claims a major place in the history of postwar American art. The painting is composed around the steel structures of a New York building on the rise, at a scale and complexity that equal the tempo of the city below. It weaves an extraordinary web of interlacing, intersecting armatures, transforming the raw materials of steel and concrete into a lyrical, symphonic composition. It is a primary example of the heights to which late cubism in America aspired, and reached. In this, Crawford ranks alongside Davis, Sheeler, Hans Hofmann, and John Marin, among others. In common with Davis (and Marin and Dove), Crawford has absorbed the structural possibilities of the late work of Mondrian into a personal idiom that is at once warm and intense, soft and tensile,

rugged and serene. Mondrian himself was inspired by the rhythms of New York, and his influence on American art, beyond such neo-plastic artists as Burgoyne Diller, was profound.[13] That Crawford and Davis, and even Pollock and Hofmann, transformed the structures of Mondrian is a fine example of American pragmatism: take what you need and can use, and leave the rest behind. Crawford belongs as much to the triumph of American art as Pollock, de Kooning, and Rothko. Furthermore, in common with that of Davis, Crawford's hard-edge style would have provided a clear example for artists seeking a way out of the increasingly clogged surfaces of later abstract expressionism.

———

A sense of the cosmic, of man before nature, embodying a reach to the higher powers of the universe, runs throughout American art. The earliest example in the twentieth century is found in the work of Marsden Hartley, a selection of whose paintings and drawings forms another significant unit of the Vilcek Collection. In the early work *Silence of High Noon—Midsummer* (c. 1907–08; page 45), we feel the stillness, the intense heat of a hot summer's day, in which all is quiet, with God and man in their places, and the world almost at the moment of creation. This takes us back to nineteenth-century American painting, especially that of John Kensett and Fitz Hugh Lane, in whose work the world is frozen in

godly, eternal perfection. In Hartley's painting, we are indeed in a New World, one overseen by a divine presence—an American version of the long search for an Arcadian idyll.[14] It is a vein continued by Dove and O'Keeffe, and in the stillness of Hartley's painting we see a mood re-created in the art of Edward Hopper, albeit in a secular tone. At the same time, Hartley, a man of many moods, could see nature as nothing but motion, with falling water depicted as single but myriad, isolated strokes in such other early works as *Untitled (Maine Landscape)* (1910; page 47).

The cosmic is present in the work of Jackson Pollock, as in his avowedly landscape paintings done after 1945, by which time he had moved to the magnificent natural setting of Springs on Long Island, New York. In *Shimmering Substance* (1946; The Museum of Modern Art, New York), the artist plunges us into the density of the landscape just behind his house, watched over by the golden sun traced into the surface of the paint. As in Hartley's *Silence of High Noon—Midsummer*, we are plunged headlong into a dense landscape. Natural effects abound in Pollock's work; he can therefore be said to be a landscape painter at heart, as were so many American artists, including Hartley. Why wouldn't they be, surrounded as they were by the glorious vistas with which the United States is blessed? The encircling tracery of the sun in *Shimmering Substance* is made specific, and literal, in such paintings of the 1950s and early 1960s by

Kenneth Noland as *Noon Afloat* (1962; location unknown) and *Morning Span* (1964; Mitchell-Innes & Nash, New York).[15] We often think of color-field painting, as practiced by Noland, as "pure form," empty of any references; in truth, however, in these works we feel the heat, the sun, our presence under God's heaven, as intensely as we do in those of Hartley.

Hartley's art began and ended in Maine. He was a loner, torn and tormented, restless and driven—understandably, given his virtual abandonment as a child. Until his return to Maine in his later years, his life was a constant search for some kind of serenity, for a connection to people and to a place that he was unable to find. Nothing seemed to satisfy him or bring him peace. He was constantly moving, seeking the next destination, the next adventure, changing style and subjects often, his life and his art defined by sharp, unexpected breaks and shifts. He was a man of intense emotion and of many moods, which could change suddenly. Yet he could always find a way to channel extreme emotional states into paintings of the highest intensity. There was, however, one constant in his work: the mountain, his "mountain madness," as he called it. He painted places the world over that could be at once lonely, awful, extreme, still, or filled with the ceaseless rage of a Maine winter. He was compelled to "follow, follow, follow" this mountain madness throughout his life. In 1933, speaking of what he called his "mountain portraits," he exclaimed

that he "must have a mountain."[16] Little wonder, then, that they form the backbone of so much of his work.

Both the cosmos and Hartley's spirituality are felt just as intensely in his abstracting, symbolic works of 1913, paintings that often asserted a direct relationship between man and God, and which reflected Hartley's study of the American philosopher and psychologist William James. They are powerful works, both in their use of line and in their high-key color. Indeed, they are often considered the best paintings by any of the pioneering first generation of American artists (those born before, roughly, 1885), an assessment with which it would be hard to disagree. To see them together is like "hearing a brass band in a closet," as O'Keeffe aptly put it after seeing them exhibited in New York in 1917 at the Little Galleries of the Photo-Secession, the gallery, known as "291," run by Alfred Stieglitz.[17] They are so strong, so exalting in every sense, that we must now consider them the equal of anything ever done in the United States, including, of course, the work of Pollock, usually thought of as the greatest American artist. Only the art critic Roberta Smith has had the courage (and presence of mind) to say this publicly.[18] For many, including the "triumphalists" (see page 17), such a claim amounts to blasphemy—but the evidence is there, loud and clear, in the Vilcek Collection.

By the same token, Hartley's work after 1915 is often seen as a disappointment, apparently returning to form only from 1938 until his death in 1943. But this

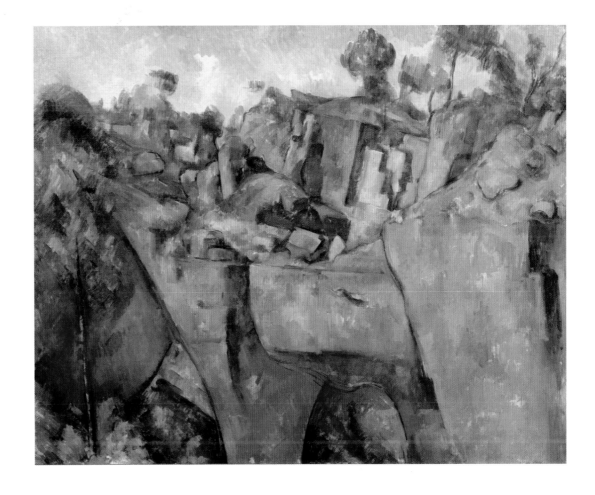

evaluation is too simplistic, for although it would be hard for anyone to maintain the level of intensity evident in Hartley's early work, it is a mistake to see that of the subsequent twenty years as a decline. It is, rather, the result of a change in mood and circumstance, both in the wider world and in Hartley's life. His work of 1916, for example, such as *Provincetown* (page 61), is certainly smaller and more contained, with quieter colors and more local subjects—in this case, the boats and docks of the summer paradise that is Provincetown, Massachusetts. The painting thus represents a significant move away from the spiritual and formal intensity of the previous four years. There is a good reason for this, and in such works Hartley was on the cutting edge of world art. The calamities of the First World War, by then bogged down in a hopeless stalemate, had brought about a profound change in the artistic and critical tone of the day. Following the prewar mood of boundless optimism, expressed in abstractions of large scale and intense color, artists saw the need to embrace a more sober, controlled, and constructive type of art. They sought an art that could be used to build a new world, both physically and morally, one born from the disasters of war. Thus, in 1917 came De Stijl, Russian constructivism, and the launching of precisionism in the United States.[19] Mondrian's art, it will be recalled, was aimed at nothing less than establishing worldwide peace and harmony, through a style (De Stijl) that could be

applied to architecture, furniture, and design in order to create a better society in the wake of the war's devastation. Both Hartley and Patrick Henry Bruce, in his *Composition* series (see, for example, page 16), announced this change of mood in 1916, ahead of its European manifestations. After this, artists all over the world moved to a more stable, articulate, even classical kind of construction. The clear, rectilinear composition of Andrew Dasburg's cubist painting *Untitled (Still Life with Artist's Portfolio and Bowl of Fruit)* (*c.* 1914–18; page 143), a very different kind of work from his earlier, more painterly abstractions, could also be considered part of this drive, and thus might be dated closer to 1916–17 than to 1914.

Hartley *et al.*'s anticipation of a more restrained form of representation is but one instance of how the United States, at an early date, played a timely and important part in world art. In 1923, Dasburg wrote an article saying that Americans did not really understand cubism, a telling example of America's longstanding cultural inferiority complex.[20] But Dasburg sold himself and his colleagues short: they were better than they realized or understood. No wonder, then, that forty years later Donald Judd could state that the first battle for an American artist was to cut himself off from Europe and dispose of its heritage.[21] In contrast to Dasburg's lack of self-belief, Stuart Davis, after his stay in Paris in 1928–29, was able to say that the most important thing about his trip was that he had come to understand that there

Michelangelo
(1475–1564)
Dying Slave
1513–16
Marble
Height: 7½ ft (2.3 m)
LOUVRE, PARIS

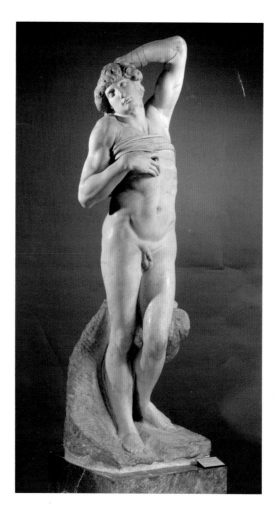

were not a hundred great artists standing on every street corner.[22] In other words: I can play with these guys, an assertion that marks a turning point in America's collective sense of confidence.

There is still something cosmic, even otherworldly, about Hartley's *New Mexico Recollections* series (c. 1923; see, for example, pages 66–69), which seems as if at the end of a long road to perdition. The paintings in the series depict a land faraway, in both setting and memory, but with an intensity that suggests it had been experienced only moments earlier. Hartley had traveled to New Mexico in 1918, a journey taken by many artists, including Dasburg and Davis. Typically, Hartley did not like it, complaining that there were too many tourists and "cheap" artists.[23] Yet, also typically, no sooner had he left the state than his imagination pulled him back to its stark and rugged landscapes. In 1931, he was able to recall the desert and "its glorious light," which could "warm me up a little," while at the same time observing that it was "certainly a dark forest for one who can't take it."[24] It was indeed a dark forest, the twilight of the soul, that he portrayed in the New Mexico series. The art historian Gail R. Scott believes that many of the paintings were produced in Berlin in 1923, and that they reflect the decadence of the city at that time. There is a sense of loss here, suggested in *New Mexico Recollection #13* by the initial "K," a reference to Hartley's close friend killed in the First World War, Karl von Freyburg, whose memory clearly haunted the

Norman Rockwell
(1894–1978)
Rosie the Riveter
1943
Oil on canvas
52 x 40 in. (132.1 x 101.6 cm)
CRYSTAL BRIDGES MUSEUM OF AMERICAN ART,
BENTONVILLE, ARKANSAS

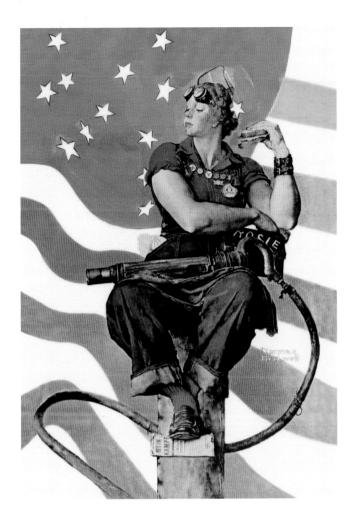

artist. The landscape rolls as Hartley's emotions did. It is a place of fear and trembling, but Hartley seems to face his demons, even if unable to banish them. The paintings are all motion and countermotion—as was his untitled landscape of 1910 (page 47)—filled with undulations that Hartley referred to as "wave rhythms."[25] All is dense and heavy, the clouds as weighty as the rocks, the sky itself like concrete, reminding us of the work of Gustave Courbet or van Gogh's rolling, relief-like surfaces. The dark colors are reminiscent of those of André Derain or André Dunoyer de Segonzac, but the series can also be seen as a homage to the dark forces at play in the work of Albert Pinkham Ryder, a patron saint of American artists from Hartley and Dove to Hans Hofmann and Pollock. Above all, however, one sees in the paintings' solidity and bulk a new concentration on the structural aspects of Cézanne, pointing to the pervasive influence of "Cézannism" in American and European art during the 1920s. At the same time, the internal rhythms recall Pollock's allover compositions, their ceaseless motion.

Hartley's New Mexico series is also a restatement of a modern classicism. Although this classicism can be detected in Hartley's work after his trip to Italy in late 1923, it is more literally evident in *The Strong Man* (c. 1923; pages 70–71), perhaps created in anticipation of that trip. The man's sculptural bulk relates to the classical figures produced by Picasso between 1917 and 1923, after he had traveled to

Rome. Hartley's figure is the start in American art of a new interest in Michelangelo, taken up again by Hartley himself in the late 1930s, at the same time as Walt Kuhn; such younger painters as Arshile Gorky and de Kooning; and no less an artist than Norman Rockwell in *Rosie the Riveter* (1943; above), his famous cover image for the *Saturday Evening Post* based on the figure of Isaiah from the ceiling of the Sistine Chapel.[26] In turn, Hartley's nude may be a reference to the figure of Dusk in Michelangelo's tomb of Lorenzo de' Medici (1519–33) in the Basilica di San Lorenzo, Florence.

The mountain was never far from Hartley's consciousness. It appears again in his extraordinary *Mont Sainte-Victoire* series (c. 1927; see, for example, page 73), one of the most glorious painterly episodes of not only Hartley's career but also American painting of the time. The mood and spirit could not be more different from that of the New Mexico series. Here, pure joy and color burst forth—a veritable rebirth of the artist, of his art, and of the world itself. We can perhaps trace this exuberance to his journey to the very home of Cézanne, the artist so thoroughly entwined with Hartley and his work. He is *with* Cézanne, in place and mood and practice. He is not recollecting anything; he is there, directly experiencing and deeply enjoying the kinship. It may be that he is so close to Cézanne in spirit that we have missed the power of this series, feeling that the paintings are therefore somehow derivative. They are

not. Look at them: their color is intense, arbitrary, invented, the chromatic expression as original as that in Hartley's abstractions of 1913. The hues vibrate, shimmering in the space, interacting with one another in as complex a color symphony as one is likely to find in modern art; indeed, only the work of Stuart Davis shares this intensity of color, and it may even recall the high color syncopation in Donald Judd's late pieces of multiple hues. Hartley's series has a light, airy quality, open and dynamic, far removed from the heavy, dense surfaces of Cézanne and much of European art. It has not attracted wider attention because we have not understood color construction and its key role in modern art, as important as cubism was to American art. It is as if Hartley, a restless soul, had at last found a place of peace and inspiration. To depict Cézanne's mountain was to return to the very source of modern art. For Cézanne's paintings of this site provided the impetus for both color and cubist construction, through the implicit grids and the patches of color, the aspects of Cézanne's art that Picasso and Matisse built on; this is why both could say that "Cézanne was the father of us all." So too, then, could Hartley rightly place himself in that lineage. In linking himself to Cézanne, Hartley was also part of the drive in the 1920s to connect art to the classic tradition, for by then Cézanne was considered the equal of any of the Old Masters, not least Poussin. This was a renewal of the drive, started as we have seen by Hartley and Patrick Henry Bruce

in 1916, to pursue an art of solidity and substance, one that, being based on centuries of tradition, would stand with the past.

Cézanne was the modern classicist above any other, and it is as though Hartley sought other sites that would remind him of Cézanne's familiar places. This was the case, perhaps, with *Autumn Landscape, Dogtown* (1934; page 75). Hartley, as he so often did, looked for and found an area of mystery, in this instance Dogtown, an abandoned, disreputable settlement near Gloucester, Massachusetts, the harbor town where Stuart Davis spent his summers for almost thirty years. In the mid-1930s, Dogtown was still considered a place of danger and unsocial activity, to be avoided by "proper" people. The farmers who had settled there in the nineteenth century, to work the lands needed to feed the people of Gloucester, were auslanders, outsiders—as was Hartley himself—foreign to the old fishing communities of Italians and Portuguese in the town. It is a rocky place, as one can see from Hartley's painting, with the remains of old structures, like haunted ruins, and ancient caves, bespeaking a murky, even illicit past. Hartley loved it, and painted it many times, in part, surely, because it reminded him of other Cézanne sites, such as the rocky terrain at Bibémus, a quarry near Aix-en-Provence in the south of France. In *The Quarry at Bibémus* (c. 1895; page 25), for example, Cézanne imbued the stone formations with the grandeur of a modern

Stonehenge; Hartley, in turn, appears to have done something similar in his depictions of Dogtown—an ancient world in modern America.

Andrew Dasburg's work of the 1920s also featured Cézannesque structures, but filtered through the rich, muted colors of the Southwest. Indeed, Dasburg grew close to the land around Taos, New Mexico, finding comfort and solace in it for the rest of his life. The Vilcek Dasburgs (see pages 140–51) demonstrate just how good an artist he was, and accord him a deservedly more elevated position in the history of American art.

———

From the start of his career, Hartley pioneered the constructive use of color, as did Max Weber, perhaps the very first American artist to absorb and incorporate the principles of both Picasso's structure and Matisse's color. As such, Hartley and Weber helped to develop the use of color as a primary method of creating a painting, a method that took root in American art even before cubism did. From at least 1907, artists in the United States were studying the theoretical aspects of color and light, that is, at the same time as many European artists were—a matter of parallel and simultaneous activity rather than *ex post facto* imitation, as American art was characterized for so long. This was particularly true of Morgan Russell and Stanton Macdonald-Wright, America's early exponents of color abstraction. For

years, they were considered short-lived followers of Robert Delaunay, until intensive research on them began in 1963. Russell's papers, discovered in 1964,[27] showed that both he and Macdonald-Wright were studying color and light at an early date, and that their first mature works of 1912 were original contributions to what was termed "orphic cubism" by the French poet and writer Guillaume Apollinaire. In the early summer of 1913, they held a major exhibition in Munich—the launch of "synchromism," their color-theory movement—followed that fall by a large show at the prestigious Bernheim-Jeune gallery in Paris, attracting wide public attention. They were notable if polarizing figures in Paris, as was Patrick Henry Bruce, another American in the French capital making original color abstractions.

Russell and Macdonald-Wright's challenge to French art (they claimed that their work was the most advanced in the world) brought them notoriety that shielded viewers from considering the work itself. Russell's *Synchromy in Orange: To Form* (1913–14; opposite) shows the basis of their approach. For all its modernity, the spiral form of the work, and of many of their abstract paintings of the time, was based on the twisted arm and body of Michelangelo's *Dying Slave* (1513–16; page 26). Both artists had studied the classic sculpture assiduously, an early example of the frequent use in American art of a classic source. *Synchromy in Orange* also demonstrates many of the principles of color theory, among them simultaneous

contrasts, gradation, harmony of opposites, and harmony of similar hues, all part of the development of the science and practice of color during the great period of scientific discovery in the nineteenth century.[28] Wedded to these principles was the use of Cézanne's discrete, parallel color patches seen as single, autonomous areas, now distilled and clarified into full-bodied forms. Russell and Macdonald-Wright represent the start of a long tradition of color use, as a formal and emotive agent in its own right, still being defined today. Furthermore, Macdonald-Wright's use of motion was passed on to Thomas Hart Benton, the former's student and close friend, and is at the heart of Benton's famous regionalist paintings of the 1930s. This same type of interlacing movement was passed on to Benton's student, none other than Jackson Pollock.

In turn, Dasburg had studied with Russell in Paris and became a skillful colorist, as can be seen in his still life of about 1914–18 (page 143). Jan Matulka was a brilliant colorist as well, as demonstrated in his sparkling *Indian Dancers* (c. 1917–18; page 169). Both paintings are part of the large corpus of American color painting that forms a significant part of American modernism. The latter work is a uniquely American interpretation of Matisse's famous *Dance* paintings of 1909 and 1910, a theme also taken up by Arthur B. Davies in his color paintings of 1916. High color continues in

Matulka's *Rodeo Rider* (c. 1917–20; page 171), albeit in a more figurative vein, part of the move toward a more classical kind of art in the wake of the First World War. Matulka casts the cowboy as the classic hero on horseback, in this case the iconic horse from the equestrian statue of Marcus Aurelius on the Capitoline Hill in Rome. Matulka, one of the many immigrants who enriched American art and culture, has gone American with a vengeance. Later, in the 1920s and 1930s, such classical themes appear in the work of the group of artists around John Graham, including that of Matulka, Arshile Gorky, and Graham himself.[29]

Arthur Dove, America's most cherished and beloved modernist, was also a pioneer of American modernism. He started in an impressionist manner, absorbed Cézanne and Matisse in 1908 during a trip to Europe, and used a modified cubist mode in his famous *Nature Symbolized* series of 1911–12. After this promising start, however, he virtually stopped painting between 1917 and 1921. Even Alfred Stieglitz, his loyal mentor, wondered if he would ever return to it. In his fierce struggle with his father—marked by hate and disdain on both sides— Dove sought above all to establish his financial and artistic independence, undertaking foolish enterprises that distracted him for years at a time. Beginning in 1910, he tried to run a chicken farm in Westport, Connecticut; then, in the 1920s, he took to living on a boat with the artist Helen Torr, first a

Arthur Dove
(1880–1946)
Indian Summer
1941
Oil on canvas
20 x 28 in. (50.8 x 71.1 cm)
THE HECKSCHER MUSEUM OF ART,
HUNTINGTON, NEW YORK

houseboat and then a leaky yawl, the maintenance of which robbed him of precious time and energy. In 1933, after the death of his remaining parent, he returned to the desolate climes of Geneva, New York, the location of the family holdings, where he attempted to turn the old farm into a going concern. He was kept from fully pursuing his talents, it seems, until late in life, when, in 1938, he moved back to Long Island to be by the water he loved. There, in Centerport, while he was living in a former post office, debilitating heart and kidney ailments meant that, by a terrible irony, he finally had the freedom he needed to realize his talents fully, for he could do nothing but make art.

Despite ill health, family troubles, and poverty, Dove still managed in his late work to produce some of his most authentic, accomplished, and deeply felt paintings, for even more than some of his earlier work they were "of the earth," as his close friend Georgia O'Keeffe had once remarked.[30] Dove was indeed a pioneer, but his full maturity did not begin to manifest itself until the late 1920s, when the Vilcek works begin. *Untitled* (c. 1929; page 81), for example, shows a new depth and richness, reminding us of the colors used by Rembrandt, a master Dove was specifically thinking of in August 1929.[31]

In common with Marsden Hartley, albeit in a different mode, Dove could also alternate between quiet, meditative paintings and works of intense and rapid movement. In *Below the Flood Gates— Huntington Harbor* (1930; page 87), he took a local, ordinary landmark, close to where his yawl was anchored in the eponymous Long Island harbor, and turned it into a universal epic of flowing water, the force of life itself embodied in the painting's swirling currents. This was Dove, once again, as a poet of nature, and of the humble. The intensity of the clockwise movement is reminiscent of Leonardo da Vinci's drawings of a great deluge (c. 1517–18; Royal Collection, London), in which the artist saw the beginning—and the end—of the world. It also calls to mind the internal energy of van Gogh's paintings, especially *Olive Trees* (1889; The Metropolitan Museum of Art, New York), seen at the Armory Show in New York in 1913. Dove had the highest regard for van Gogh, whose letters he often read. No artist was closer to nature than the Dutchman, so Dove's attachment to him is understandable, as is his humility as a worker in nature. Lastly, we can see in Dove's painting a forecast of Pollock's allover technique, the pours and strokings of his classic works of 1947–50. Dove, in the style and intensity of his work, was truly a proto-abstract expressionist; some, notably the scholar Helen A. Harrison, believe that Dove was in fact the *first* abstract expressionist.[32] Such a claim is given weight by *Colored Drawing, Canvas* (1929; page 83), in which linear tracery makes its way across a view of the Huntington shore from

Dove's boat anchored in the harbor. The line is free and independent, seemingly going its own way over and across the canvas, and is the dominant element in the painting. In its openness, autonomy of line, and smudges of color, *Colored Drawing* may be said to resemble the work of Vasily Kandinsky, especially *Improvisation 27 (Garden of Love II)* (1912; The Metropolitan Museum of Art, New York), a telling comparison made by Emily Schuchardt Navratil.[33] The use of line even suggests the "automatic drawing" found in surrealist and, later, abstract expressionist art. Dove was a pioneer in its practice, as can be seen in his *Orange Grove in California, by Irving Berlin* (1927; Museo Thyssen-Bornemisza, Madrid). This work represents the first such use of automatic drawing in American modernism, a clear prototype for its increasing use after 1940, when drawing itself became the source of gestural abstraction. There is much to be said for this argument; but at the very least we can see yet another line of continuity between early modernism and post-1945 art. Indeed, the abstract expressionists Theodoros Stamos and William Baziotes revered Dove, the latter in his beautiful, swimming biomorphic shapes. Later, Frank Stella deeply admired Dove, saying that if he could make a work as direct and honest as Dove had, he would have accomplished something.[34]

Dove's art became only richer and deeper as he grew older, and his late work, produced after he had moved to Centerport, marks a true pinnacle in his career. Despite his restricted movement, he did not need to venture far from his house to find everything he wanted: the water, the sun, the sky, the local architecture. Increasingly, he concentrated on working in small sizes, on paper, producing a sustained series of gems often no bigger than 6 x 9 inches (15 x 23 centimeters) or even smaller. They are overlooked icons of American art, and we find them in some depth in the Vilcek Collection. By 1939, Dove was "getting some new directions,"[35] as he put it, moving into a more linear, flatter format, with larger, bolder areas of color reflecting his newly discovered interest in Mondrian, László Moholy-Nagy, and some of the other constructivist-oriented artists he had seen in 1936 at the *Cubism and Abstract Art* exhibition at the Museum of Modern Art in New York.[36] In *Continuity* (1939; page 95), we see these "directions" in play, the rolling forms still there, but now more tempered and poised, and, as the title makes clear, demonstrating the ongoing connections in his art and life. The landscape of his new home, the gentle hills and the harbor, seems to be suggested here, a hallmark of his late work. (Think ahead to Stuart Davis in 1950 and his "amazing continuity"; see page 22.) Indeed, hallmarks of Dove's early work are also evident. As early as 1913, in *Drawing* (page 29), a sunrise, speaking of the cycle of life, of life and rebirth on a daily basis, is at the core of his art. And so it

was at the very last in the Vilcek Collection's small *Sunrise* paintings (*c.* 1941; page 97). Here, the theme is the same—as is the huge scale that stood for the world as Dove saw and loved it—but rendered in a small size. Even *Untitled Drawing* (1941; page 91) relates to the sun-filled painting *Indian Summer* (1941; page 31), done in November on an unusually warm day.

The *Sunrise* paintings are part of a series that concludes Dove's lifework. In another painting from the series, the near-perfect *That Red One* (1944; above), everything is as it needs to and should be, the forms and colors direct and clear, with no extraneous parts. Everything is at its fullest possibility.[37] It is as good, exalting, and important as anything done that year in the United States. It can be seen as the point at which an older and a younger generation were joined. If in 1944 Georgia O'Keeffe was depicting her anxiety, and Ralston Crawford the terrible detritus of war, Dove turned despair into joy, darkness into light, gloom into life and energy. Dove fulfills the early hope of the possibility of an American art. The theme of the sun and its rise in the morning marks the work of van Gogh, of Dove's friend O'Keeffe, even of Matisse in certain cutouts—and thus Dove's own place in the story of modern art. Dove was a man of deep humility; every morning, he would rise early and record the temperature and the weather conditions, as if literally to connect himself to the world, and to

give thanks for his place in it. His series of works from 1936–37, including *Sunrise* (*c.* 1936; page 90), is his proclamation of man's connection to God, of the divine character of nature and the world. In this, it is quintessentially American. The series' intimate character demands our closest attention, and rewards us with a reminder of the power of art to engage and move us at our very core.

Notes

1 For a full history of the Phillips Collection, see Erika D. Passantino, ed., *The Eye of Duncan Phillips: A Collection in the Making*, Washington, D.C. (The Phillips Collection in association with Yale University Press) 1999.

2 Irving Sandler, *The Triumph of American Painting: A History of Abstract Expressionism*, New York (Praeger) 1970. See also, more recently, Katy Siegel, ed., *Abstract Expressionism*, London (Phaidon) 2011.

3 *American Vanguards: Graham, Davis, Gorky, De Kooning, and Their Circle, 1927–1942*, exhib. cat. by William C. Agee *et al.*, Purchase, NY, Fort Worth, Tex., and Andover, Mass., 2012.

4 Willem de Kooning, quoted in *ibid.*, p. 130.

5 Irving Sandler, "A Conversation with the Curators: American Vanguards," William C. Agee, Irving Sandler, and Karen Wilkin in conversation, New York Studio School, March 27, 2012.

6 Stuart Davis, notebook entry, March 1922, quoted in *Stuart Davis, 1892–1964: The Breakthrough Years, 1922–1924*, exhib. cat. by William C. Agee, New York, Salander-O'Reilly Galleries, November–December 1987, n.p.

7 *High Notes of American Modernism: Selections from the Tommy and Gill LiPuma Collection*, exhib. cat. by William C. Agee, New York, Berry-Hill Galleries, November–December 2002.

8 *Stuart Davis, 1892–1964: Black and White*, exhib. cat. by William C. Agee, New York, Salander-O'Reilly Galleries, November–December 1985.

9 Davis described Pollock's painting as "stimulating." Stuart Davis, diary entry, November 27, 1952, quoted in Emily Schuchardt Navratil, "Stuart Davis and Abstract Expressionism: 1938–1963," unpublished paper, 2006, p. 16.

10 *Stuart Davis*, exhib. cat. by Stuart Davis and H. Harvard Arnason, Minneapolis, Des Moines, San Francisco, and New York, 1957.

11 Donald Judd, "Stuart Davis," *Arts Magazine*, September 1962, reprinted in Donald Judd, *Donald Judd: Complete Writings 1959–1975*, Halifax (Press of the Nova Scotia College of Art and Design) 1975, pp. 55–56. Although Davis was in fact sixty-nine at the time of the article, he claimed throughout his life to have been born in 1894, hence Judd's error.

12 William C. Agee, "The Last Years, 1960–1964," in *Stuart Davis: A Catalogue Raisonné*, ed. Ani Boyajian and Mark Rutkoski, 3 vols., New Haven, Conn. (Yale University Press) 2007, vol. 1, pp. 115–23.

13 Emily Schuchardt Navratil, "Beyond Neo-Plasticism: Piet Mondrian in America, 1926–1968; His Impact on Stuart Davis, John Marin, and Robert Motherwell," MA thesis, Hunter College, City University of New York, 2007; and *John Marin: The Late Oils*, exhib. cat. by William C. Agee, New York, Adelson Galleries, November–December 2008.

14 See *Gauguin, Cézanne, Matisse: Visions of Arcadia*, exhib. cat., ed. Joseph J. Rishell, Philadelphia Museum of Art, June–September 2012.

15 *Kenneth Noland: The Circle Paintings 1956–1963*, exhib. cat. by William C. Agee, Houston, Tex., Museum of Fine Arts, November 1993 – January 1994; Fort Lauderdale, Fla., Museum of Art, March–May 1994.

16 Marsden Hartley, quoted in Jeanne Hokin, *Pinnacles & Pyramids: The Art of Marsden Hartley*, Albuquerque (University of New Mexico Press) 1993, pp. xvii, xxii, 18, 104.

17 Georgia O'Keeffe, quoted in Roxana Robinson, *Georgia O'Keeffe: A Life*, New York (Harper & Row) 1989, p. 136.

18 Roberta Smith, "Marsden Hartley's World," *New York Times*, January 31, 2003, p. E3.

19 See William C. Agee, "The Rediscovery of a Forgotten Modern Master," in *Patrick Henry Bruce, American Modernist: A Catalogue Raisonné*, William C. Agee and Barbara Rose, New York (The Museum of Modern Art) 1979; and "Graham, Gorky, de Kooning: A New Classicism, an Alternate Modernism," in *American Vanguards*, exhib. cat., pp. 117–45. See also *Chaos and Classicism: Art in France, Italy, and Germany, 1918–1936*, exhib. cat. by Kenneth E. Silver, New York, Solomon R. Guggenheim Museum, October 2010 – January 2011; Guggenheim Museum Bilbao, February–May 2011.

20 Andrew Dasburg, "Cubism—Its Rise and Influence," *The Arts*, November 1923, pp. 278–84.

21 Donald Judd, "Specific Objects," in *Contemporary Sculpture: Arts Yearbook 8*, ed. William Seitz, New York (The Art Digest) 1965, pp. 74–82.

22 Stuart Davis, "Self-Interview," *Creative Art*, 9, September 1931, pp. 208–11.

23 Marsden Hartley, letter to Harriet Monroe, June 23, 1919, Elizabeth McCausland Papers, Archives of American Art, Smithsonian Institution, Washington, D.C.

24 Marsden Hartley, quoted in Sharyn Rohlfsen Udall, *Modernist Painting in New Mexico, 1913–1935*, Albuquerque (University of New Mexico Press) 1984, p. 51.

25 Marsden Hartley, quoted in *ibid.*, p. 49.

26 *American Vanguards*, exhib. cat., pp. 117–45; and "De Kooning: 1927–42: The Four Musketeers and other Local Sources," talk given as part of "De Kooning Now," panel discussion and symposium, The Museum of Modern Art, New York, November 11, 2011.

27 The papers are now held by the Montclair Art Museum, New Jersey. First published in William C. Agee, *Synchromism and Color Principles in American Painting, 1910–1930*, New York (M. Knoedler and Co.) 1965.

28 For more on the mechanics of color, see *ibid.* and William Innes Homer, *Seurat and the Science of Painting*, Cambridge, Mass. (MIT Press) 1964.

29 *American Vanguards*, exhib. cat., pp. 46, 56–59, 130.

30 Georgia O'Keeffe, quoted in Suzanne Mullett, "Arthur G. Dove (1880–): A Study in Contemporary Art," MA thesis, The American University, Washington, D.C., 1944, p. 27.

31 Helen Torr, diary entry, August 13, 1929, Arthur and Helen Torr Dove Papers, Archives of American Art, Smithsonian Institution, Washington, D.C. The diary entry reads: "Arthur searching and exploring his inner horizon for new ideas. Said he was bored silly—all but Picasso, Cezanne, and Rembrandt—'and that's an awful state to be in.'"

32 Helen A. Harrison, "Arthur Dove and the Origins of Abstract Expressionism," *American Art*, Spring 1998, pp. 67–83.

33 Emily Schuchardt Navratil, e-mail to author, November 4, 2012.

34 See William C. Agee, *Modern Art in America 1908–1968*, London (Phaidon) forthcoming; and "Raising America's Iron Curtain: Continuities and Connections in Pre- and Post-1945 Art," paper presented at Georgia O'Keeffe Museum Research Center Symposium, Santa Fe, New Mexico, July 2011.

35 Arthur Dove, quoted in William C. Agee, "Arthur Dove: The Late Work, 1938–1946," in *Arthur Dove: A Retrospective*, exhib. cat. by Debra Bricker Balken *et al.*, Washington, D.C., The Phillips Collection, September 1997 – January 1998, then traveling, p. 136.

36 *Ibid.*, pp. 137–38.

37 *Ibid.*, p. 149.

The Vilcek Collection

Lewis Kachur

Oscar Bluemner
(1867–1938)

Young Tree in a Red Courtyard
1919
Signed lower left: "OBLÜMNER"
Watercolor on paper
19 x 14 in. (48.3 x 35.6 cm)
2010.05.02

Young Tree in a Red Courtyard is one of only a handful of paintings by Oscar Bluemner that date from the late 1910s, a period in which the artist decreased production owing to impoverishment. It is one of three large watercolors he made at the time with the support and encouragement of the gallery owner Stephen Bourgeois.

The yellow sapling is centralized and dominant, but there are smaller trees painted in a different style on either side. In a complex appropriation, Bluemner was quoting from styles of Chinese landscape painting: "maple . . . à la Mi Fei [Mi Fu] . . . bush à la Mushi [Muqi] old tree Wutaotse [Wu Daozi]."[1] All this as part of a fusion by Bluemner of Eastern thought and Western values, toward a higher spirituality.

Color, too, has its programmatic aspect. The central area is built up of primaries, the yellow of the maple, the red of the building, and the blue of the water corresponding to, respectively, rebirth, passion, and faith. Add to these the colors green (vitality) and gray (decay).

"*Color* is a force," Bluemner wrote at the time.[2] That is certainly true of the yellow maple, which stands out coloristically, almost like a figural presence. It is dramatically ringed by a ghostly gray-white aura, and overlaps and joins the central primary-color triad. Billowing cumulus clouds in the background, a contrast to all the angular forms, add to the drama.

There is a small, more painterly gouache study for this work in the collection of the Smithsonian American Art Museum in Washington, D.C.

1 Oscar Bluemner, painting diary, April 21, 1919, quoted in Jeffrey R. Hayes, *Oscar Bluemner*, Cambridge (Cambridge University Press) 1991, p. 101.
2 Oscar Bluemner, painting diary, April 28, 1919, quoted in *ibid.*, p. 102. Italics in the original.

Oscar Bluemner
(1867–1938)

Scales House, Soho
February 3, 1920
Signed lower left: "OFB—20"
Gouache on paper
4 x 5 in. (10.2 x 12.7 cm)
2009.02.01

In September 1916, Bluemner and his family left New York to live in a series of locations just over the Hudson River in New Jersey, beginning with Bloomfield. After being evicted from their home there in January 1918, they moved east to nearby Belleville. Bluemner later referred to living in ten different places in New Jersey over the next decade, often being unable to pay the rent.

Scales House, Soho, depicting a scene in the neighborhood of Belleville known as Soho, juxtaposes an anthropomorphic tree with the house of the painting's title. The tree's gnarled branches counterpoint the blocky solidity of the house, with a path leading into the distance between them. Trees for Bluemner, as in the case of *Young Tree in a Red Courtyard* (1919; page 39), are often dramatic actors. A tree, he wrote, is "a living thing, lowly humanlike . . . [it] has life, youth and age."[1]

The house is bright red, a favorite hue of the artist, which he infused with multiple meanings: "the chief color, the signal, the warning, the symbol of power, vitality, energy, life."[2]

That Bluemner strove for a more transcendental art is underlined by a note he made in a copy of Paul Signac's treatise on color theory, *From Eugène Delacroix to Neo-Impressionism* (1899): "Cezanne, Signac, Matisse already signify the formal, even if still not the spiritual, transition to the new: the rebirth of spiritual painting, which in the first place begins to struggle again toward abstract effects and elements."[3]

1 Oscar Bluemner, painting diary, July 29, 1918, quoted in *Oscar Bluemner: The New Jersey Years—Drawings and Watercolors 1916–1926*, exhib. cat. by Jeffrey R. Hayes, Mahwah, NJ, Ramapo College Art Gallery, October–November 1982, p. 6.
2 Oscar Bluemner, painting diary, April 21, 1918, quoted in *ibid.*, p. 7.
3 Oscar Bluemner, June 5, 1918, quoted in *ibid.*, pp. 7, 9 n. 12.

Oscar Bluemner
(1867–1938)

Red Night, Thoughts
1929
Signed lower right: "OBLÜMNER"
Oil on board mounted on panel
8 x 10 in. (20.3 x 25.4 cm)
2008.04.01

Red Night, Thoughts is one of twenty small panel paintings that Bluemner exhibited in his show at the Whitney Studio Galleries in New York in November 1929. They were painted using an experimental technique that involved the elaborate layering of the white panel with oil resin and pigment, with coats of poppy oil in between.[1] It is these layers that give the paintings a particular glow.

Bluemner's use of red was one of the highlights of the show, and of his fanciful catalogue essay. He writes of red ochre, as discovered by accident by a woman in ancient times, as the first rouge. As though rediscovering this rouge, Bluemner "let colors as psychological plasma create their own forms (cells)."[2] The exhibition was a striking critical success, and Bluemner made $2000 in sales—despite the stock market crash of the previous month.

In the late 1920s, Bluemner pursued a "consciously concerned Freudian idea," which he projected in his landscapes. His aim was "to render such a scene as if it were a person [with] eyes and bearing . . . since all such turns to ego, landscape painting is semi-self-portraiture. Art is like a disease or neurosis by which the psyche finds outlet."[3]

Critics have noted a "psychosexual" element to Bluemner's juxtaposition of phallic forms and more rounded, "female" forms—"altera versus ego," as the artist termed it.[4] Here, the chimney is contrasted with angular forms in dark hues of green and brown, in a shallow space. Bluemner's notes on the painting indicate that the scene depicts a location in the semirural Bronx, New York. The "phallus . . . fiery red" of the chimney is contrasted with the blue ravine, "soft deep . . . uncanny." The work is a nocturne lit by "electric light," conveying an "intimate dark mood" associated, surprisingly, with "murder."[5] Bluemner thus achieves a unique combination of cubist space and Freudian-tinged, expressionist content.

1 *Oscar Bluemner: A Passion for Color*, exhib. cat. by Barbara Haskell, New York, Whitney Museum of American Art, October 2005 – February 2006, p. 117.
2 *Oscar Bluemner: Landscapes of Sorrow and Joy*, exhib. cat. by Jeffrey R. Hayes, Washington, D.C., Fort Worth, and Trenton, 1988–89, p. 60.
3 *Ibid.*, p. xiii.
4 Oscar Bluemner, painting diary, September 1928 – April 1929, quoted in Jeffrey R. Hayes, *Oscar Bluemner*, Cambridge (Cambridge University Press) 1991, p. 137.
5 Oscar Bluemner, painting diary, September 1928 – July 1929, quoted in *ibid.*

Marsden Hartley
(1877–1943)

Silence of High Noon—Midsummer
c. 1907–08
Oil on canvas
30½ x 30½ in. (77.5 x 77.5 cm)
2008.07.01

Marsden Hartley's first solo exhibition was held in May 1909 at the Little Galleries of the Photo-Secession, Alfred Stieglitz's gallery in New York commonly known as "291." Despite none of the thirty-three paintings finding a buyer, this was the beginning of Stieglitz's near-lifelong support for Hartley's art. *Silence of High Noon—Midsummer* was the first item listed in the catalogue.

The painting reflects Hartley's interest in the landscape of his native Maine. It is doubly stylized, with the colors falling into wavy, alternating patterns, as well as long, filamented brushstrokes, reminiscent of the work of the Italian postimpressionist Giovanni Segantini. Although now little-known in the United States, Segantini at the time was very popular, and was recognized by a critic reviewing the Stieglitz show as the source for Hartley's technique, "a version of the famous Segantini 'stitch,' of using colors pure and laying them side by side upon the canvas in long flecks that look like stitches of embroidery."[1] Segantini, too, often painted brightly lit, mountainous rural scenes; indeed, Hartley dubbed him "the master of the mountain."[2]

Hartley had moved back to his native Maine in the fall of 1908, staying in an abandoned shack in the Stoneham Valley near North Lovell. As Hartley wrote to a friend, he was "happily contented to be climbing the heights and the clouds by the brush method . . . rendering the God-spirit of the mountains."[3] This reflects the transcendentalist thought of the writer Ralph Waldo Emerson, whose work Hartley admired.

Hartley used a canvas of identical proportions for *Carnival of Autumn* (1908; Museum of Fine Arts, Boston), a very close variant of this work, with a redder tonality to the leaves, and a stream rather than a meadow in the foreground. A similar work of the period, *Cosmos* (1908–09; Columbus Museum of Art, Ohio), has been connected through its title to the poet Walt Whitman. But it could also refer to the magnum opus of the naturalist Alexander von Humboldt. Humboldt's five-volume *Kosmos* (1845) attempted to unify the various branches of scientific knowledge.

Hall of the Mountain King (c. 1908–09; Crystal Bridges Museum of American Art, Bentonville, Arkansas) is another of Hartley's works that share the same-sized square format. All these paintings, and others, have a high horizon line, flattening the space and bringing out the decorative patterns on the surface. The similarities between them suggest that Hartley was pursuing a series across the seasons, from summer to winter, analogous to Monet's series paintings of the 1890s, such as *Haystacks* (1890–91).

1 Charles H. Caffin, "Unphotographic Paint," reprinted in *Camera Work*, 28, October 1909, pp. 20–23.
2 Marsden Hartley, "On the Persistence of the Imagination: The Painting of Milton Avery, American Imaginative" [1938], in *On Art by Marsden Hartley*, ed. Gail R. Scott, New York (Horizon Press) 1982, p. 204.
3 Marsden Hartley, letter to Horace Traubel, postmarked February 10, 1907, quoted in Gail R. Scott, *Marsden Hartley*, New York (Abbeville Press) 1988, p. 18.

Marsden Hartley
(1877–1943)

Untitled
(Maine Landscape)
1910
Signed lower right: "MARSDEN HARTLEY"
Oil on board
12⅛ x 12 in. (30.8 x 30.5 cm)
2010.01.01

In February 1910, Hartley dedicated this landscape, in an inscription on its verso, to Kenneth Hayes Miller, a more conservative contemporary painter who had befriended Albert Pinkham Ryder, an older, reclusive artist who greatly interested Hartley. Hartley had returned to New York that month in part to see the acclaimed show of Henri Matisse's work at Alfred Stieglitz's 291 gallery.

Hartley's landscape is one of at least four similar paintings of a small waterfall cascading over rocks into a pool, done on panels measuring roughly 12 inches (30.5 centimeters) square. The version held by the Fogg Museum at Harvard University has more yellows and reds, while that held by the Weisman Art Museum at the University of Minnesota is considerably darker.[1] All feature long white brushstrokes mixed with short dabs of bright color.

In creating these works, Hartley seems to have abandoned the Segantini "stitch" (see page 44) for a more painterly approach, compressed space, and vivid hues. In the Vilcek picture, the white brushstrokes are the most controlled, thus the cascade is more modest. The work pans back, with less horizon but slightly more foreground space than in the other versions. There is a wider, leaf-strewn pool in the lower part of the painting, and two white birches in the top right-hand corner; at the very top, a third birch appears to have fallen across the stream.

1 For the Fogg Museum version, see *Marsden Hartley*, exhib. cat. by Barbara Haskell, New York, Whitney Museum of American Art, March–May 1980, then traveling, plate 72; for the Weisman Art Museum version, see Gail R. Scott, *Marsden Hartley*, New York (Abbeville Press) 1988, fig. 21. A third version was sold at auction in 2011; see Christie's, Sale 2444: Important American Paintings, Drawings, and Sculpture, May 18, 2011, New York, Rockefeller Plaza, lot 10.

Marsden Hartley
(1877–1943)

Indian Pottery
c. 1912
Oil on canvas
20¼ x 20¼ in. (51.4 x 51.4 cm)
2006.05.01

Before a hanging curtain sit three or four unique examples of Native American art, two of which are from the pueblos in the Southwest. The largest, central form is an Acoma polychrome storage jar of the mid-nineteenth century, decorated with a bird-and-flower motif. On the left is a crouching figure that has been identified as a wooden carving by the Kwakiutl (Kwakwaka'wakw) of British Columbia.[1] In the shadows on the right is a double-mouthed black pueblo jar with a stirrup handle.[2] The two smaller, dark objects thus frame the larger, lighter one. It has recently been proposed that the rectangular object in the foreground, always taken to be a book, may in fact be a birch-bark container from the northeastern woodlands of the United States.[3]

As it happens, Hartley painted *Indian Pottery* in Paris, after a visit to the Musée d'Ethnographie du Trocadéro, thus following in the footsteps of Picasso and others. Afterward, he reported positively to Alfred Stieglitz: "I am taking a very sudden turn in a big direction owing to a recent visit to the Trocadéro. One can no longer remain the same in the presence of these mighty children who get so close to the universal ideal in their mud baking" (a reference, perhaps, to such ceramics as featured in the painting).[4] The art historian W. Jackson Rushing sees the objects as "signs of [Hartley's] longing for the primitive and the natural";[5] others have seen them as an affirmation of Native American culture.

Hartley's use of earth tones suggests the influence of the cubists, while the forms and space recall Cézanne. Hartley would have seen the work of these artists on his visits to the collection of Gertrude Stein, with whom he became friends while living in Paris.

1 Gail Levin, "American Art," in *Primitivism in 20th Century Art: Affinity of the Tribal and the Modern*, exhib. cat., ed. William Rubin, New York, Detroit, and Dallas, 1984–85, p. 457.
2 W. Jackson Rushing, *Native American Art and the New York Avant-Garde: A History of Cultural Primitivism*, Austin (University of Texas Press) 1995, p. 55.
3 Dr. Peter Bolz, e-mail to Emily Schuchardt Navratil, August 7, 2012.
4 Marsden Hartley, letter to Alfred Stieglitz, n.d. (September 1912), Marsden Hartley Collection, Beinecke Rare Book and Manuscript Library, Yale University, New Haven, Connecticut.
5 Rushing, *Native American Art*, p. 55.

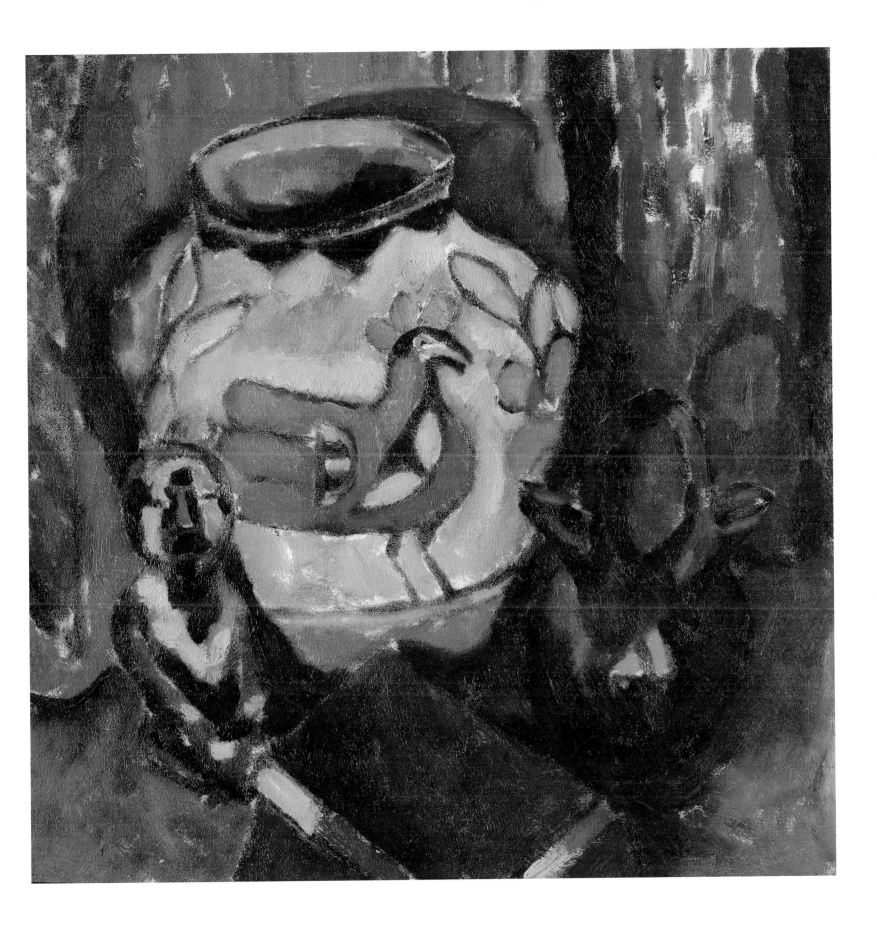

Marsden Hartley
(1877–1943)

Oranges, Apples and Lemons in a Bowl
c. 1912
Signed on verso: "Marsden Hartley"
Oil on board
14 x 12 in. (35.6 x 30.5 cm)
2005.05.02

At his second solo show for Alfred Stieglitz, held in February 1912, Hartley exhibited mostly still lifes, such as this one. They were highly praised by critics, especially for their color. One writer described Hartley as "the gentle painter of superheated still life . . . [his color] is deep and often spiritual; no man can put more of the esoteric into a cucumber than Mr. Hartley does."[1]

Oranges, Apples and Lemons in a Bowl is vivid, the fruit standing out strongly against the deep blue, almost black background. Lemons and oranges are paired, while numerous red and green apples are scattered. A radical flattening heightens the fruit's iconic quality; no depth is suggested by either the tabletop or the background.

The recipient of this painting, Waldo Frank (1889–1967), was a prolific novelist and critic. Early on in his career, he was interested in the transcendentalists, such as Ralph Waldo Emerson and Walt Whitman, as was Hartley (see page 44). In 1916, Frank was named an associate editor of the literary journal the *Seven Arts*, in which Hartley published three essays over the course of the journal's twelve-month existence. In the 1920s, Frank was active as an art critic in the Stieglitz circle. He also wrote the preface to Hartley's *Adventures in the Arts* (1921), in which he said of the artist: "This man has mastered the plastic messages of modern Europe: he has gone deep in the classic forms of the ancient Indian Dance . . . He is always the child—whatever wise old worlds he contemplates—the child, wistful, poignant, trammeled, of New England."[2]

1 Joseph Chamberlain, *New York Evening Herald*, February 17, 1912, quoted in *The Heart of the Matter: The Still Lifes of Marsden Hartley*, exhib. cat. by Bruce Weber, New York, Berry-Hill Galleries, May–June 2003, p. 20.
2 Waldo Frank, "Preface," in Marsden Hartley, *Adventures in the Arts: Informal Chapters on Painters, Vaudeville, and Poets*, New York (Boni and Liveright) 1921, pp. xv–xvi.

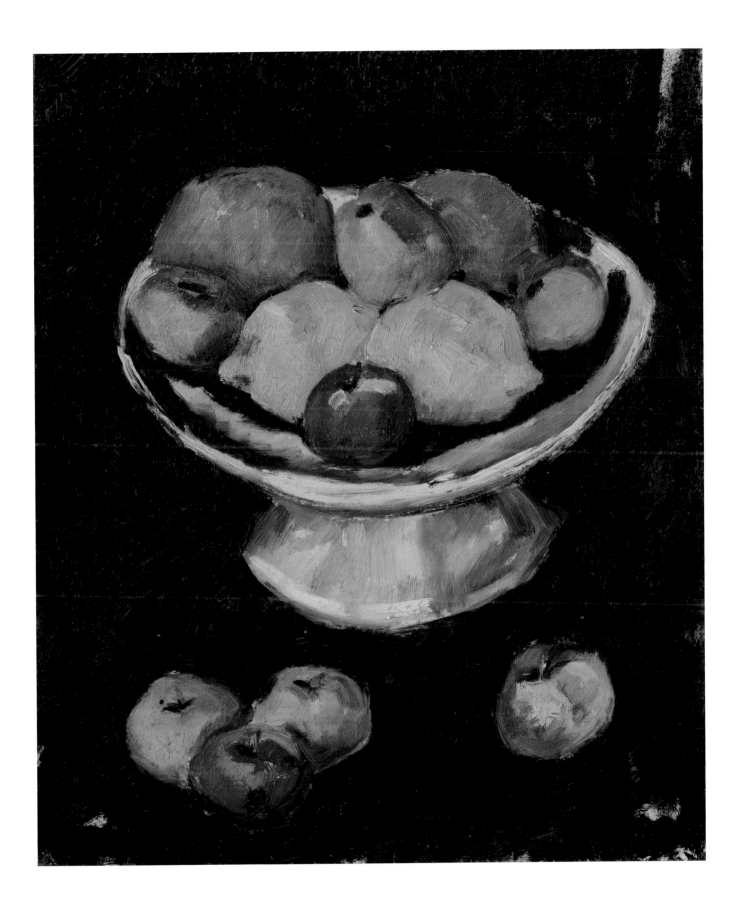

Marsden Hartley
(1877–1943)

Portrait Arrangement No. 2
1912–13
Oil on canvas
39½ x 31¾ in. (100.3 x 80.6 cm)
2005.09.01

When Hartley arrived in Paris in the spring of 1912, he informed himself of the latest developments in cubism. More surprisingly, he also encountered the key publications of the German avant-garde: Vasily Kandinsky's *On the Spiritual in Art* (1911) and the almanac published by Der Blaue Reiter (1912). He soon fell in with members of the German art community in Paris, notably befriending the sculptor Arnold Rönnebeck and Rönnebeck's cousin Karl von Freyburg. Hartley took a three-week trip to Germany with Rönnebeck in January 1913, around the time this work was painted. He would soon return to Berlin for a longer stay.

In its painterliness, colorful hues, wavy lines, and inset imagery, *Portrait Arrangement No. 2* is similar to Hartley's *Musical Theme (Oriental Symphony)* (1912–13; Rose Art Museum, Brandeis University, Massachusetts). Both works feature linear pictographs, hand gestures, and three interlocked circles.

Portrait Arrangement No. 2 exemplifies Hartley's "cosmic cubism."[1] A shallow modernist space is infused with emblems of Hartley's mystical interests, which he felt made his work unique. He was reading widely, including the writings of German mystic philosophers and such ancient Asian texts as the Bhagavad Gita, part of the Mahabharata. He aimed "to present a sensation of cosmic bodies in harmony with each other by means of color & form."[2]

The painting centers on the hand (see also detail, pages 54–55), which appears to be forming the *shunya mudra*, one of the symbolic hand gestures used in the religious ceremonies and dances of India, as well as in yoga. The index finger touches the upper circular form, which encloses a Prussian officer in white regalia, atop a white horse. Although a small image, it forms a focal point, ringed in radiant colors that draw the viewer's eye. It may suggest the white-wearing Garde du Corps, the kaiser's most elite regiment, or a more general association with purity. Hartley was very taken with the military ceremonies he witnessed in Berlin, with "my child's love for the public spectacle," and went on to develop this aspect in later paintings.[3]

Hartley's supporter Alfred Stieglitz, who owned the painting, had German parentage, and the two men shared a preference for Germany over France. Hartley opined that the Germans "are more mystical, whereas the French are merely intellectual," and also saw the countries in gendered terms, with Germany possessing "a masculine ruggedness and vitality."[4] Hence, perhaps, some of the ruggedness and vitality in Hartley's painting style, in terms of both the application of paint and the use of bold forms.

1 *Marsden Hartley*, exhib. cat., ed. Elizabeth Mankin Kornhauser, Hartford, Washington, D.C., and Kansas City, Mo., 2003–04, p. 18.
2 Marsden Hartley, letter to Rockwell Kent, December 24, 1912, quoted in *ibid.*, p. 291.
3 Marsden Hartley, letter to Rockwell Kent, n.d. (March 1913), quoted in Gail Levin, "Hidden Symbolism in Marsden Hartley's Military Pictures," *Arts Magazine*, 54, October 1979, p. 157.
4 *Ibid.*

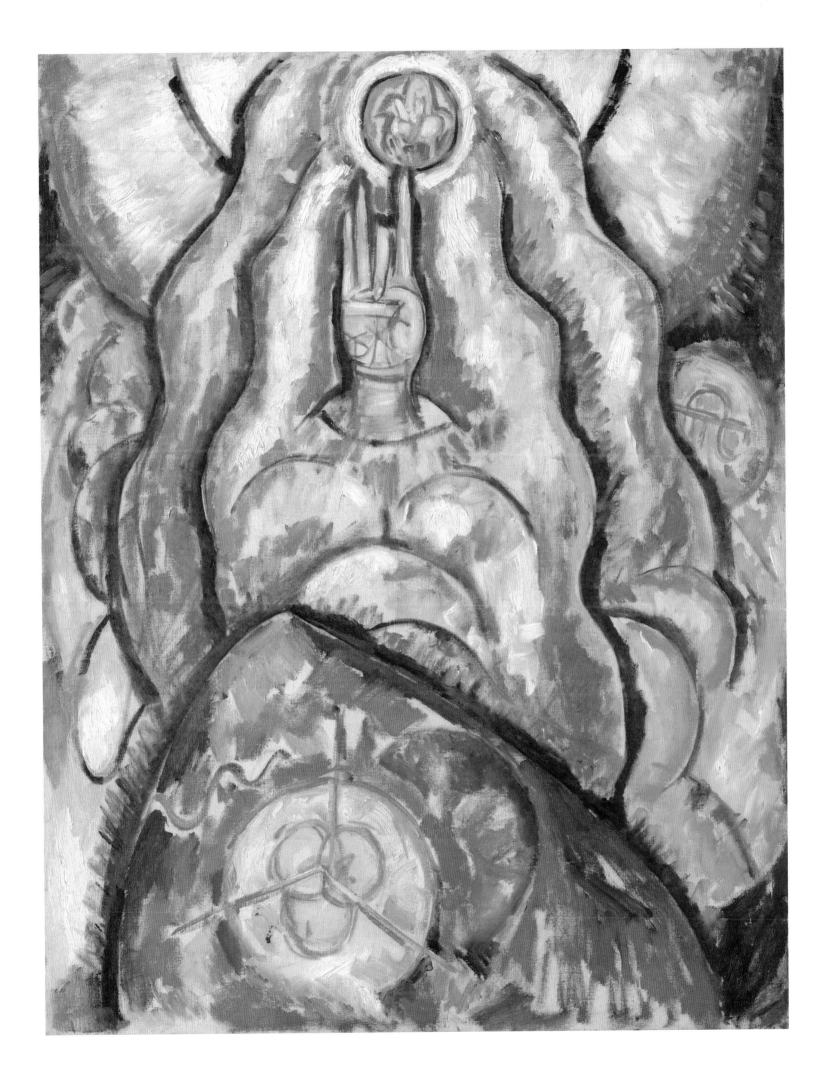

Marsden Hartley
(1877–1943)

Berlin Series No. 1
1913
Oil on canvas board
18 x 15 in. (45.7 x 38.1 cm)
2012.01.01

Hartley's *Indian Pottery* (c. 1912; page 49) featured Native American artifacts within the context of a still life. A year later, his formal vocabulary had evolved with his engagement with cubism, yet the impulse to draw on Native American culture continued. Thus, the more abstracted hieroglyphics of the painting shown here still reference Native American symbols.

Berlin Series No. 1 is a highly iconic composition, with flat forms in a near-symmetrical arrangement. The green semicircle at the bottom can be read as the entry to a teepee-like triangle, the slender yellow form of which terminates at the center of a red eight-pointed star. The symmetry of these forms is broken only by the scattering of smaller, colorful shapes on the black ground of the upper part. These are topped by a stripe-winged eagle, a bird that Hartley associated with himself on his first visit to Berlin in early 1913. On the right-hand side is a small red-and-blue V-shape, which is the pictograph used by the Hopi people of northeastern Arizona to signify small corn plants, seen also in the drawing *Symbol V* (page 59); the zigzag line and eight-pointed star are also echoed in the drawing. Here, the white line on the left may be a modified Hopi symbol for large corn plants.

Berlin Series No. 1 is closely related to *An Abstract Arrangement of American Indian Symbols* (1914; Beinecke Rare Book and Manuscript Library, Yale University, New Haven, Connecticut); together, the two works "are probably Hartley's earliest Berlin paintings, and—somewhat surprisingly—among his most abstract renditions of the Native American theme."[1] The larger, white eagle in *An Abstract Arrangement* carries a green snake in its talons. There, the broader, central white triangle more clearly resolves as a tepee. The symmetry of most of the elements, and the bright colors set off against a black background, are comparable to those in *Berlin Series No. 1*. In both paintings, Hartley distills simple circular and linear Native American motifs into what he described as "an abstract arrangement of American Indian symbols . . . pictorial arrangements of things seen and felt."[2]

Hartley would not visit the American West until some years later, so scholars have long wondered what drove him to seek out inspirational Native American artifacts in Paris and then Berlin. In this, Hartley was displaying the modernist taste for non-European native art, but one with a distinctly North American character, thus distinguishing himself from French and German artists, who looked more to the works coming back from their African and Polynesian colonies. Some scholars also feel that Hartley's Native American–themed works were calculated to appeal to his new artist contacts, Vasily Kandinsky and Franz Marc, as well as to a German market in general.[3] Clearly, too, Hartley sought to tap into the romanticism of the "noble savage" cliché, to the point of fantasizing: "I find myself wanting to be an Indian—to paint my face with the symbols of that race I adore[,] to go to the West and face the sun forever."[4]

Two additional canvas boards, of the same size as *Berlin Series No. 1* and *An Abstract Arrangement*, are related: *Berlin Series No. 2* (1914; private collection) and *Pyramid and Cross* (1914; private collection). Together, all four constitute a subset within the approximately fourteen paintings Hartley dubbed his *Amerika* series. He continued the series, on an increasing scale and with more illustrational details, up to and beyond the outbreak of the First World War in 1914.

1 Gail R. Scott, catalogue entry for *Berlin Series No. 1*, Sotheby's New York, May 19, 2010, lot 9. Both were painted on canvas board purchased in Paris, which Scott hypothesizes Hartley brought with him to Berlin.
2 Transcript of a letter from Marsden Hartley to Caryl Harris, March 26, 1930, Elizabeth McCausland Papers, Archives of American Art, Smithsonian Institution, Washington, D.C. The letter was written in response to Mr. Harris's inquiry about a painting he owned—now titled *An Abstract Arrangement of American Indian Symbols*.
3 Wanda M. Corn, "Marsden Hartley's Native Amerika," in *Marsden Hartley*, exhib. cat., ed. Elizabeth Mankin Kornhauser, Hartford, Washington, D.C., and Kansas City, Mo., 2003–04, pp. 73–77.
4 Marsden Hartley, letter to Alfred Stieglitz, November 12, 1914, quoted in *ibid.*, p. 69.

Marsden Hartley
(1877–1943)

Symbol IV

Symbol V

Symbol IV and *Symbol V* exemplify Hartley's pictographic drawing style during his first stay in Berlin. There is no traditional shading, or space. The V-shapes, zigzag lines, and eight-pointed stars also appear in Hartley's *Amerika* series of paintings (1913–14), including *Berlin Series No. 1* (1913; page 57) and *Indian Composition* (1914; Frances Lehman Loeb Art Center, Vassar College, Poughkeepsie, New York). Yet these charcoal drawings are independent works, done in a large format, not studies for any of the *Amerika* paintings.

Hartley drawings of this period are rare. The closest in form to the examples shown here is the same-sized *Berlin Symbols #6* (1913; Corcoran Gallery of Art, Washington, D.C.).[1] It features an eight-pointed asterisk-star and the same curving line with extensions inside a circle as appears in *Symbol V*. The art historian Gail Levin identifies the curving line as a symbol used by the Hopi people of northeastern Arizona to signify large corn plants, adapted by Hartley from the kachina dolls (effigies of Native American spirit beings; see page 158) he saw in the vast collection of the Museum für Völkerkunde in Berlin.[2] The V-shapes to the left of the line in *Symbol V* are likewise Hopi pictographs for small corn plants.

Three other drawings made at this time, *Military Symbols 1–3* (c. 1913–14; The Metropolitan Museum of Art, New York), are of a different intent, being detailed studies for the *German Officer* series of paintings, including *Portrait of a German Officer* (1914; The Metropolitan Museum of Art).

1 Illustrated in James Harithas, "Marsden Hartley's German Period Abstractions," *Corcoran Gallery of Art Bulletin*, 16, November 1967, p. 25. The work is said to use "Indian pictographic symbols" (*ibid.*, p. 24).
2 Gail Levin, "American Art," in *Primitivism in 20th Century Art: Affinity of the Tribal and the Modern*, exhib. cat., ed. William Rubin, New York, Detroit, and Dallas, 1984–85, p. 461.

Symbol IV
c. 1913–14
Charcoal on paper
24½ x 18⅞ in. (62.2 x 47.9 cm)
2005.03.01

Symbol V
c. 1913–14
Charcoal on paper
24½ x 18⅞ in. (62.2 x 47.9 cm)
2005.03.02

Marsden Hartley
(1877–1943)

Provincetown
1916
Oil on canvas board
19 x 15½ in. (48.3 x 39.4 cm)
2008.05.03

At the invitation of the journalist John Reed, Hartley spent the summer of 1916 in Provincetown, a seaside town at the tip of Cape Cod in Massachusetts. By the 1890s, Provincetown was booming, and had begun to develop a resident population of writers and artists, as well as a summer tourist industry. When Hartley arrived, it had a reputation as an experimental artists' colony, and was incubating the Provincetown Players, a theater company best known for producing the plays of American playwright Eugene O'Neill.

The works Hartley painted in Provincetown are among his most abstract, paralleling those of his first Berlin period, yet without their emphasis on patterns, letters, and numbers. The vocabulary is much more pared down. Floating on a light-gray ground are largely rectilinear planes of color. Several recur, notably the black and salmon planes, but with subtle variations in hue. Some overlap, especially in the lower half of the painting, but mostly they abut one another. They are anchored to the edge only by the black line at the top. One might read this line as suggestive of a mast, with the large white plane implying the sail of a boat. Yet, in common with the Russian artist Kazimir Malevich, Hartley had developed the planar approach of later, synthetic cubism into the language of abstraction.

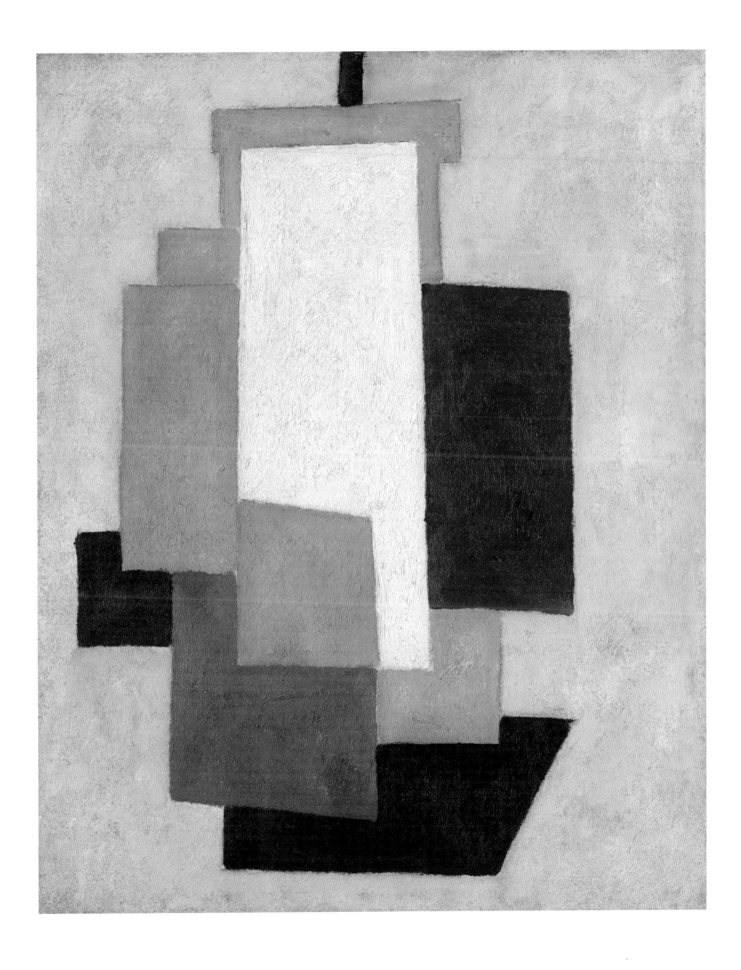

Marsden Hartley
(1877–1943)

*Atlantic Window in the
New England Character*
c. 1917
Inscribed on verso: "MARSDEN HARTLEY"
Oil on board
31⅝ x 25 in. (80.3 x 63.5 cm)
2005.04.01

Atlantic Window in the New England Character presents what was a new motif for Hartley, a combination of interior still life and seascape exterior. The first impression of an iconic and symmetrical composition gives way to an awareness of subtle variations. The curtain at the right falls in front of the table, that at the left (or is it a wall?) falls behind. The curving sweep of the shoreline is blocked by the central, dominant calla lily.

The work was painted during the twelve-month period in which Hartley spent time in Provincetown and then, with the artist Charles Demuth, Bermuda. He began painting it in Bermuda, but some scholars believe he finished it later, in New York. Critics have linked it to the long-standing "open window" motif of Matisse (a theme continued by Picasso in a series of still lifes on a balcony window painted in 1919). André Derain's *Window at Vers* (1912; The Museum of Modern Art, New York), with its weighty curtain and monumental fruits, has also been convincingly cited as a source.[1]

In both size and content, *Atlantic Window* is very similar to Hartley's *Bermuda Window in a Semi-Tropical Character* (1917; Fine Arts Museums of San Francisco). The analogous titles suggest that Hartley may have thought of the two works as pendants. He also referred to the "character" of the respective locations in his autobiography, writing of Bermuda architecture: "I have never seen such an array of sky-blue, pink, and chocolate homes, and they were such a contrast to the little white snug ones of New England—the proverbial white with green blinds."[2]

In 1921, the critic Paul Rosenfeld bought *Atlantic Window* at an exhibition of the work of Hartley and James N. Rosenberg at the Anderson Galleries in New York. In a letter to Alfred Stieglitz, Rosenfeld likened the lily to a bird, "screeching and flapping its devilish wings like a fiend on a holiday. [When I purchased the painting] I really had no idea how brilliant and sardonically joyous it was."[3]

Rosenfeld also wrote about his new possession in an essay on Hartley of the same year, interpreting, in rather overheated, gendered terms, the artist's still-life objects as "heavy stiff golden bananas."[4] Likewise, describing *Atlantic Window* in his landmark book of 1924, *Port of New York*, he wrote of "this regal white lily with its wickedly horned leaves, erect between butter-yellow draperies."[5] Nonetheless, Rosenfeld was an important promoter of American modernism of this era, especially the work of the artists supported by Stieglitz.[6]

1 *The Heart of the Matter: The Still Lifes of Marsden Hartley*, exhib. cat. by Bruce Weber, New York, Berry-Hill Galleries, May–June 2003, pp. 36, 148 n. 124.
2 Marsden Hartley, *Somehow a Past: The Autobiography of Marsden Hartley*, ed. Susan Elizabeth Ryan, Cambridge, Mass. (MIT Press) 1998, p. 105.
3 Paul Rosenfeld, letter to Alfred Stieglitz, September 20, 1921, quoted in *The Heart of the Matter*, exhib. cat., p. 36.
4 Paul Rosenfeld, "American Painting," *The Dial*, December 1921, quoted in *Marsden Hartley*, exhib. cat. by Barbara Haskell, New York, Whitney Museum of American Art, March–May 1980, then traveling, p. 56. Hartley rejected what he felt was Rosenfeld's overly "symbolist" interpretation; see *The Heart of the Matter*, exhib. cat., p. 48.
5 Paul Rosenfeld, *Port of New York: Essays on Fourteen American Moderns* (1924), quoted in Bruce Robertson, *Marsden Hartley*, New York (Abrams in association with the National Museum of American Art, Smithsonian Institution, Washington, D.C.) 1995, p. 75. See also *The Heart of the Matter*, exhib. cat., p. 37.
6 On Rosenfeld, see Wanda M. Corn, *The Great American Thing: Modern Art and National Identity, 1915–1935*, Berkeley (University of California Press) 1999, pp. 4–11.

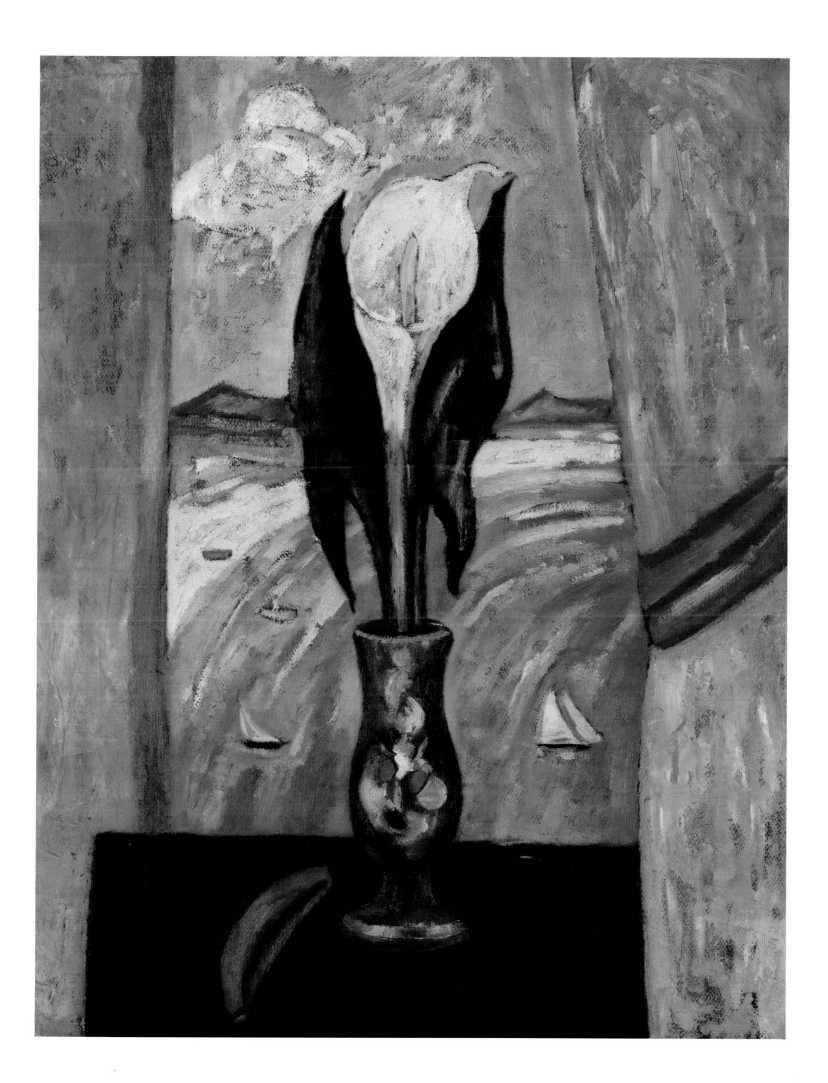

Marsden Hartley
(1877–1943)

Grapes—Berlin
1922/23
Oil on canvas
10⅝ x 18⅜ in. (27 x 46.7 cm)
2005.05.01

Vigorously painted and closely colored, these grapes appear freshly unwrapped, as if they have just been purchased from the market. Hartley pushes the red and golden grapes toward us in a tactile, shallow space. The close-up focus gives no hint of setting, and allows the scale to become monumental.

Still lifes were the first subject Hartley tackled on his return to Berlin at the end of November 1921 for a two-year stay (see page 69). He found life in the city "at the highest pitch of sophistication and abandon," and benefited from the high value of the dollar against the inflated mark.[1] He painted in the studio of his friend Arnold Rönnebeck, and by January 1923 had completed some sixty still-life canvases. Of these, the art critic and writer Elizabeth McCausland catalogued five paintings with grapes as their subject made between 1922 and 1923. By April 1923, Hartley had turned from still life to the more ambitious memory landscapes of his *New Mexico Recollections* series (see, for example, pages 66–69).

Nonetheless, Hartley was happy with his "good old fashioned honest painting as Renoir cared [for]—as Cézanne [and] Courbet cared [for]—just the idea for its own sake. And how I hunger to be all artist and nothing else—as Cézanne and Renoir were . . . most of all to escape from all things that are not simple and splendid in their simplicity."[2] Hence the simple means and some of the artistic ancestry of these grapes.

1 Marsden Hartley, *Somehow a Past: The Autobiography of Marsden Hartley*, ed. Susan Elizabeth Ryan, Cambridge, Mass. (MIT Press) 1998, p. 107.
2 Marsden Hartley, letter to Alfred Stieglitz, April 28, 1923, quoted in *The Heart of the Matter: The Still Lifes of Marsden Hartley*, exhib. cat. by Bruce Weber, New York, Berry-Hill Galleries, May–June 2003, p. 48.

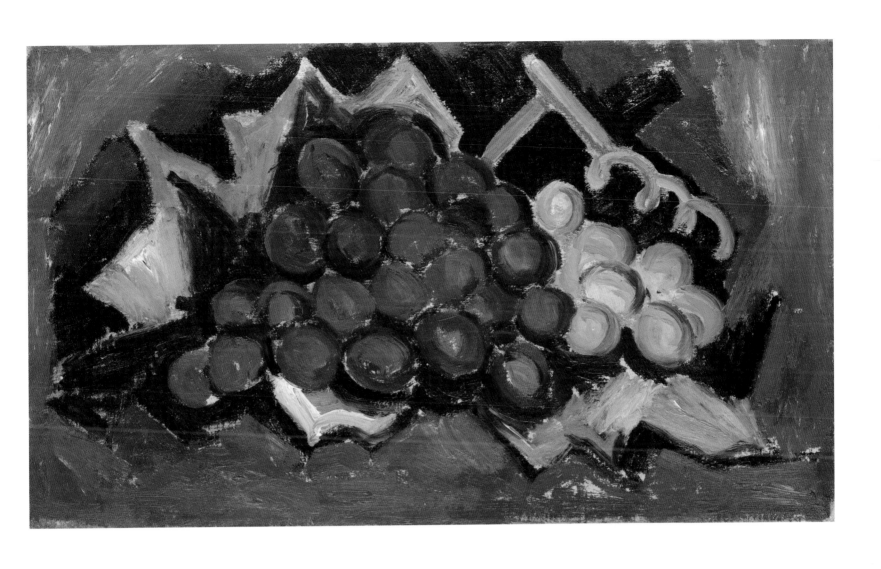

Marsden Hartley
(1877–1943)

New Mexico Recollection

New Mexico Recollection #14

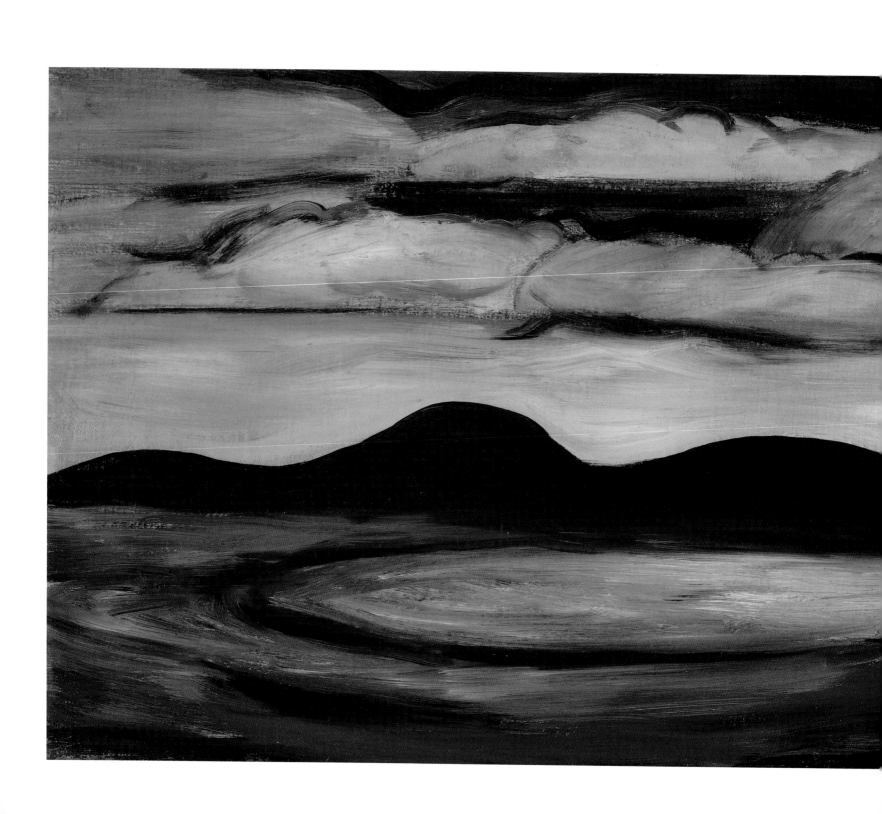

New Mexico Recollection
1923
Oil on canvas
12¾ x 32¼ in. (32.4 x 81.9 cm)
2008.06.01

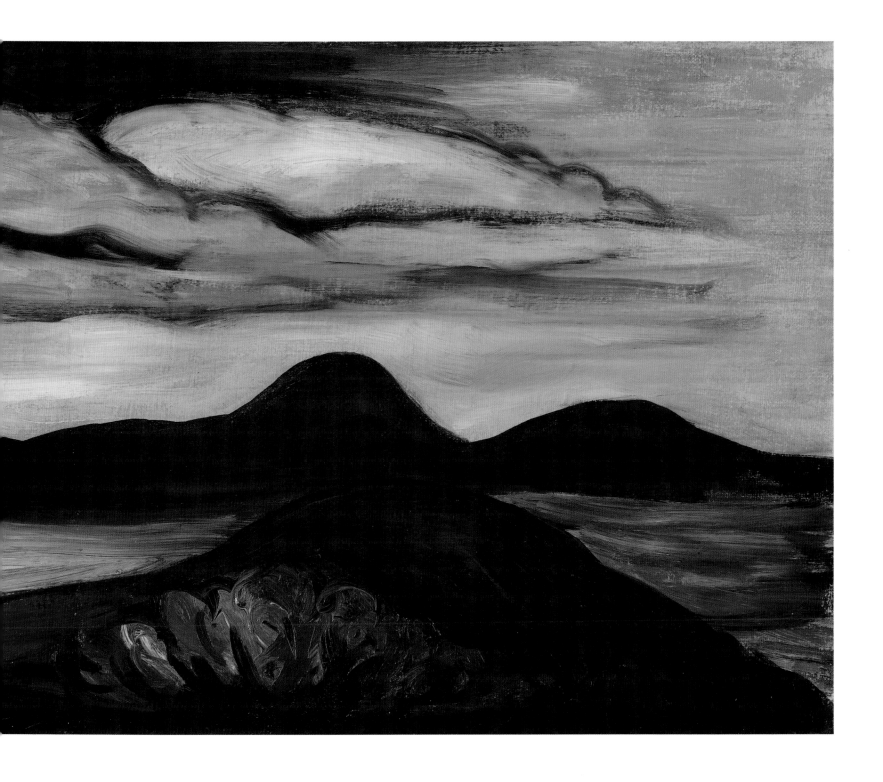

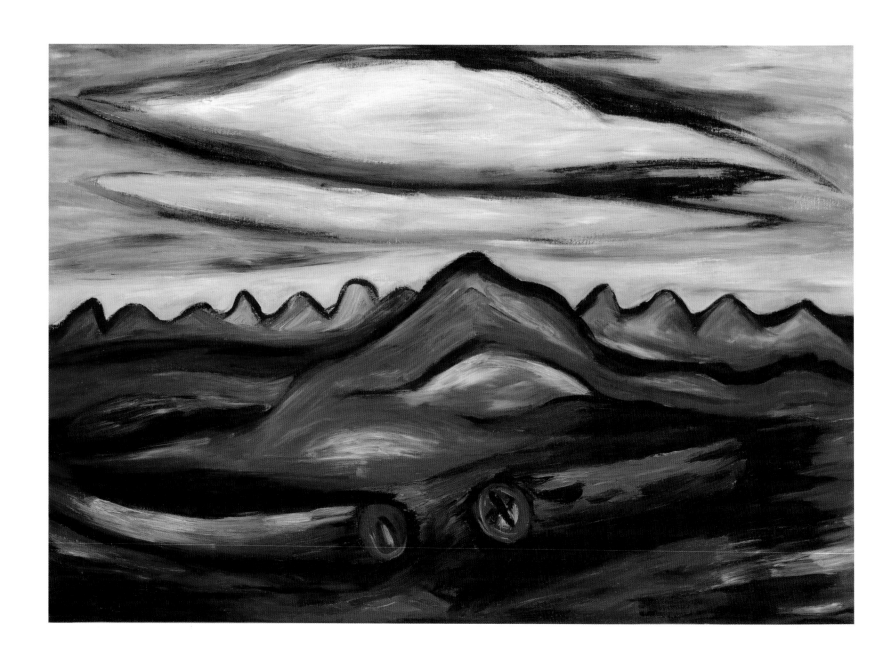

New Mexico Recollection #14
c. 1923
Oil on canvas
30 x 40 in. (76.2 x 101.6 cm)
2009.01.01

Marsden Hartley
(1877–1943)

The more than thirty-five works that make up Hartley's *New Mexico Recollections* series (see also pages 66–67) were conceived and mostly painted in Germany in 1923, with a smaller group executed later, in Paris. Following a successful auction sale of his works in 1921, at the Anderson Galleries in New York, Hartley traveled to Europe, arriving in Berlin late that year. He was energized by his return to the city, writing that "Berlin is in many ways more extraordinary than ever . . . I think there was never a freer city in all history."[1]

The landscapes in this series constitute a major body of work produced by Hartley in a little more than a year in Berlin, along with a return to drawing from the nude. They are thickly painted, with loaded brushes, in dark shades of green, brown, and black. They have none of the traditional charm of place or weather. Unpeopled and apparently unfertile, they are largely barren, with only a few scrubby growths. They seem less like a naturalistic response and more like an objective correlative, the landscape as a brooding projection of the artist's moods.

They are in a horizontal format and, in some cases, are roughly two and a half times wider than they are high. This panoramic quality suggests the vastness of the plains and mountain ranges of New Mexico, with cumulus clouds stretching across the skies above. In *New Mexico Recollection* (pages 66–67), an area of pinkish tones in the middle ground hints at a change in topography, perhaps a body of water.

In *New Mexico Recollection #14*, two felled tree trunks occupy the foreground. At least two other works in the series share this feature, while in one, *#13*, the letter "K" has been inscribed across the exposed rings of one of the trunks. It has been suggested that this initial refers to Karl von Freyburg, Hartley's close friend who was cut down in the early days of the First World War.[2] The felled trees, and the stump in *#13*, also recall the nineteenth-century American landscape theme of the axe's incursion into nature. They have also been associated with the Petrified Forest in Arizona (see page 236, fig. 11).[3]

The trees seem more of New England than of New Mexico. Hartley, however, had spent more than a year in Taos and Santa Fe from June 1918. The pastels he did there do reflect specific places, but the *New Mexico Recollections* works do not. Hartley was captivated by the Native American ceremonies he witnessed, putting his thoughts into words. He was also enchanted by the scenery, and by its subdued color: "These beautiful arroyos and canyons [are] a living example of the splendour of the ages . . . and I am bewitched by their magnificence and their austerity."[4]

Six of the *New Mexico Recollections* paintings were exhibited as part of a group show in Paris in early 1925, and another selection by Alfred Stieglitz in New York in March of that year. The response to the Paris show was strong; the paintings were thought to embody "Americanness." One reviewer cited "the almost terrifying power" of Hartley's "vigorous sweeping strokes."[5] Back in New York, the paintings' stylization and expression were less well received.

1 Marsden Hartley, letter to Alfred Stieglitz, March 1, 1923, quoted in *Marsden Hartley and the West: The Search for an American Modernism*, exhib. cat. by Heather Hole, Santa Fe, N. Mex., Georgia O'Keeffe Museum, 2008, p. 97.
2 *Marsden Hartley and the West*, exhib. cat., p. 98.
3 A photo of *New Mexico Recollection #14* in the files of Hartley's biographer Elizabeth McCausland is inscribed with an undated reference to the Petrified Forest. Elizabeth McCausland Papers, Archives of American Art, Smithsonian Institution, Washington, D.C.
4 Marsden Hartley, letter to Harriet Monroe, September 13, 1918, quoted in *Marsden Hartley*, exhib. cat. by Barbara Haskell, New York, Whitney Museum of American Art, March–May 1980, then traveling, p. 58.
5 Undated *Chicago Tribune* article cited in Marsden Hartley, letter to Alfred Stieglitz, January 21, 1925, quoted in *Marsden Hartley and the West*, exhib. cat., pp. 125, 155 n. 23.

Marsden Hartley
(1877–1943)

The Strong Man
c. 1923
Oil on canvas
13 x 32¼ in. (33 x 81.9 cm)
2006.03.05

The Strong Man (traditionally known as "Gymnast") compresses within its narrow horizontal format a muscular male nude and an array of weightlifting equipment. Dumbbells and gray exercise pins are joined by a rather atypical cannon barrel, the latter an obvious reference to male sexuality.

In July 1923, having lived in Berlin for more than a year, Hartley began a series of pastels of male and female nudes. These were the first life drawings he had made since his early years as an artist (1908–09). He completed sixteen in total, twelve being of the male figure. The nude here is closely adapted from one of these pastels,[1] although positioned less upright to fit within the unusually restrictive canvas, which is two and a half times wider than it is high. He is haloed with sketchy gray paint, and separated from the gym equipment on the right.

Paintings of the male nude are rare in this era. Hartley wrote of finding the right model: "Yesterday I began to draw from the model again . . . A simple streak of luck brought me a male model the nature of which I had seen much of here but could never get at . . . This is the son of my shoemaker, himself a former wrestler—with the result that this boy of 22 has an extraordinary array of forms such as I have wanted—and it is likewise with the heat that I can have someone pose nude without distress to myself or said model."[2]

The Strong Man foreshadows the powerful male bathers and nudes painted by Hartley after 1938, when he was living back in Maine.

1 See Gail R. Scott, *Marsden Hartley*, New York (Abbeville Press) 1988, p. 73.
2 Marsden Hartley, letter to Alfred Stieglitz, July 17, 1923, quoted in *Marsden Hartley and the West: The Search for an American Modernism*, exhib. cat. by Heather Hole, Santa Fe, N. Mex., Georgia O'Keeffe Museum, 2008, p. 115.

Marsden Hartley
(1877–1943)

Mont Sainte-Victoire

c. 1927
Signed on verso: "Marsden Hartley"
Inscribed on stretcher: "Mt. St. Victoire Aix en Provence"
Oil on canvas
20 x 24 in. (50.8 x 61 cm)
2007.06.01

Mont Sainte-Victoire, a limestone mountain ridge in the south of France, is celebrated for its many appearances in the late work of Cézanne, who, for the last years of his life, lived in the hills to the north of nearby Aix-en-Provence. When choosing to rent an apartment in Aix in October 1926, Hartley was literally following in Cézanne's footsteps, all the more so when he relocated two months later to the Maison Maria in the forests around the Château Noir, a neo-Gothic castle that had also been depicted by Cézanne.

Hartley began painting the Mont Sainte-Victoire in mid-1927, working in series as Cézanne had done. In a productive period, he completed numerous versions before traveling to Paris in December of that year. This version does not feature the trees or road that appear in the foreground of others, thus telescoping the space. The colors are arrayed in bands of striking hues: pinks, violets, and oranges alternating with dark blues. Surprisingly, Hartley claimed a naturalistic basis for this color intensity, writing in his autobiography: "The country about Aix is very rich and original-looking . . . for the earth is very red—full of iron—below the unique mountain of Sainte-Victoire, which 'en face' looks like a mountain and really isn't, but the abrupt ending of a . . . cliff."[1]

Hartley goes on to discuss Cézanne's relationship with his subject matter in similar terms, citing an article by the American painter and art historian Erle Loran: "This study shows in an estimable degree just how true Cézanne was to his nature—how he understood the laws of each composition—producing the true rhythmic sensation of all this highly original scene in nature."[2] Hartley, too, strove to realize this "sensation," looking through Cézanne's example to its source in nature.

Hartley's Mont Sainte-Victoire paintings are therefore not simply a homage to Cézanne, as much as they adopt his spirit, serial images, and "constructive" brushstrokes. The coloristic element in particular goes beyond Cézanne, almost as if Hartley were submitting the mountainscape to the flaming autumnal colors of a New England painter. There is an element of competition alongside that of homage.

Alfred Stieglitz showed a number of these paintings at his Intimate Gallery in New York in January 1929, to poor reviews. The critic Henry McBride, for example, termed them "disappointingly academic."[3]

1 Marsden Hartley, *Somehow a Past: The Autobiography of Marsden Hartley*, ed. Susan Elizabeth Ryan, Cambridge, Mass. (MIT Press) 1998, p. 138.
2 *Ibid.* Loran's article appeared in *The Arts* (April 1930).
3 Henry McBride, "Attractions in the Galleries," *New York Sun*, January 5, 1929, quoted in Jeanne Hokin, *Pinnacles & Pyramids: The Art of Marsden Hartley*, Albuquerque (University of New Mexico Press) 1993, p. 129 n. 40. The paintings were also poorly reviewed when they were exhibited at the Chicago Arts Club in January 1928 (*ibid.*, p. 65).

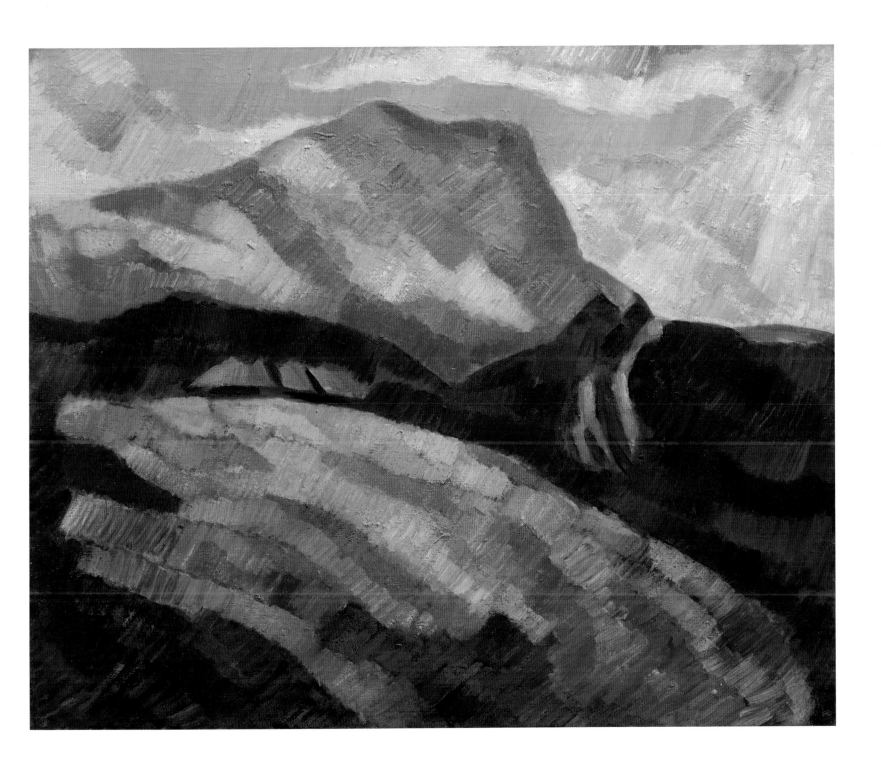

Marsden Hartley
(1877–1943)

Autumn Landscape, Dogtown
1934
Oil on Masonite
20 x 27¾ in. (50.8 x 70.5 cm)
2012.04.01

Dogtown is the name of a former agricultural community on Cape Ann in Massachusetts, to the north of Gloucester. It was populated by about sixty families before it was abandoned in the mid-1700s. By Hartley's time, only glacial boulders and some crumbling stone walls remained. He wrote emotively of its character in his autobiography: "I found the two available entrances to that strange little forsaken hamlet. No houses left now of that time—the time of pirates, when people had to take refuge in this uncanny upland at the top of Cape Anne [*sic*]— a place so original in its appearance as not to be duplicated either in New England or anywhere else— the rocks all heaped up there from the glacial period, and the air of being made for no one, for nothing but itself . . . A sense of eeriness pervades all the place."[1]

Hartley had two painting campaigns at Dogtown, the first in the last six months of 1931, and the second in the summer and fall of 1934, after spending time in Mexico. He contrasted his choice of primeval subject with the usual "summer sketch artist's" views of the harbor at Gloucester.[2] "No one in all the years of Gloucester painting celebrity had ever done anything about Dogtown."[3] Thus he found a niche for a New England painter.

In this "uncanny" landscape from Hartley's second campaign at Dogtown, each element of nature seems rough and scrubbed, be it foliage, grass, or rocks. As Gail R. Scott observes, these elements tend to meld into one: "The landscape elements—the boulders, vertical juniper trees, and flaming red shrubbery— defy normal perspectival logic. Piled up and tumbled together, there is little differentiation between solid rock, ground plane, or leafy vegetation. In fact, the helter-skelter of painting seems an objective correlative to the geological upheaval that formed the glacial moraine eons ago."[4]

Hartley exhibited his first group of Dogtown paintings at the Downtown Gallery in New York in April 1932. To mark the occasion he wrote a poem, "The Return of the Native," which emphasized his repatriation as a New England painter after years of travel abroad. The ungainly character of the Dogtown works signaled the onset of his final period, in which his works often achieved a rough-hewn grandeur.

1 Marsden Hartley, *Somehow a Past: The Autobiography of Marsden Hartley*, ed. Susan Elizabeth Ryan, Cambridge, Mass. (MIT Press) 1998, p. 144.
2 *Ibid.*
3 *Ibid.*, p. 143.
4 Gail R. Scott, note to Lot 148, Sale 1838: Important American Paintings, Drawings and Sculpture, Christie's, New York, May 24, 2007, available online at christies.com/lotfinder/lot/marsden-hartley-autumn-landscape-dogtown-4907578-details.aspx?intobjectid=4907578, accessed November 2012.

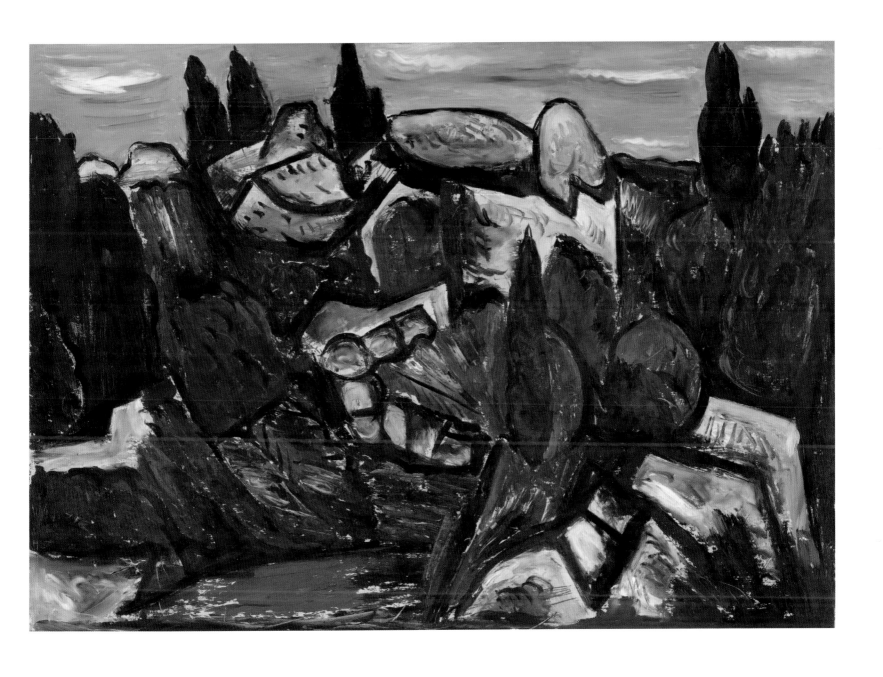

Marsden Hartley
(1877–1943)

Three Shells
c. 1941–43
Oil on board
22 x 28 in. (55.9 x 71.1 cm)
2012.04.02

The subjects of *Three Shells* were probably collected on a beach near Corea, Maine, the traditional fishing village where Hartley spent his last four summers, lodging with a local lobster-fishing family, the Youngs. The three shells are presented without spatial indication, close up on a black background. They also do not overlap, thus appearing to float on the monochrome, dark field, a compositional strategy seen as early as Hartley's still lifes of 1912, such as *Oranges, Apples and Lemons in a Bowl* (page 51).

In his final years, Hartley painted a number of animal still lifes, with subjects ranging from lobsters, fish, and birds to the shells he collected at the ocean's edge. Here, the shells take on an iconic and monumental presence beyond their humble nature.

Hartley wrote a poem about white shells, "Wingaersheek Beach," part of which reads:

> *Holding, folding, moulding*
> *Last curve, ancestral swirl*
> *Bleached whiter*
> *Lying lighter*
> *For the whiter way, jeopardy*
> *Of lying, by wind, sun, mist, rain bent*
> > *And torn . . .*
> *When death strike it*
> *White*[1]

In *Three Shells*, painted when Hartley was in his mid-sixties, white shells become complex symbols of wear and mortality.

1 For the full text of the poem, which is undated and remained unpublished in Hartley's lifetime, see Gail R. Scott, ed., *The Collected Poems of Marsden Hartley, 1904–1943*, Santa Rosa, Calif. (Black Sparrow Press) 1987, p. 189.

Joseph Stella
(1877–1946)

Brooklyn Bridge Abstraction
c. 1918–19
Signed lower center: "Joseph Stella"
Watercolor and gouache on paper
9¾ x 7 in. (24.8 x 17.8 cm)
2006.04.01

The Brooklyn Bridge was Joseph Stella's quintessential motif, depicted in such paintings as his landmark, five-panel *Voice of the City of New York Interpreted* (1920–22; Newark Museum, New Jersey), as well as in numerous drawings. The bridge itself was a technological marvel, the world's longest suspension bridge when it opened in 1883, a title it held for two decades. It was the first bridge to span the East River.

This drawing combines multiple impressions of the bridge, which Stella walked over regularly to reach his home in Brooklyn. We look past crisscrossed cables in the foreground, past dynamic diagonals, to wires and vertical cables in the upper part of the work. One of the arches from the massive neo-Gothic piers is hinted at in the negative space cropped at the top. (This area resembles the play of positive and negative rectangles at the upper right of "The Bridge," one of the panels of *New York Interpreted*.) In the lower part of the drawing is a side view of the structure, with an exaggerated curve like a rainbow.

Such views connecting the east and west banks of the East River also implied a larger, national linkage of the east and west coasts of the United States. Thus the Brooklyn Bridge transcends its status as a New York icon to become a national one, as in the title of Stella's later painting of the bridge, *American Landscape* (1929; Walker Art Center, Minneapolis).

Stella also wrote movingly of the Brooklyn Bridge: "Seen for the first time, as a weird metallic Apparition under a metallic sky, out of proportion with the winged lightness of its arch, traced for the conjunction of WORLDS … it impressed me as the shrine containing all the efforts of the new civilization of AMERICA."[1]

1 Joseph Stella, "The Brooklyn Bridge (A Page of My Life)," *transition*, June 1929, p. 87. See also Lewis Kachur, "The Bridge as Icon," in *The Great East River Bridge, 1883–1983*, exhib. cat., New York, Brooklyn Museum, March–June 1983.

Arthur Dove
(1880–1946)

Untitled
c. 1929
Oil on metal
28 x 20 in. (71.1 x 50.8 cm)
2007.07.01

Arthur Dove used stylized, abstract forms in his art from around 1910–11. He is generally considered the first American artist to create nonrepresentational works.

This seemingly abstract painting is a later example of Dove's invention of organic forms for their own sake. Yet the artist preferred to use the term "extraction" to describe the way in which he simplified his forms from natural ones. Sometimes the source is apparent; in other cases, as here, it is not.

At the time of the painting's creation, Dove stressed the *tableau-objet*, or "canvas-as-object," quality of his work: "Am more interested now than ever in doing things rather than doing something about things. The pure paintings seem to stand out from those related too closely to what the eye sees there."[1]

In 1924, Dove and the artist Helen Torr, nicknamed "Reds" by Dove, had moored the yawl on which they were living, the *Mona*, at Halesite, a hamlet adjacent to Huntington Harbor, Long Island. In some respects, this work seems watery, with its blues and white highlights, which suggest breaking waves. The orientation of the shapes on a diagonal adds to their dynamic presence.

Dove regularly experimented technically. This is one of a number of paintings done not on canvas but on a metal plate.

1 Arthur Dove, letter to Alfred Stieglitz, October 1929, quoted in Ann Lee Morgan, ed., *Dear Stieglitz, Dear Dove*, Newark, NJ (University of Delaware Press) 1988, p. 180.

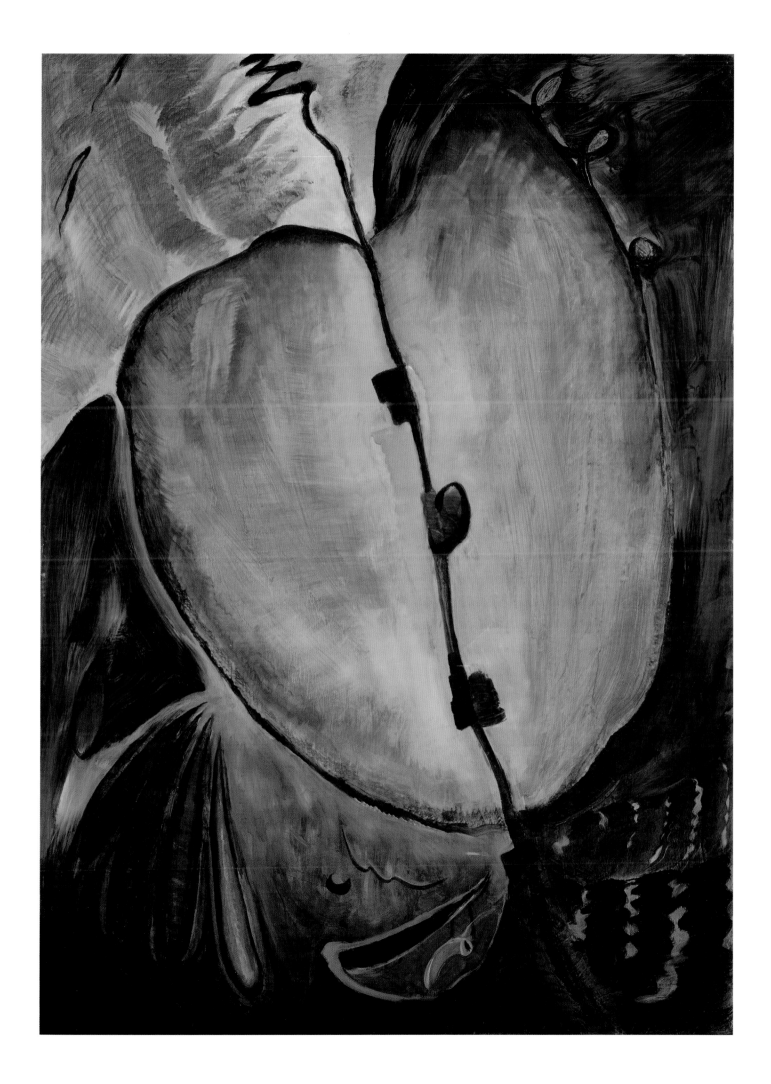

Arthur Dove
(1880–1946)

Colored Drawing, Canvas
1929
Signed lower right: "Dove"
Oil on canvas
17½ x 21¾ in. (44.5 x 55.2 cm)
2012.09.01

Arthur Dove's *Colored Drawing, Canvas* carries a title that points to abstraction. It also interestingly implies that drawing can be painting, and indeed much of the work is linear.

There is a notable variety in the application of paint, from the thin tendrils of black and the brushy browns to the juicy impasto of the row of five olive-colored circles with black centers (see also detail, pages 84–85). The upper and lower borders are marked by, respectively, a thick black and a more liquid, wavy gray. In between is an undulating line that hints at a hilly horizon. The sides of the painting are open, and much of the background is bare canvas, lending the whole an airy, light feeling.

Colored Drawing, Canvas was included in *Arthur G. Dove: 27 New Paintings*, an exhibition of Dove's work held at Alfred Stieglitz's An American Place gallery in New York in March 1930; also on display were the similarly titled *Colored Drawing, Paper* (1929; location unknown) and *Below the Flood Gates—Huntington Harbor* (1930; page 87). *Colored Drawing* was also the subject of a misunderstanding involving the prominent *New York Times* critic Edward Alden Jewell. In the typed exhibition checklist, the title of the work was mistakenly given as *Colored Dog*, an animal that Jewell was unable to identify in the image. He complained about this in his review, saying that one may need to go "temporarily ga-ga" to see a dog. Jewell suggested that Dove "dispense with his titles" and use "Improvisation" or "Composition." Today, such titles seem too Kandinsky-like, yet they were on the right track in terms of seeing Dove's work as primarily nonrepresentational, "designs in massed color and line."[1]

In an exchange of letters between Jewell and the artist, the typo was revealed. Dove joked, "I happened to remember that I had used the abbreviation 'd'w'gs,' meaning 'drawings,' and that is how the 'dogs' were turned loose."[2] Jewell wrote Dove a sympathetic reply, and the *Times* published the explanation. Such were the circumstances of another mishap in the history of the public's attempt to grapple with modernist abstraction.

1 Edward Alden Jewell, "Concerning Mr. Dove: With Prelude about Realism—The African Sculptures—Art from Central America," *New York Times*, March 30, 1930, p. x12.
2 Edward Alden Jewell, "Telescoping Centuries," *New York Times*, April 6, 1930, p. 156.

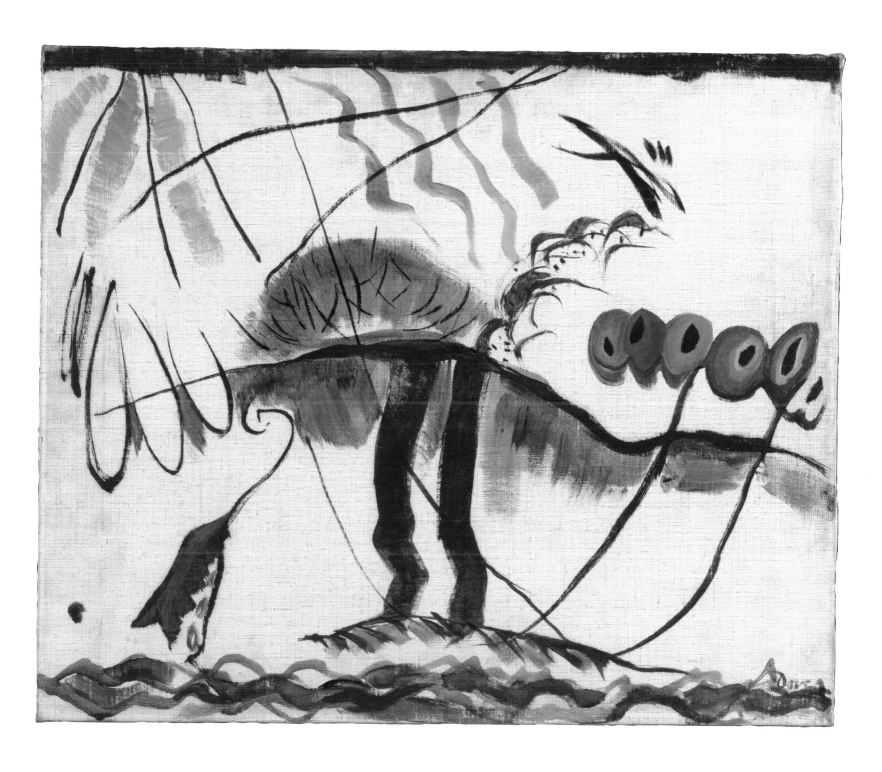

Arthur Dove
(1880–1946)

Below the Flood Gates— Huntington Harbor

1930
Signed lower right: "Dove '30"
Oil on canvas
24¼ x 28⅛ in. (61.6 x 71.4 cm)
2007.01.01

In common with *Untitled* of the year before, *Below the Flood Gates—Huntington Harbor* is a watery painting, but with crucial differences. While the former is two-dimensional, the latter has a distinct foreground, middle ground and background, rendered in subdued earth tones.

Using parallel lines, Dove suggests a rushing stream, with upright lines for the white foam in the foreground and the river bank in the distance. The title suggests that the stream's swirling energy may have been occasioned by the opening of flood gates. The painting's rhythmic stylization of water recalls that of Katsushika Hokusai's classic nineteenth-century print *The Great Wave of Kanagawa.*

In the Dove catalogue raisonné, *Below the Floodgates* is listed with its full title, as here, correcting the omission of "Huntington Harbor" from a number of earlier references to the work. Indeed, as the catalogue raisonné shows, of the twenty-four paintings known to have been created by Dove in 1930, three others feature "Huntington Harbor" in their title: *Mill Wheel*, *Tar Barrels*, and *Snow on Ice*.[1] As we have seen (page 80), Dove's yawl, the *Mona*, was moored in Huntington Harbor, at Halesite.

In 1930, *Below the Flood Gates* was exhibited under its full title as part of Dove's *27 New Paintings* exhibition at Alfred Stieglitz's An American Place gallery in New York. The noted critic Edward Alden Jewell praised the work's "liberated form of realism," adding that "many of the canvases are eloquently evocative."[2]

1 *Arthur Dove: Life and Work, with a Catalogue Raisonné*, exhib. cat. by Ann Lee Morgan, New York, 1984, p. 179.
2 Edward Alden Jewell, "Concerning Mr. Dove: With Prelude about Realism—The African Sculptures—Art from Central America," *New York Times*, March 30, 1930, p. x12.

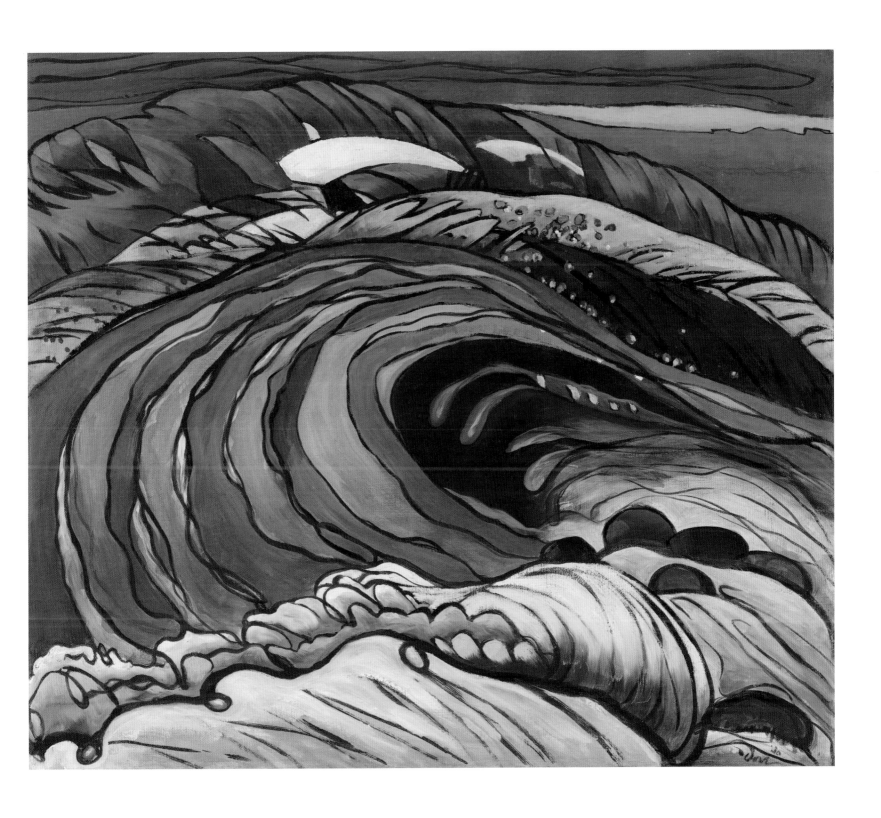

Arthur Dove
(1880–1946)

Forms

Sunrise

Untitled Drawing

These three works give an overview of Dove's drawing practice, one that increased in his last decade. *Forms* (opposite) clusters rounded shapes that have been created using heavy ink outlines and filled in with quick crayon hatching. While the sketchier green around the perimeter hints at a pastoral setting, *Forms* remains an abstract play of shape and color. "I would like to make something that is real in itself," Dove once wrote, "that does not remind anyone of any other thing, and that does not have to be explained like the letter A, for instance."[1]

Crayon is applied even more vigorously in *Sunrise* (page 90), drawn on a page from a spiral-bound sketchbook turned sideways to form a landscape. While the sun bursts forth at the left, a spiral and a cross float in a still-dark sky. In the sweep of American art, Dove's visionary pantheism is a modest-sized work existing between Thomas Cole's studies of the 1840s for his unrealized *The Cross and the World* and Adolph Gottlieb's *Burst* series, the first of which was painted in 1957. *Sunrise* was created around the same time as Dove's *Sunrise* series of paintings of 1936.

Untitled Drawing (page 91), in pencil, is the largest of the three works. It plays on positive and negative space. The dark circle and asterisk shapes within the outlined white cone and circle on the left are the opposite of the white sun formed with negative space on the right. The "new directions" Dove felt in his late work (see, for example, page 96) were often to do with abstraction, alternating between the geometric and the curvilinear.[2]

1 Arthur Dove, quoted in *Arthur G. Dove: Paintings 1942–1943*, exhib. brochure, New York, An American Place, February–March 1943, n.p.
2 William C. Agee, "Arthur Dove: The Late Work, 1938–1946," in *Arthur Dove: A Retrospective*, exhib. cat. by Debra Bricker Balken *et al.*, Washington, D.C., The Phillips Collection, September 1997 – January 1998, then traveling, p. 141.

Forms
1932
Signed lower center: "Dove"
Ink and crayon on paper
4¾ x 6¾ in. (12.1 x 17.1 cm)
2006.03.02

Arthur Dove
(1880–1946)

Sunrise
c. 1936
Signed lower center: "Dove"
Crayon on paper
5 x 7 in. (12.7 x 17.8 cm)
2007.02.02

Untitled Drawing
c. 1941
Graphite on paper
9 x 11¾ in. (22.9 x 29.8 cm)
2006.02.02

Arthur Dove
(1880–1946)

The Green House
1934
Signed lower center: "Dove"
Oil on canvas
25½ x 31¾ (64.8 x 80.7 cm)
2007.01.02

From notes in the diary of his second wife, Helen Torr, we know that Dove painted this work continuously over four days, April 3–6, 1934.[1] Shortly thereafter, on April 17, an exhibition of Dove's work opened at Alfred Stieglitz's An American Place gallery in New York, although this painting was not included. After the exhibition, Dove's patron, Duncan Phillips, increased his monthly stipend to $75.

With subdued hues, Dove skillfully weaves together foreground tree branches and middle-ground swollen houses. Some of the tree bark is green, rhyming with the two central windows of the main house. At the left, a tree appears to sprout from the roof of the smaller building. Where one would expect the regularity of a doorway or window frame, Dove introduces wavy, irregular contours, fusing the man-made with nature's organicism. In the upper part of the painting, leaf-like shapes gradually detach from branches and float free as animated life-forms. The sky is subtly divided into areas of tan, beige, and white, the last of these, being nearest the horizon, setting off the dark forms of the buildings.

The work was painted in Geneva, New York, the town to which Dove had reluctantly moved in July 1933 to settle his family's debt-ridden estate. He and Torr lived on the family property for five Depression-era years, selling parts of it and farming others. As Georgia O'Keeffe noted, "Dove comes from the Finger Lakes region. He was up there painting, doing abstractions, that looked just like that country, that could not have been done anywhere else."[2]

The Green House is one of only twelve works painted by Dove in 1934. It relates to *Brickyard Shed* of the same year (location unknown), which seems to be a closer view of the smaller building in the work shown here. From about 1930, Dove sometimes made watercolors as studies for his oils; in this case, the related watercolor (*Study for The Green House*, 1934; Lane Collection, on loan to Museum of Fine Arts, Boston) is more naturalistic, and lighter in tonality.

1 Arthur and Helen Torr Dove Papers, Archives of American Art, Smithsonian Institution, Washington, D.C.
2 Georgia O'Keeffe, quoted in *Arthur Dove*, exhib. cat. by Barbara Haskell, San Francisco, Buffalo, St. Louis, Chicago, Des Moines, and New York, 1974–76, p. 77.

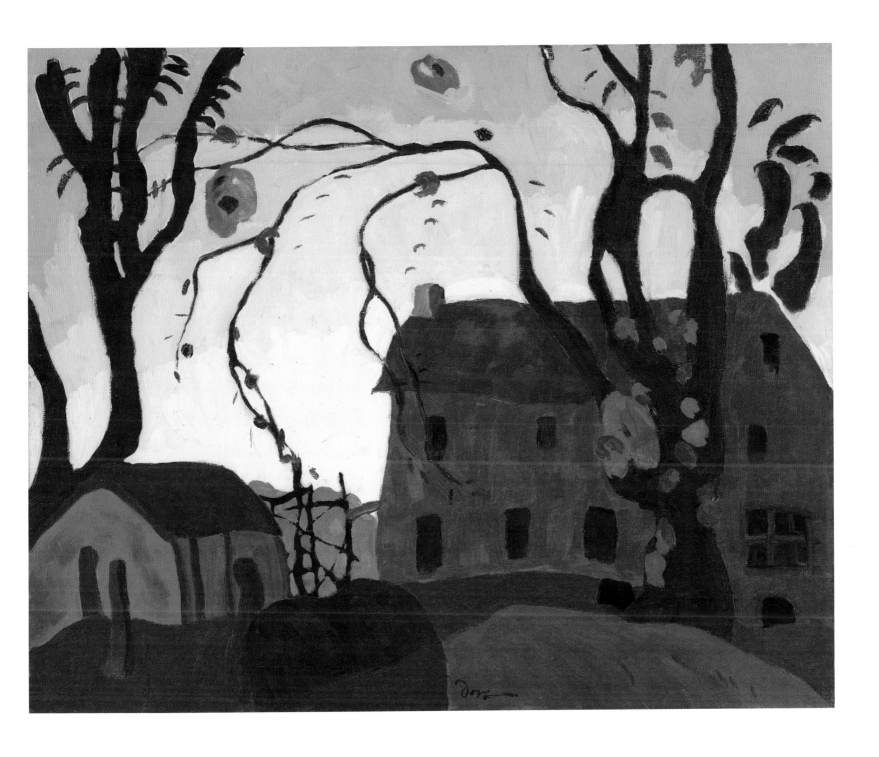

Arthur Dove
(1880–1946)

Continuity
1939
Signed lower center: "Dove"
Tempera and encaustic on canvas
6⅛ x 8 in. (15.6 x 20.3 cm)
2009.02.04

Dove's "extraction" here (see page 80) is vaguely landscape-based, with its lower and upper bands of color the only parts of the work stretching the length of the canvas; otherwise, it seems abstract. Many shades of green oppose two upright, adjoining patches of orange. Organic color areas abut one another on the resolutely flat surface.

In a letter to Alfred Stieglitz written in 1938, the year before he painted *Continuity*, Dove notes: "I have come to the conclusion that one must have a means governed by a definitive rhythmic sense beyond geometric repetition. The play or spread or swing of space can only be felt with this kind of consciousness ... To make it breathe as does the rest of nature it must have a basic rhythm."[1] Stieglitz was the first owner of this painting.

The title of the work suggests thematic persistence, even in the face of another world war. It may also refer to the artist's life; Dove had survived a heart attack in January 1939. *Continuity* is one of only three paintings completed by the artist that year.

Dove began experimenting with tempera in June 1935, while living in Geneva, New York. In 1937, he began using wax emulsion (encaustic) with tempera underpainting, as here, usually on a small scale. Together, they create a unique soft glow. His use of encaustic would continue in the 1940s, foreshadowing Jasper Johns's use of the medium in the 1950s.

1 Arthur Dove, letter to Alfred Stieglitz, March 6, 1938, quoted in Frederick S. Wight, *Arthur G. Dove*, Berkeley (University of California Press) 1958, p. 6.

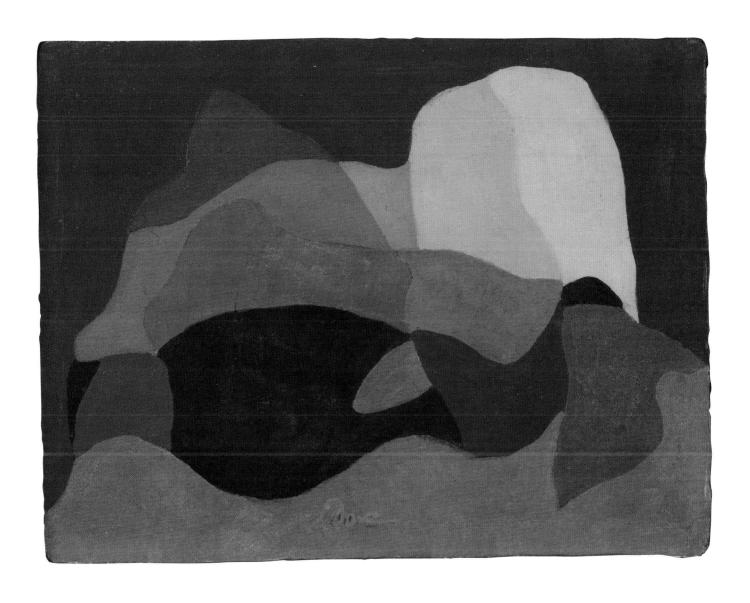

Arthur Dove
(1880–1946)

Sunrise I
(Set of Three)
c. 1941
Signed lower center: "Dove"
Graphite, watercolor, and ink
on paper
4 x 5½ in. (10.2 x 14 cm)
2007.05.02

Sunrise II
(Set of Three)
c. 1941
Signed lower center: "Dove"
Graphite, watercolor, and ink
on paper
4 x 5½ in. (10.2 x 14 cm)
2007.05.03

Sunrise III
(Set of Three)
December 1, 1941
Signed lower center: "Dove 12.1.41"
Graphite, watercolor, and ink
on paper
4 x 5½ in. (10.2 x 14 cm)
2007.05.04

Dove had first painted a series of works titled *Sunrise* in 1936; *Sunrise I* from that series (private collection) is closest in form to the third of this later series, with its concentric rings around the solar orb (a format to which Dove would return in *Partly Cloudy,* 1942; University of Arizona Museum of Art, Tucson). Both works may be numbered among Dove's periodic impulses toward "a more close up thing in the paintings."[1] Instead of the wavering horizon in the earlier painting, however, the later work features a bold horizontal stroke on top of the other colors.

Signed on December 1, 1941, *Sunrise III* is the one dated work in the series of three variants, presumably all created at roughly the same time. (The attack on Pearl Harbor occurred six days later.) The first two bear a close resemblance to each other, sharing the dark zigzag shape (clouds?) below the sun. All three were painted quickly, with strokes resembling the marks of Eastern calligraphy.

For Dove, 1941 was the year in which "the dual modes of [his] 'new directions,' the geometric and the curvilinear, were firmly established . . . The sun and moon provided an inherent, cosmic structure within the curvilinear paintings."[2] The same can be said of the watercolors here.

1 Arthur Dove, letter to Alfred Stieglitz, June 2/3, 1932, quoted in Ann Lee Morgan, ed., *Dear Stieglitz, Dear Dove,* Newark, NJ (University of Delaware Press) 1988, p. 243.
2 William C. Agee, "Arthur Dove: The Late Work, 1938–1946," in *Arthur Dove: A Retrospective,* exhib. cat. by Debra Bricker Balken *et al.,* Washington, D.C., The Phillips Collection, September 1997 – January 1998, then traveling, p. 141.

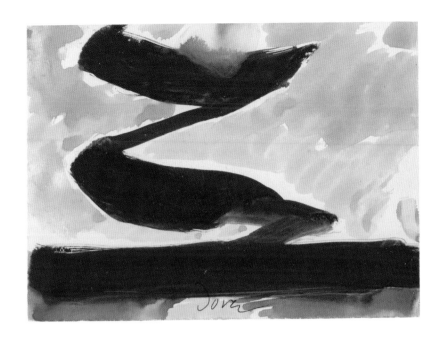

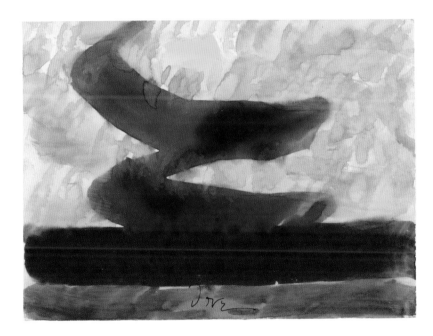

Arthur Dove
(1880–1946)

Centerport XIV
1942
Gouache on paper
3 x 4 in. (7.6 x 10.2 cm)
2006.03.01

This symmetrical composition is loosely brushed in bands of gouache. Basic contrasts are played out in colors and simplified forms: oval and triangle, white and black, earth and sky. It calls to mind Dove's diary entry for August 20, 1942, in which he resolves to work at the "point where abstraction and reality meet."[1]

The *Centerport* series to which this work belongs refers to the artist's residence. In 1938, he and his second wife, Helen Torr, moved into a former post office and general store on Center Shore Road in Centerport, Long Island. They purchased the property, a tiny, one-room cottage on the banks of Titus Mill Pond, for $980.

In weakened health, Dove largely worked in and around his home, most often in watercolor. The *Centerport* series, begun in 1939, would number as many as thirty works in one year. *Centerport XIV* is one of more than 200 works from this series done on paper in the 3 x 4-inch format. William C. Agee has pointed out that these works closely parallel the size and intention of Alfred Stieglitz's near-abstract photographs of clouds, known collectively as *Equivalents* (1922–29), which Dove admired.[2] Indeed, Dove purchased two of them in the same year as creating this gouache.

1 Arthur and Helen Torr Dove Papers, Archives of American Art, Smithsonian Institution, Washington, D.C.
2 William C. Agee, "Arthur Dove: A Place to Find Things," in *Modern Art and America: Alfred Stieglitz and His New York Galleries*, exhib. cat. by Sarah Greenough *et al.*, Washington, D.C., National Gallery of Art, January–April 2001, pp. 428–29; see also p. 424.

Morton Livingston Schamberg
(1881–1918)

Abstraction

c. 1916
Signed lower right: "Schamberg"
Graphite and pastel on paper
9¼ x 6⅛ in. (23.5 x 15.6 cm)
2009.02.02

Pastel was an uncommon medium among the modernist artists. Yet Morton Livingston Schamberg deployed it frequently, using a confident variety of techniques, including rubbing and blending, to create blurred areas suggestive of machines in motion. In *Abstraction*, he also used a pair of compasses and a sharp pencil to add a circle and two arcs, a nod, perhaps, to his days as an architecture student; the resulting precise circular elements suggest cams and drive wheels. He may have also used a straight edge for some of the lines, which run parallel to the edge of the paper.

In around 1982, a group of thirty Schamberg pastels from 1916 were discovered in Philadelphia. In his description of these works, which also focus on mechanical-based subjects, particularly printing and textile machines, William C. Agee writes: "Schamberg's employment of a soft, ephemeral medium to depict metallic images from the modern industrial world is, in itself, an apparent contradiction between means and ends. Not the least intriguing aspects of these works, however, is Schamberg's ability to capture the machines' speed and power while imbuing them with just those lyrical qualities of pastel."[1]

Abstraction is closely related to these rediscovered works, including in its use of sizeable areas of blank space. In the body of the work, arcs of radiant turquoise and white made with the side of the crayon combine with stronger orange lines created with the point; staccato red dots and small strokes are scattered throughout.

Schamberg worked closely with his fellow Philadelphia artist Charles Sheeler, with whom he took up photography in 1912. Three years later, he was introduced to the Dadaists Marcel Duchamp and Francis Picabia, and their example may have encouraged him to pursue his mechanical subjects. Yet Schamberg achieved a clean-lined "precisionism" that seems positivistic and untouched by Dada irony.

1 *Morton Livingston Schamberg: The Machine Pastels*, exhib. cat. by William C. Agee, New York, Salander-O'Reilly Galleries, January–February 1986, n.p.

Max Weber
(1881–1961)

Still Life with Bananas
1909
Signed lower right: "MAX WEBER"
Oil on canvas
32¼ x 26 in. (81.9 x 66 cm)
2004.03.02

On his return to the United States at the end of 1908, after living in Paris for three years at the heart of the emergent avant-garde, Weber felt the greatest admiration for Cézanne. As Marsden Hartley recalled, "Weber returned [from Europe] with a full understanding of the principles of Cézanne and of Cubism";[1] indeed, Weber quotes Cézanne's letters in the catalogue for his own show at the Haas Gallery, New York, in 1909. Weber also returned from Europe with the first Picasso painting to reach America, *Still Life* (c. 1908; private collection), a small work featuring fruits and a vessel on a tipped-up tabletop, the whole painted in browns and subdued colors.[2]

Still Life with Bananas is a boldly Cézannesque work, echoing the advice given to Weber by Matisse, who had told him to focus on "Cézanne's architectonic, masonic plasticity."[3] The innovative overhead view bends the near end of the table toward us, and radically tips up the dynamically oblique tabletop. One scholar has compared Weber's painting to Cézanne's *Apples and Oranges* (c. 1899; Musée d'Orsay, Paris), with its bold diagonal organization, yet less pronounced overhead view.[4] Weber painted it in a barn on Long Island that he had rented for the summer of 1909. This would explain the unusual subject matter for a still life: an old jug, a colorfully decorated basket, a row of oars hung behind.[5]

Weber's still lifes were among his more accepted works. Thus even as she attacked his "nightmarish" figures, the critic Elizabeth Luther Carey observed: "Max Weber's bits of still life are delightful."[6]

1 Marsden Hartley, quoted in *The Heart of the Matter: The Still Lifes of Marsden Hartley*, exhib. cat. by Bruce Weber, New York, Berry-Hill Galleries, May–June 2003, p. 16.
2 *Picasso and American Art*, exhib. cat. by Michael FitzGerald, New York, San Francisco, and Minneapolis, 2007–08, pp. 15–17.
3 Max Weber, quoted in Robert M. Crunden, *American Salons: Encounters with European Modernism, 1885–1917*, Oxford (Oxford University Press) 1993, p. 293.
4 Jill Anderson Kyle, "Cézanne and American Painting, 1900 to 1920," Ph.D. diss., The University of Texas at Austin, 1995, pp. 349–50. Kyle notes that Weber owned a reproduction of this Cézanne.
5 *Max Weber: An American Modern*, exhib. cat. by Percy North, New York, Jewish Museum, October 1982 – January 1983, then traveling, p. 28.
6 Elizabeth Luther Carey, *New York Times*, quoted in *Camera Work*, 31, July 1910, p. 45.

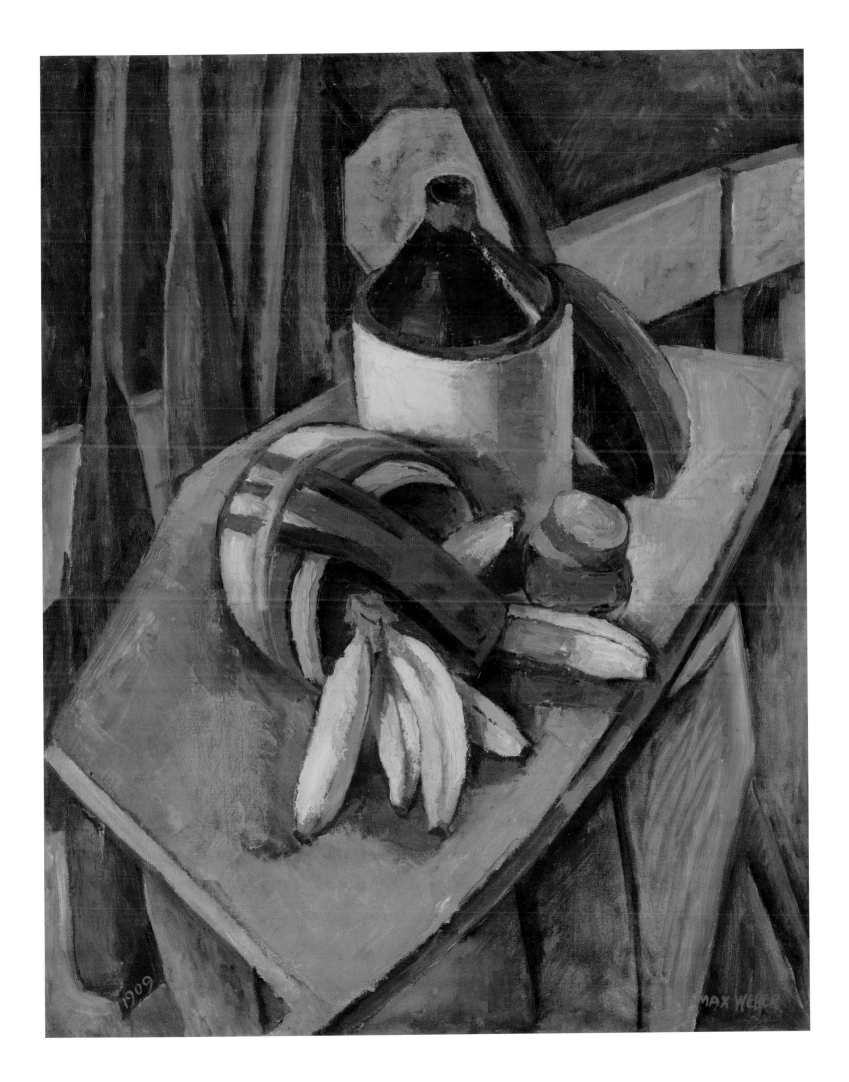

Max Weber
(1881–1961)

Mexican Statuette
1910
Signed lower right: "MAX WEBER 1910"
Gouache on paper
29 x 24 in. (73.7 x 61 cm) (sight)
2005.02.02

Mexican Statuette is an early and prime example of the interest shown by North American modernist artists in native cultures; it thus compares closely to Marsden Hartley's *Indian Pottery* (c. 1912; page 49). It has not yet been possible to identify specifically either the Southwest Native American ceramic bowl on the table, although it may be a Zuni pot, or the decorative fabric hanging behind it. These objects seem to be contrasted with a vestige of Cézanne in the apple and the red cloth tumbling off the table. Weber was among the first of the circle of artists supported by Alfred Stieglitz to extol the virtues of non-Western art. In an article for Stieglitz's journal, *Camera Work*, Weber wrote: "I have seen Chinese dolls, Hopi Kachinas images, and also Indian quilts and blankets, and other works of savages, much finer in color than the works of the modern painter-colorists."[1]

The statuette in the foreground of the work has been identified as a standing figure from the Cochiti Pueblo in New Mexico. In its arms-akimbo posture and black boots, it is identical to a similar figure acquired by the American Museum of Natural History, New York, in the same year as Weber created *Mexican Statuette*; only the body paint differs slightly.[2] It is known that Weber frequented the museum at this time, making sketches of pueblo pottery.[3]

Together with *Women and Trees* (1911; page 107), *Mexican Statuette* was exhibited as part of Weber's one-man show at Murray Hill Galleries, New York, in February, 1912.

1 Max Weber, "Chinese Dolls and Modern Colorists," *Camera Work,* 31, July 1910, p. 51.
2 Identified by Emily Schuchardt Navratil, e-mail to the author, August 2, 2012. For the museum's figure, see AMNH cat. no. 50.1/3490.
3 W. Jackson Rushing, *Native American Art and the New York Avant-Garde: A History of Cultural Primitivism*, Austin (University of Texas Press) 1995, pp. 44–45.

Max Weber
(1881–1961)

Women and Trees
1911
Signed lower left, twice: "MAX WEBER"
Oil on burlap
31½ x 25½ in. (80 x 64.8 cm)
2006.01.01

Women and Trees is a major multi-figure composition that exemplifies Weber's ambition to modernize the traditional nude. Weber saw the body in formal terms: "The human figure which affords infinitely greater channels for expression of life . . . is to me important first of all as a piece of architecture or structure of so many forms, so varied and movable. I rebuild it . . . or relate it to its accessories."[1] The subject relates in a general way to Cézanne's numerous paintings of bathers; Matisse's visions of Arcadia, such as *The Joy of Life* (1905–06; Barnes Foundation, Philadelphia); and Picasso's "Nudes in a Forest" series from the spring of 1908, all of which Weber would have known from his years in Paris. But the mood is different from that of these contemporary works, and takes a turn toward symbolism, or the nude in pictorialist photography.

With their large eyes and stylized bodies, the nine women are arranged with a seemingly hieratic yet vague purpose. They mostly cluster in pairs, the exception being the trio of women in the foreground (see also detail, pages 108–109). Curiously, all the womens' legs are obscured by elements of the forest; no feet are visible. This is particularly striking in the case of the central pair in the background, their eyes closed or lowered, whose legs and torsos are entirely immersed in the green of the undergrowth. Skin is tinted with the bluish-green of the Henri Rousseau–like bare landscape.

The otherworldly air of the painting is closest in spirit to some of Arthur B. Davies's forest-nude groups, such as *Isle of Destiny* (1910; Pennsylvania Academy of the Fine Arts, Philadelphia). Davies, an older-generation member of the avant-garde, had purchased two of Weber's paintings at his first solo exhibition, held in New York in 1909. The two artists remained friends.

1 Max Weber, "My Aim," unpublished manuscript, 1910, quoted in Jill Anderson Kyle, "Cézanne and American Painting, 1900 to 1920," Ph.D. diss., The University of Texas at Austin, 1995, p. 351.

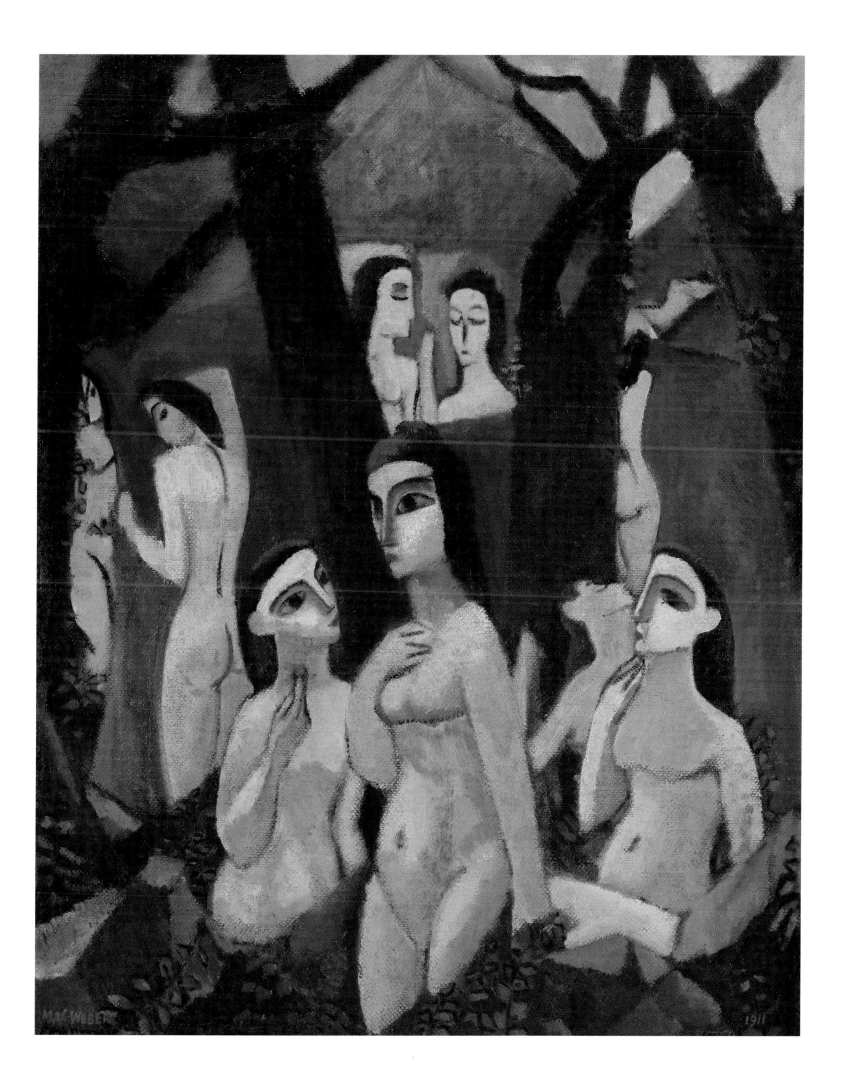

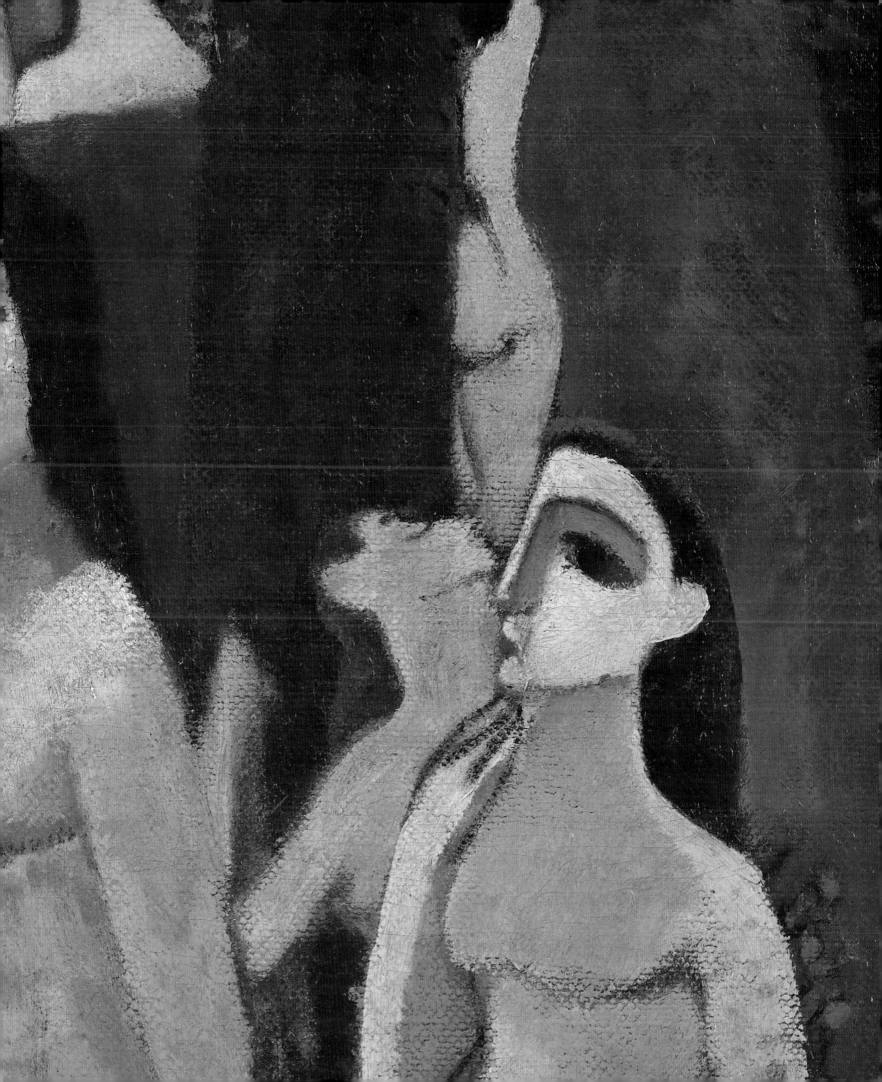

Max Weber
(1881–1961)

Figure in Rotation
c. 1948 (modeled 1917)
Inscribed lower rear: "Max Weber /3"
Plaster and polychrome
25 x 7½ x 7 in. (63.5 x 19.1 x 17.8 cm)
2005.02.01

Although known primarily as a painter, Max Weber pursued sculpture at three points in his career: first, around 1915, when he exhibited thirty sculptures at Montross Gallery, New York; secondly, in the mid-1940s; and thirdly, from 1955 to 1960. He preferred to work in plaster, and did not cast in bronze until the late 1950s.[1] Some of his early pieces were less than 3 inches (7.6 centimeters) tall, and were meant to be handled. Over the course of his life, he produced a total of some seventy sculptures.

While preparing for his retrospective of 1949 at the Whitney Museum of American Art, New York, Weber cast the work shown here: a plaster version of his *Figure in Rotation* of 1917 enlarged by a factor of three. It is one of an edition of three, and it is presumed that the other two casts were produced at the same time. Each was painted, and Weber exhibited both the original sculpture of 1917 and one of the enlarged versions at the Whitney, among a total of fourteen plaster sculptures. A slightly larger (25½ inches/64.8 centimeters high) bronze version was cast later, also in an edition of three; examples are in the collections of the Metropolitan Museum of Art, New York, and the Whitney.[2]

Figure in Rotation is of a woman in a standing position. Her body is twisted around its central axis, so that her face and rear are simultaneously visible. This pose recalls the squatting woman in the foreground of Picasso's landmark canvas *Les Demoiselles d'Avignon* (1907; The Museum of Modern Art, New York). Weber's sculpture also varies in scale, with the eruption of enlarged details, such as an eye or a breast.

As Weber was a painter-sculptor, his sculpture is often related to his paintings—in this case, his blocky cubist female nudes of 1910. "Distortion is born of a poetic impulse," Weber once wrote. "A work may be ever so anatomically incorrect or 'distorted' and still be endowed with the miraculous and indescribable elements of beauty that thrill the discerning spectator."[3]

1 *Max Weber: Sculpture, Drawings and Prints*, exhib. cat. by Ellen Schwartz, New York, Forum Gallery, October–November 1979, n.p. Schwartz indicates that Weber cast with Joseph Ternbach, who continued to cast for the artist's estate.
2 Joan M. Marter, "Max Weber," in *American Sculpture in the Metropolitan Museum of Art*, ed. Thayer Tolles, 2 vols., New York (The Metropolitan Museum of Art) 1999–2000, vol. 2, p. 656.
3 Max Weber, quoted in *Max Weber*, New York (American Artists' Group) 1945, n.p.

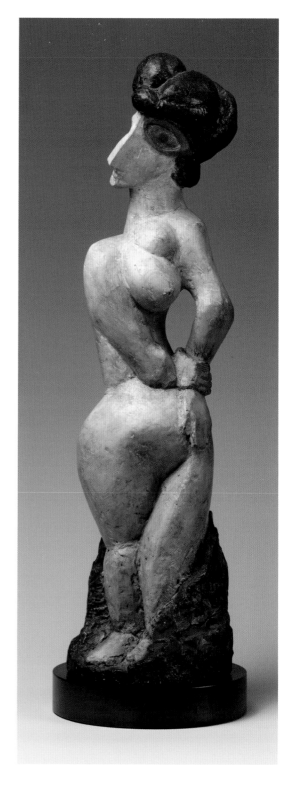

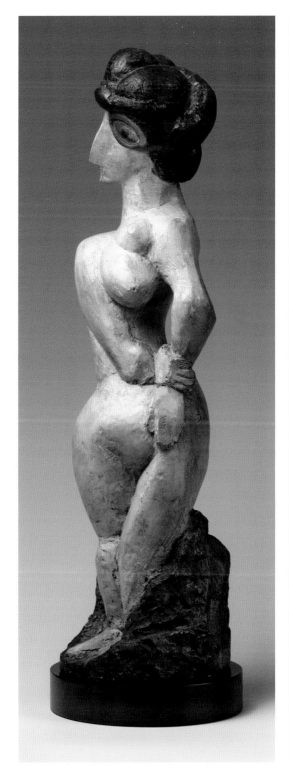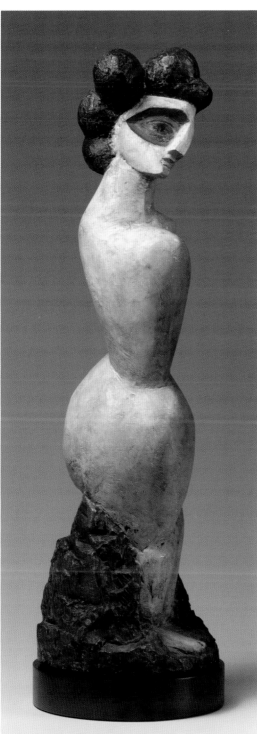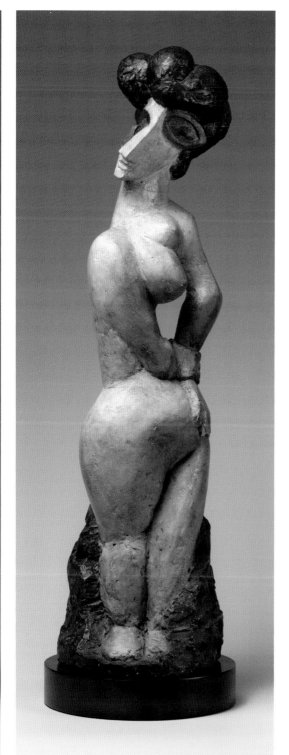

José de Creeft
(1884–1982)

Voyage to Africa
1927
Inscribed: "J. de Creeft"
Limestone
26 x 5 x 5 in. (66 x 12.7 x 12.7 cm)
2007.03.01

Creeft's limestone sculpture, embellished with art deco–like geometric details, recalls John Storrs's contemporaneous *Abstraction* (1924; page 123). In the 1920s, both artists were in Paris pursuing the technique of carving directly in stone. Creeft's work, with its strong, pillar-like form and echoes of a caryatid, seems to hint at an architectural context. In one view (opposite), the half-size African-style mask in relief suggests a decoration on the chair of an enthroned partial figure. Other views (pages 114–15), with their zigzag or parallel-line patterns, are clearly abstract.

The title *Voyage to Africa* acknowledges Creeft's wide-ranging interest in non-Western art. The stylized mask is the main evidence of this, reflecting also the vogue for "*art nègre*" among many modernist artists, although it does not have a single specific source. In appearance, it most closely resembles the masks of the native peoples of Gabon, Liberia, and the Côte d'Ivoire.

Creeft strongly favored a Michelangelo-style approach to sculpture. "In carving directly," he once observed, "the sculptor creates by releasing the forms he has seen hidden in the material, or perhaps it is better to say, the forms he has created in his mind and projected into the material. In either case, carving is the elimination of the excess material which covers the forms."[1]

1 *José de Creeft: A Retrospective Exhibition*, exhib. cat. by José de Creeft, New York, New School Art Center, October–November 1974, n.p.

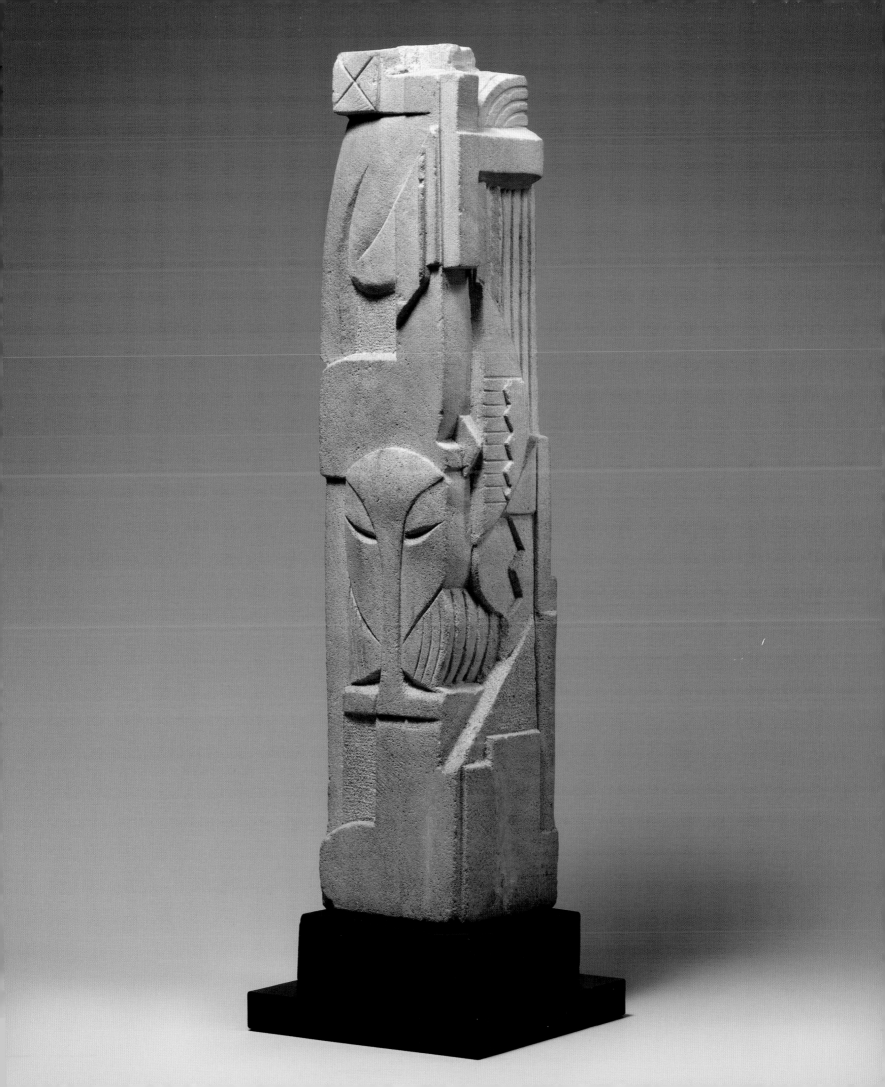

José de Creeft
(1884–1982)

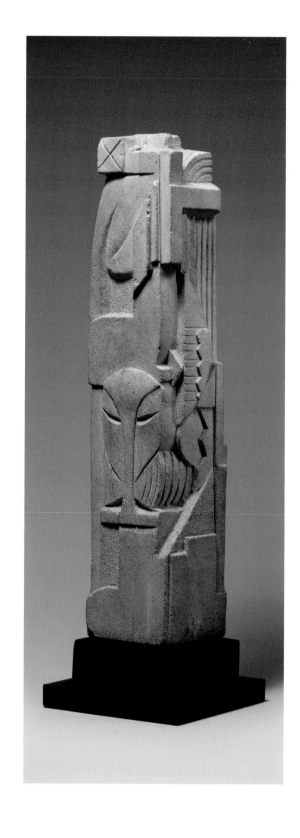

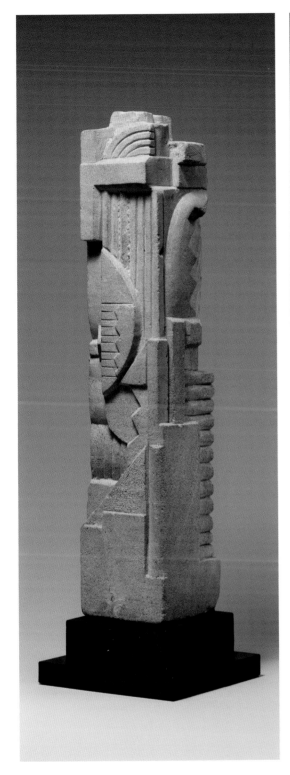 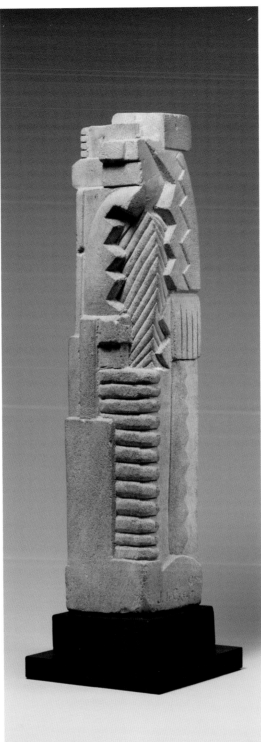 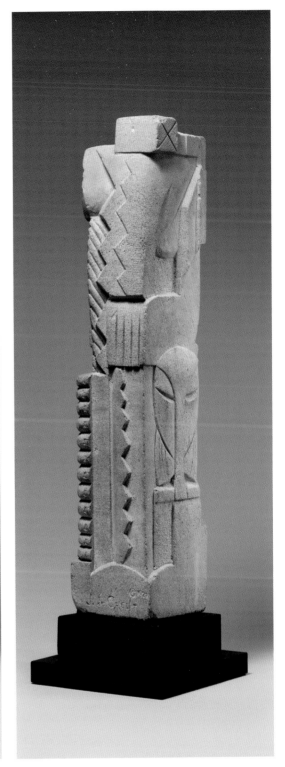

John Storrs
(1885–1956)

Abstraction
1919
Signed on the underside: "JOHN/STORRS/5-6-19"
Painted terra-cotta
4¾ x 2¾ x 2 in. (12.1 x 7 x 5.1 cm)
2011.01.01

Storrs's *Abstraction* develops out of cubist angularity and fragmentation into a non-objective language. The underlying upright rectangular block is cut into mostly rectilinear shapes, with some circles and arcs providing contrast. Black and white paint is used mainly to reinforce the rectilinearity, but also to break down larger forms by highlighting smaller circular and linear areas; the paint also brackets the earth tone of the terra-cotta itself. Moving around the work, the views vary considerably. One, with its circular shapes, is almost physiognomic (opposite); another, with more white rectangles, is architectonic (below, left); a third suggests a figure playing a stringed instrument (below, right). The effect is a dynamic fusion of time and space.

Abstraction is among the first of Storrs's works in which he moves away from figurative representation. Storrs felt that "abstraction is not a new mode but something that I feel is very characteristic of our time and age and a very legitimate path to self-expression."[1] Yet in 1920, at his exhibition at Folsom Galleries in New York, he showed the more figurative works and left the abstractions to one side.

Storrs's experiments in this direction have been linked to the English modernist group known as the Vorticists. In particular, a lesser-known Vorticist painter and poet, Jessie Dismoor, dedicated a book of her poems to Storrs and his wife in 1918; the cover of the book featured an abstract planar design.[2] The geometric abstract woodcuts by the Vorticist painter Edward Wadsworth, based on aerial city views, have also been likened to Storrs's terra-cotta.[3]

Carved in a material traditionally used for architectural ornament, *Abstraction* was nonetheless conceived as a freestanding sculpture; there are even carved forms on the top, painted black. Later works, such as the stylized *Abstraction* of 1924 (page 123), would engage more directly with the architectonic.

1 John Henry Bradley Storrs Papers, Archives of American Art, Smithsonian Institution, Washington, D.C.
2 See *John Storrs*, exhib. cat. by Noel S. Frackman, New York, Whitney Museum of American Art, December 1986 – March 1987, p. 43. Frackman also indicates Storrs's awareness of the Vorticist sculpture of Henri Gaudier-Brzeska (*ibid.*, p. 45).
3 Kenneth Dinin, "John Storrs: Organic Functionalism in a Modern Idiom," *Journal of Decorative and Propaganda Arts*, 6, Fall 1987, p. 63.

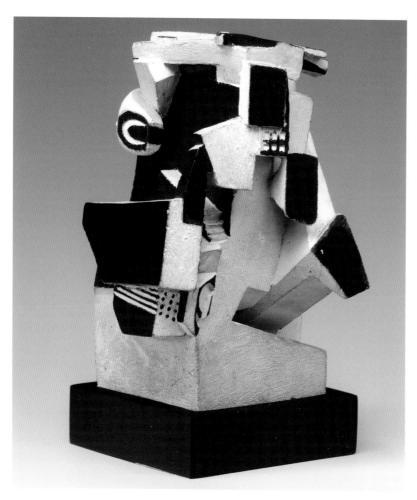

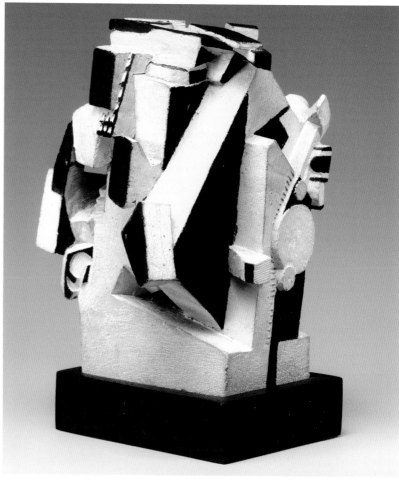

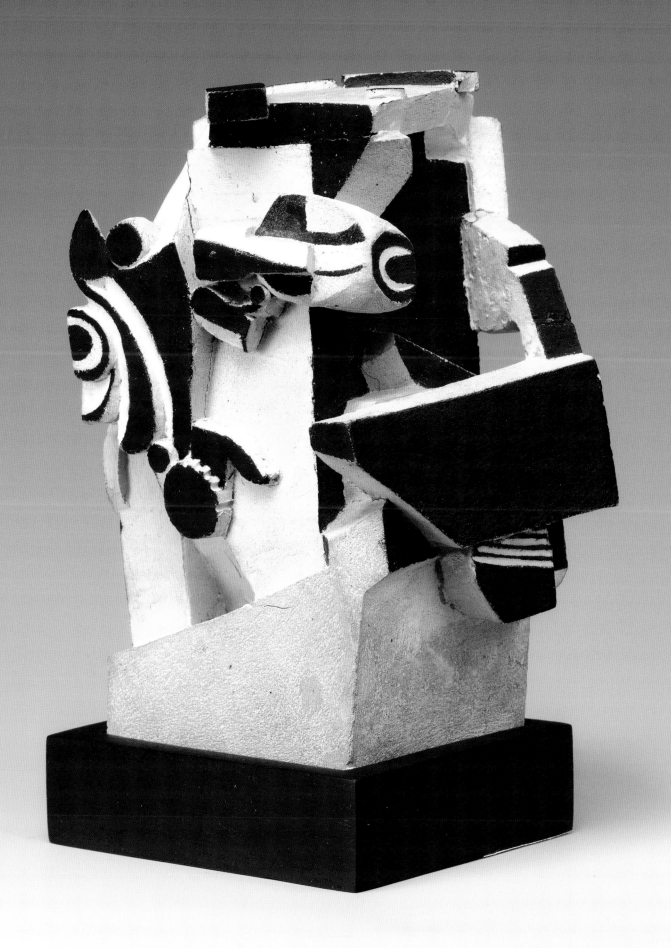

John Storrs
(1885–1956)

Untitled
(Study for Figure)

Untitled
(Study for Figure)

Untitled
(Study for Figure)

Untitled
(Study for Roullier Galleries Exhibition Invitation)

Untitled
(Study for Roullier Galleries Exhibition Invitation)

Untitled (Study for Figure) (opposite, left), a statuette carved in wood, relates stylistically to Storrs's contemporaneous experiments in abstraction using stone (see, for example, page 123). It can be seen as a geometric configuration of a circle and a diamond raised on a semicircle. Alternatively, it can be read as an abstracted figure, with the circle suggesting the head, the diamond the body, and the semicircle the legs.

Storrs returned to the statuette fifteen years later and had it cast in polychromed steel just before his exhibition of 1935 at the Roullier Galleries in Chicago, his first sculpture exhibition in seven years. The cast sold for $125 to a local collector; Storrs kept the wood original.

The three related drawings (pages 120–21) trace the development of the invitation for the Roullier exhibition. In two of the drawings, the circular form is labeled "sculpture," the central diamond "painting," and the semicircle "and drawing," indicating the range of media on show. In a letter to Storrs, the sculptor Alexander Calder included a humorous sketch based on the final invitation.[1] In anticipation of Andy Warhol, Calder equates painting with peeing.

One critic's review of the exhibition spoke of "abstract forms, stern and relentless, but at the same time architecturally and emotionally impressive."[2]

1 Alexander Calder, letter to John Storrs, February 16, 1935, illustrated in *John Storrs*, exhib. cat. by Noel S. Frackman, New York, Whitney Museum of American Art, December 1986 – March 1987, p. 110.
2 C.J. Bulliett, quoted in *John Storrs*, exhib. cat., p. 107.

Untitled
(Study for Figure)
1920
Wood
6¾ x 2½ x 2 in. (17.2 x 6.3 x 5.1 cm)
2011.06.01

Untitled
(Study for Figure)
1935 (modeled 1920), unique
Polychromed steel
6¾ x 2½ x 1⅞ in. (17.3 x 6.4 x 4.8 cm)
2009.02.03

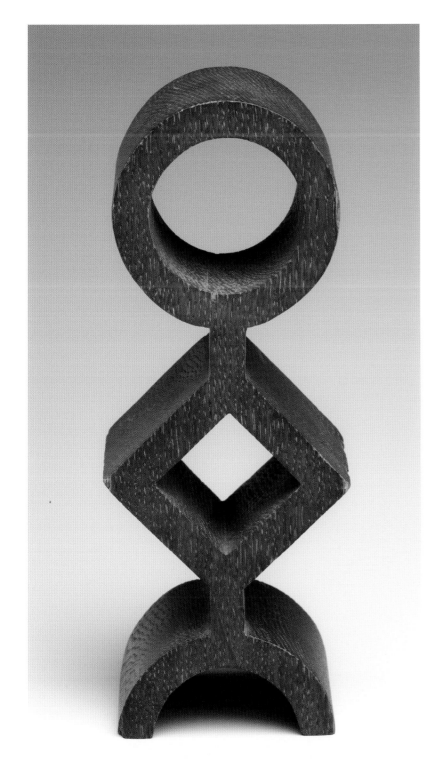

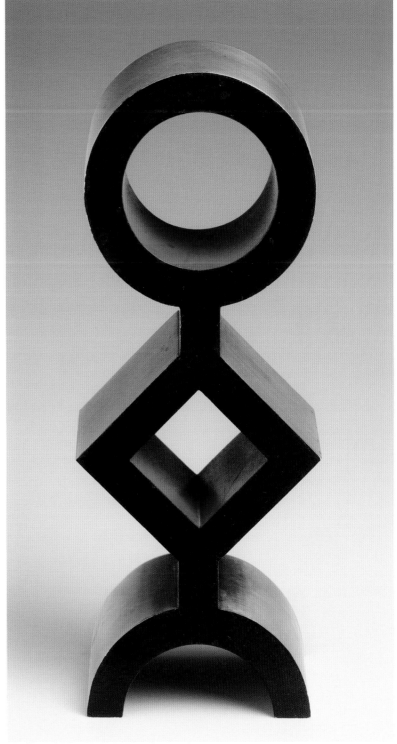

John Storrs
(1885–1956)

Untitled
(Study for Figure)
c. 1935
Graphite on paper
9½ x 5⅞ in. (24.1 x 14.9 cm)
2009.04.03

Untitled
(Study for Roullier Galleries Exhibition Invitation)
c. 1935
Graphite and crayon on paper
9¹/₂ x 5⁷/₈ in. (24.1 x 14.9 cm)
2009.04.02

Untitled
(Study for Roullier Galleries Exhibition Invitation)
c. 1935
Crayon on paper
9³/₈ x 4¹/₄ in. (23.8 x 10.8 cm)
2009.04.01

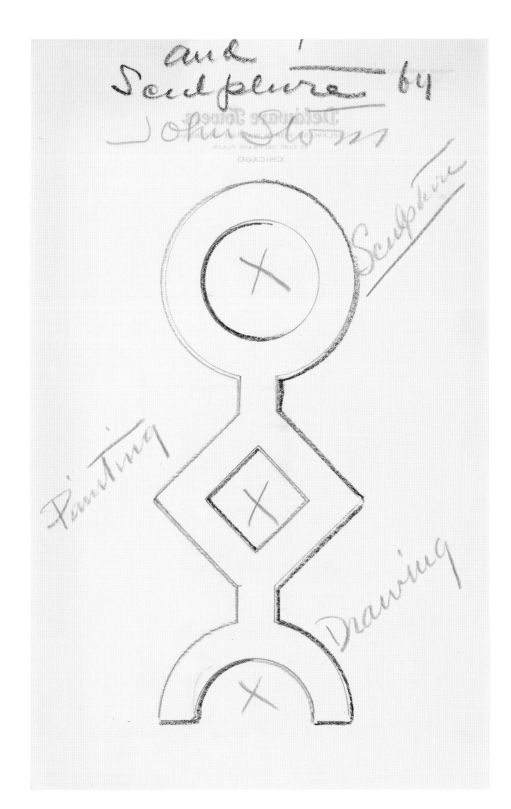

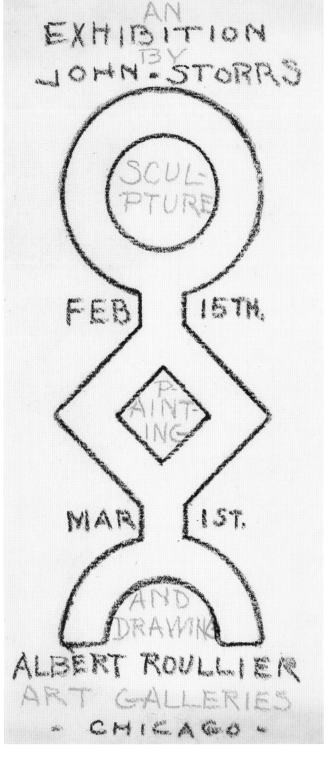

John Storrs
(1885–1956)

Abstraction

1924
Incised signature and date underneath:
"1924/STORRS"
Limestone and marble inlay
17 x 13 x 4¾ in. (43.2 x 33 x 12.1 cm)
2011.03.01

Abstraction is an upright slab of limestone carved in relief on two sides; one, the recto, features a greater amount of carving. Its array of zigzag patterns has been compared to the designs found on Navajo rugs, as well as to aspects of art deco.[1] The use of marble inlay, in particular, is a common art deco device, as seen in the work of the French designer Jacques-Émile Ruhlman, with whom Storrs was in contact around 1919. The greatest variety of shapes, including a forceful spiral, is located in the upper half of the block. The verso is less elaborately carved, although the spiral shell there is segmented with inlay. Both sides are united by the flecks in the limestone.

The work, one of Storrs's finest, seems ready for placement in an architectural context. Its flatness, as Kenneth Dinin has observed, "creates a dialectic on two levels: the obvious one of the interplay between pictorial and sculptural values, and the deeper one of the confrontation between the fine and decorative arts."[2] Storrs allows for both dialectics to be read, depending on how it is displayed: on a pedestal in a gallery, or inset on a pediment.

In a letter of 1949, Storrs refers to the sculpture as one of his first inlay abstractions, carved in around 1917–19, and exhibited as part of his landmark exhibition at the Société Anonyme in New York in February 1923.[3] It was acquired by a member of a well-to-do Philadelphia family, William C. Bullitt. A diplomat, journalist, and novelist, Bullitt became the third husband of the radical journalist and writer Louise Bryant in early 1924. In 1933, he became the first US ambassador to the Soviet Union, a position he held until 1936, when he was made ambassador to France. The sculpture was bequeathed to his daughter, Anne, who kept it throughout her life. It resurfaced at auction in 2008.

1 *John Storrs*, exhib. cat. by Noel S. Frackman, New York, Whitney Museum of American Art, December 1986 – March 1987, p. 45.
2 Kenneth Dinin, "John Storrs: Organic Functionalism in a Modern Idiom," *Journal of Decorative and Propaganda Arts*, 6, Fall 1987, pp. 57–58.
3 John Storrs, letter to Katherine Dreier, May 15, 1949, quoted in *John Storrs*, exhib. cat., p. 55 n. 11. Frackman speculates that the work was signed and dated when acquired by Bullitt, perhaps as a wedding gift.

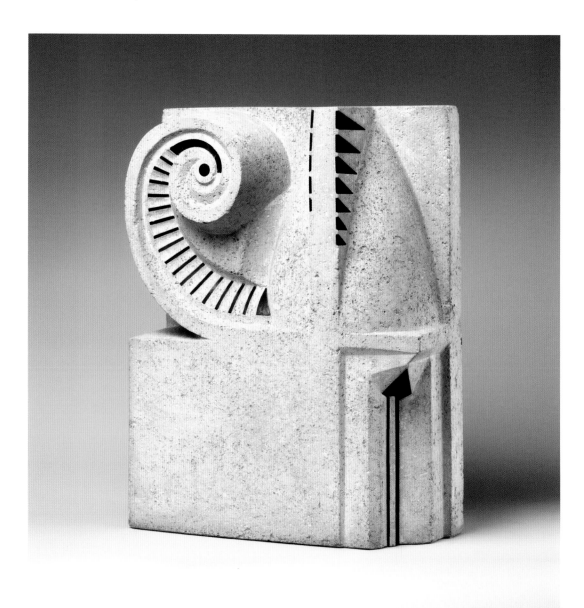

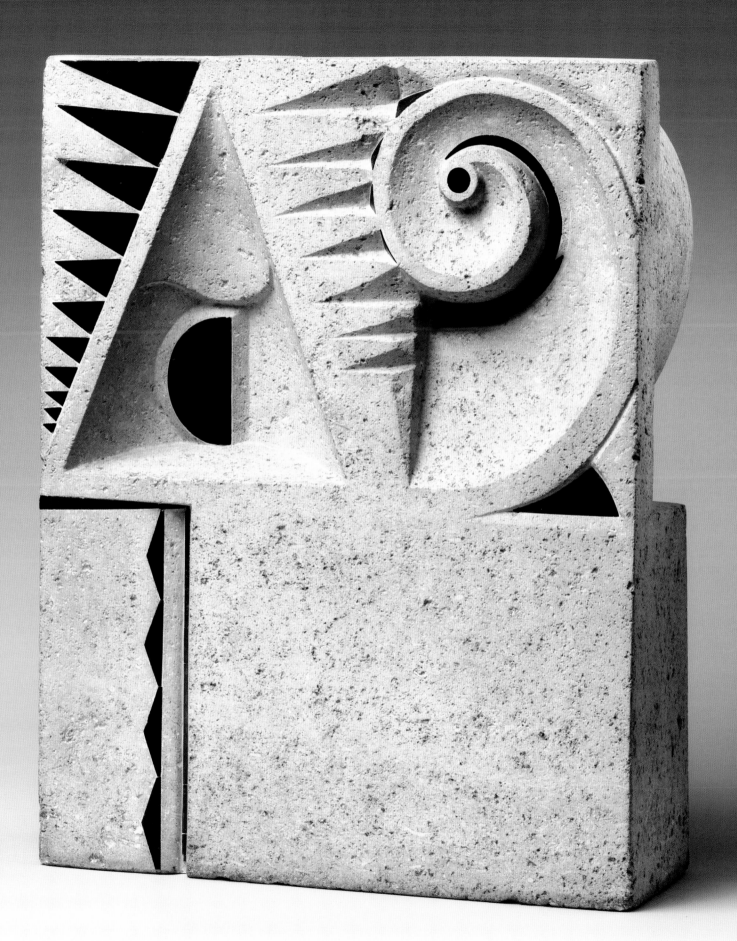

John Storrs
(1885–1956)

Study in Pure Form
(Forms in Space No. 4)
c. 1924
Inscribed on lower edge of brass: "JS II/X"
Steel, copper, and brass
Height: 12¼ in. (31.1 cm)
2010.04.06

Storrs had embarked on the *Forms in Space* series by 1924. Supervising the sculptures' fabrication, he began forming in metal the geometric shapes he had earlier cut into stone. There are at least four versions of this sculpture in the series. Storrs left New York for Paris in 1923, and worked with the Parisian industrial fabricator G. Sueur to create an edition of ten, probably using wooden models. The metal is not welded, but elaborately bolted together.[1]

Study in Pure Form, a collection of mostly elongated geometric forms, makes particular use of the differences in color between steel, copper, and brass. With the exception of the taller copper form, which is inlaid with vertical strips of steel, each form consists of just one metal. Clustered together, they resemble a bevy of tall buildings in an urban center. Thus, as in the case of his stone carvings, Storrs creates a kind of architectural sculpture, albeit using different means. Although small in actual size, it is as monumental as a scale model of a skyscraper.

Twelve such sculptures, referred to as simply "Studies in Form (Stone, Bronze and Metal)," were shown at the Brummer Gallery in New York in February 1928. The writer and critic André Salmon praised them: "The more John Storrs advances in his constructive researches, the more he approaches the great architectural relationship, which is the very aim of sculpture."[2] They received further praise, likewise in architectural terms, from a critic wishing to see "the new towers of Manhattan rise up in such a burnished beauty as Mr. Storrs indicates, with a new and rigid economy of material and architectural detail that would let him express all the shining efficiency of our metallic age."[3]

Storrs's œuvre generally relates to precisionist architectonics, especially those of Joseph Stella. Stella's monumental, five-panel *Voice of the City of New York Interpreted* (1920–22; Newark Museum, New Jersey) was an important source for Storrs, particularly the "Skyscraper" panel. There, too, skyscrapers are clustered and elongated vertically with a drama not seen in actual buildings. *Voice of the City* was hung at the Société Anonyme galleries in New York, where Storrs admired it.[4]

Storrs met Constantin Brancusi in Paris around the time he began the *Forms in Space* series. Its title echoes that of Brancusi's series *Bird in Space*, which was started in 1923.[5] Curiously, examples from both series were detained by the US Customs Service in the mid-1920s, their status as "works of art" questioned by officials. Storrs's sculpture, together with another by him, was being sent to the collector Barry Byrne in Chicago in 1925 when it was held for two months while official letters of support were produced.[6]

1 Noel S. Frackman, "The Art of John Storrs," Ph.D. diss., New York University, 1987, pp. 181–85.
2 *Storrs Exhibition*, exhib. cat., intro. by André Salmon, New York, Brummer Gallery, February 1928, n.p. Constantin Brancusi had shown avant-garde sculpture at the Brummer Gallery in November 1926.
3 Anonymous, untitled review, *Christian Science Monitor*, 13 February 1928, quoted in Kenneth Dinin, "John Storrs: Organic Functionalism in a Modern Idiom," *Journal of Decorative and Propaganda Arts*, 6, Fall 1987, p. 61.
4 *John Storrs: Machine-Age Modernist*, exhib. cat. by Debra Bricker Balken, Boston, West Palm Beach, Fla., and New York, 2010–11, p. 39. See also Frackman, "The Art of John Storrs," p. 184.
5 *John Storrs*, exhib. cat., pp. 45–46.
6 Frackman, "The Art of John Storrs," pp. 185–87. Brancusi's sculpture was infamously detained and dutied the following year, in conjunction with his large exhibition at the Brummer Gallery in November 1926.

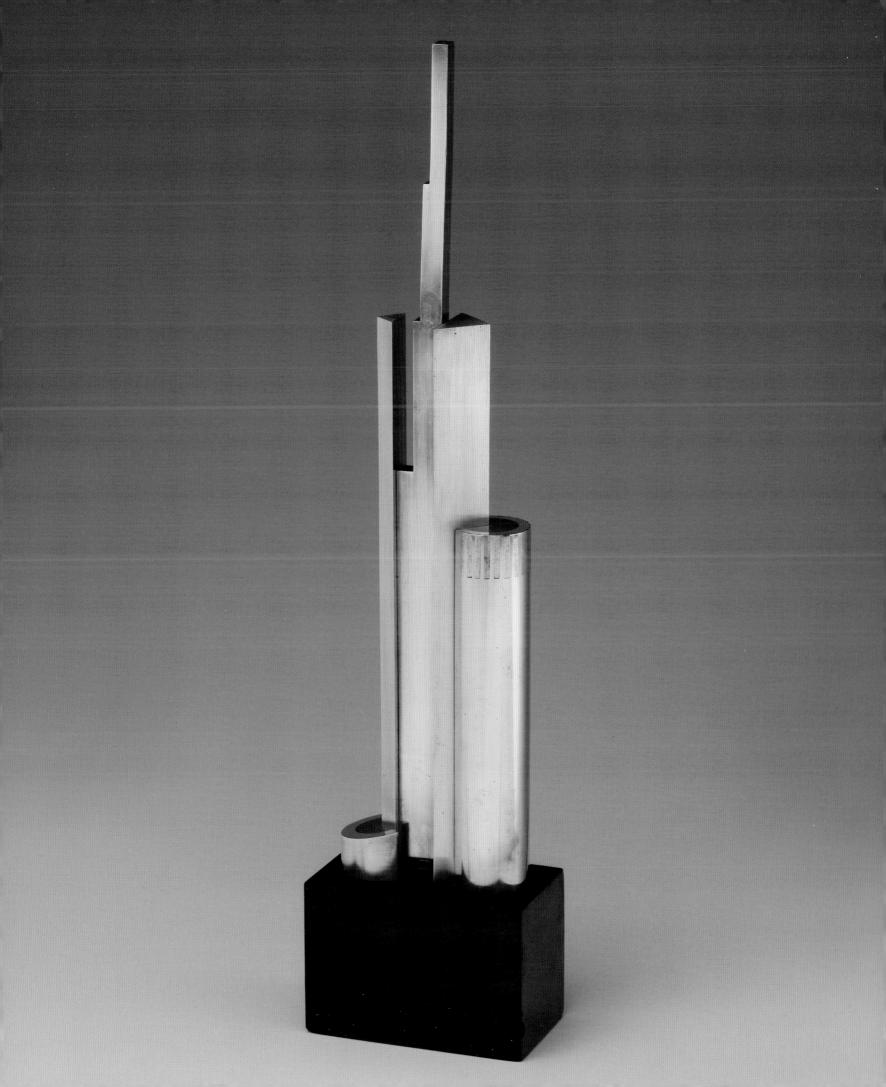

John Storrs
(1885–1956)

Man and Woman
1930
Signed lower right: "STORRS"
Oil on canvas
14⅛ x 12⅛ in. (35.6 x 30.5 cm)
2011.07.01

Man and Woman depicts two solid, irregular forms suspended against a pink background. Light strikes from above and behind, leaving their front planes in shadow and creating a strong volume. There are white highlights but no cast shadows. The forms are oblique, and recede sharply into space, from left to right.

As Storrs's sculpture made reference to architecture, so, too, his painting seems sculptural and architectonic. Thus, although *Man and Woman* is small in scale, the forms are monumental in impact. The title, however, leads us elsewhere, imagining the more angular form to the left as the male, and the more rounded form as the female. To infuse the mechanistic with human gender reflects a hint of Dada wit.

Completed in December 1930, this was Storrs's first painting since his student days, and he continued to paint into the 1930s. (He had recently exchanged studio visits with Fernand Léger, an experience that may have had an impact, particularly in regard to the gradated modeling seen here.) It was a surprising turn for a sculptor at the age of forty-five, but he had no commissions, and the Depression was beginning to bite. He was successful enough to have a show of his paintings in Chicago in 1931, an exhibition that included the similarly colored *Double Entry* (1931; private collection).[1]

1 *John Storrs*, exhib. cat. by Noel S. Frackman, New York, Whitney Museum of American Art, December 1986 – March 1987, p. 91.

Morgan Russell
(1886–1953)

Der Neue Kunstsalon Exhibition Poster

Bernheim-Jeune & Cie. Galleries Exhibition Poster

These exhibition posters (see also pages 130–31) were part of the multinational launch in 1913 of synchromism ("with color"), an art movement developed by Russell and Stanton Macdonald-Wright. The two men had been friends since meeting in an art class in Paris in 1911.

Their first joint exhibition of synchromist works was held in June 1913 at the Neue Kunstsalon in Munich; Russell showed sixteen paintings, Macdonald-Wright thirteen. The poster for the exhibition (right), more abstract than anything in the show itself, was designed by Russell. It proved extremely popular with the locals, who removed it from walls and kiosks, and a second run had to be printed.

Most of the works shown in Munich were earmarked for an exhibition in Paris four months later. Russell designed a new poster for the show (page 131), which shrank the name of the movement and enlarged the names of the artists and the gallery. Bernheim-Jeune had been established in 1863, and later hosted the impressionists. In the early years of the twentieth century, it showed the work of the fauves and, in February 1912, staged the first Paris exhibition of the Italian futurists, which was a sensation. Indeed, the futurists were the synchromists' yardstick for the launch of their movement. As Russell wrote, "Our exhibition was up to expectation—biggest and most seriously attended since the Futurists of [almost] two years ago and while naturally a joke in some circles was accepted as the most important in leading circles."[1]

There is only one other known copy of the Neue Kunstsalon poster (Montclair Art Museum, New Jersey), while the Bernheim-Jeune poster is unique. Both were among the contents of Russell's former home in Aigremont in central France, bought by Louis Sol, an art publisher specializing in posters, in 1946. William C. Agee discovered them on a research trip to France in 1964, and arranged for their purchase by the art collector Benjamin F. Garber. They were later sold to the art collector Henry Reed.[2]

1 Morgan Russell, letter to Gertrude Vanderbilt Whitney, December 1, 1913, quoted in *Morgan Russell*, exhib. cat. by Marilyn S. Kushner, Montclair, NJ, Chicago, and Buffalo, 1990, p. 68.
2 William C. Agee, e-mail to author, September 18, 2012.

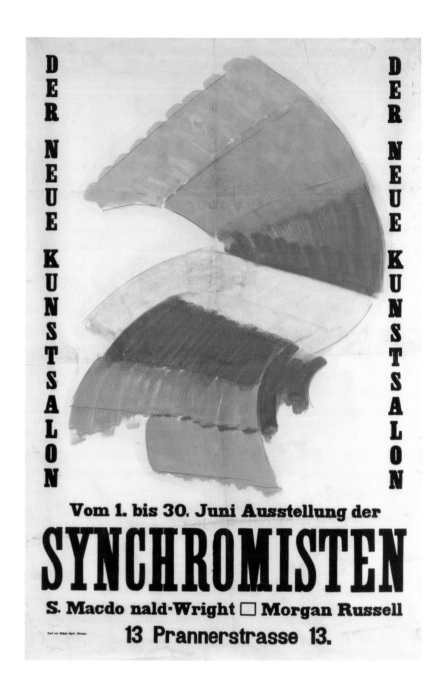

Der Neue Kunstsalon Exhibition Poster
1913
Commercial print with gouache painting
42¼ x 28⅛ in. (107.3 x 71.4 cm)
2010.04.03

DER NEUE KUNSTSALON

ET
S. MACDONALD-W

DU
27
OCTOBRE
AU
8
NOVEMBRE
1913

CHEZ

BERNHEIM-JEUNE

Morgan Russell
(1886–1953)

Bernheim-Jeune & Cie. Galleries
Exhibition Poster
1913
Signed lower right, central panel: "Morgan Russell"
Commercial print with gouache painting
33⅜ x 20⅜ in. (84.8 x 51.8 cm)
2010.04.02

Morgan Russell
(1886–1953)

Study for Synchromy in Blue-Violet
1912/13
Oil on paper
9¼ x 6⅞ in. (23.5 x 17.5 cm)
2010.04.04

Synchromy in Blue-Violet (1913; Regis Corporation, Minneapolis) was the first of two enormous works painted by Morgan Russell for exhibition in Paris. As such, it formed part of the opening salvo of synchromism, the short-lived movement developed by Russell and Stanton Macdonald-Wright (see page 128).

Russell prepared extensively for the 10-foot-high (3 meters) canvas with numerous sketches and studies. This oil-on-paper example focuses on the vivid color relations, with a rainbow of color patches forming a dominant reversed-S shape in the center of the composition. As Russell explained, "I have found the solution in my manner of treating light—i.e. translating the half tones by colors naturally midway in value from yellow to blue—that is by reds, orange and greens."[1] These are indeed the five colors seen here. However, for the final work, Russell would break up the reversed-S shape and integrate it more into the background.

Russell dedicated *Synchromy in Blue-Violet*, his first abstract painting, to the patron and sculptor Gertrude Vanderbilt Whitney. He also prepared a short explanatory booklet for her, in which he wrote: "Never in painting has color been composed in the same sense . . . I have always felt the need of imposing on color the same violent twists and spirals that Rubens, Michelangelo, etc. imposed on form . . . It is only by a sense of continuity or curves in color that one can produce an effect as emotional as that of music on us."[2] The mention of Michelangelo is telling, for Russell had made many studies after the sculptor's *Dying Slave* (1513–16; page 26). This figurative starting point was gradually subsumed into pure form in both the finished *Synchromy* and this equally abstract study.

1 Morgan Russell, "Harmonic Analysis of the Big *Synchromie in Blue-Violacé*," unpublished manuscript, quoted in *Morgan Russell*, exhib. cat. by Marilyn S. Kushner, Montclair, NJ, Chicago, and Buffalo, 1990, p. 76.
2 *Ibid.*

Morgan Russell
(1886–1953)

A Synchromy
1913/14
Oil on paper
9 x 5⅞ in. (22.9 x 14.9 cm)
2010.04.05

This stand-alone "synchromy" on paper seems to have been painted after the exhibition of Russell's *Synchromy in Blue-Violet* in Paris in 1913 (see page 132). Compared to that work, the color groupings have shifted, while more angular wedges, outlined in contrasting blue or black, have been introduced. These shapes establish juxtaposed upward and downward motion. Although many of Russell's abstractions of this period have a figurative underpinning, this work appears to be an abstract play of color.

In the winter of 1913/14, Russell was preparing a monumental painting for the Salon des Indépendants of 1914. There, his *Synchromy in Orange: To Form* (1913–14; page 28) would rival Robert Delaunay's grand *Homage to Blériot* (c. 1914; Kunstmuseum Basel) as the leading example of post-cubist color, with Russell's work the more abstracted. It has been suggested that *A Synchromy* relates to *Synchromy in Orange*.[1]

Synchromy in Orange was Russell's largest canvas, and was based on studies of Michelangelo's sculpture *Dying Slave* (1513–16; page 26). In a letter sent from Paris to the United States, Russell wrote: "The present Salon des Indépendants is divided in interest according to all the papers between myself under the name of Synchromisme and Delaunay under Simultaneisme."[2] Russell made sketches of Delaunay's *Blériot* at the Salon.

Russell continued creating synchromies only until 1915. They are still regarded as the high point of his career.

1 *Synchromism: Morgan Russell and Stanton Macdonald-Wright*, exhib. cat. by Henry M. Reed, New York, Hollis Taggart Galleries, May 1999, pp. 14, 18.
2 Morgan Russell, letter to Andrew Dasburg, March 12, 1914, quoted in *Morgan Russell*, exhib. cat. by Marilyn S. Kushner, Montclair, NJ, Chicago, and Buffalo, 1990, p. 83.

Helen Torr
(1886–1967)

Impromptu
1929
Signed on verso: "Helen Torr/Halesite/N.Y."
Oil on canvas board
9½ x 15⅝ in. (24.1 x 39.8 cm)
2008.05.02

Torr painted and inscribed this abstraction in Halesite, Long Island, where she and Arthur Dove had started mooring their yawl, the *Mona*, in the mid-1920s. From 1927, they began spending the winter on land, sailing only in the summer. In the winter of 1929/30 they accepted a position as caretakers of the nearby Ketewomoke Yacht Club. They had spent the winter of 1928/29 in a similar position on Pratt's Island, Connecticut, returning to Halesite in May 1929. This work must have been completed after their return.

In its total abstraction, *Impromptu* might be compared with Dove's *Untitled* of about the same time (page 81). However, it is more classically composed and evenly balanced. The areas of muted color—olives, maroons, and grays—are suspended on a beige ground, so that they float free of the edge of the canvas. Within half the areas of color are a variety of black-and-white patterns: checkerboard, concentric semicircles, horizontal and vertical lines.

During 1929, Dove praised Torr's paintings in letters to Alfred Stieglitz. *Impromptu* was eventually among twenty-one works by Torr exhibited at Stieglitz's An American Place gallery in New York in 1933, as part of a joint show with Dove. No works were sold, and critical response was scant.[1] The experiment of a joint exhibition was not repeated.

Torr stopped painting in 1943. Her work has begun to receive more attention since her retrospective at the Heckscher Museum of Art in Huntington, New York, in 2003.

1 *Out of the Shadows: Helen Torr, a Retrospective*, exhib. cat. by Anne Cohen DePietro, Huntington, NY, Heckscher Museum of Art, February–April 2003, p. 29. According to DePietro, a reference to a painting called *Beach Mosaic* is the most likely reference to *Impromptu* in the Dove/Torr diaries. It was entitled *Impromptu* when shown in 1933.

Alexander Archipenko
(1887–1964)

Woman with a Fan
c. 1958 (modeled 1914)
Inscribed front, lower right: "Archipenko 1914
Variant 2"
Stamped front, lower right: "S 12 2/8 ©"
Polychromed bronze on wooden base
Height: 35½ in. (90.2 cm), excluding base
2009.03.02

Woman with a Fan (1914; Tel Aviv Museum of Art), on which this work is based, is the earliest of Archipenko's surviving "sculpto-paintings." Having settled in Paris in 1908, he began these experimental works there in 1914. After France entered the First World War in August of that year, he relocated to Nice, where he remained for the duration of the conflict.

Archipenko generally started each sculpto-painting by gluing burlap and linen on to a wooden support. Next he created relief by attaching pieces of metal, wood, or glass to the support, and then painting them—as in the case of the fan and torso in the original *Woman with a Fan*—to heighten the illusion of volume. Archipenko thus achieved an innovative fusion of painting and sculpture, one that would be influential in the further development of the constructivist "planar dimension," and a forerunner to the mixed-media works of today.

In the late 1950s, Archipenko recovered a group of early plasters, including a plaster *Woman with a Fan*, that had been stored in the south of France during the Second World War. He reworked the *Woman with a Fan* plaster, then cast it in polychromed bronze in an edition of eight, one of which is shown here.

The rectilinear format of the sculpto-painting was altered to form a shaped background, which echoes the contour of the woman. The fan became openwork, while the woman's breast, originally flesh-colored, is now the green of bronze. This and other details render the original sensuality of the subject more mechanistic.

Andrew Dasburg
(1887–1979)

Still Life—Fruit

Untitled
(Still Life with Artist's Portfolio and Bowl of Fruit)

In 1909, Dasburg traveled from New York to his native Paris, where, through his friend Morgan Russell, he had his first contact with members of the French avant-garde. He was also introduced to the influential art collectors, writers, and patrons Leo and Gertrude Stein. The effect of this and a later visit to Paris can be seen in two still lifes, *Still Life—Fruit* (opposite) and *Untitled (Still Life with Artist's Portfolio and Bowl of Fruit)* (page 143; see also detail, pages 144–45).

In *Still Life—Fruit*, a close-up of fruit in a bowl, Dasburg presents a lively contrast between a bunch of bananas, twisted and contorted, and a calm yet unusual prickly pear. The spatial compression and use of highlight recall Dasburg's enthusiasm for the work of Cézanne, which he had first encountered in a shop window during his visit to Paris of 1909. "I was immediately impressed by the great plastic reality of the paintings," he later recalled. Inside the shop were many more. "I was completely imbued with what I saw."[1] It turned out that Dasburg had stumbled on Ambroise Vollard's gallery on the rue Laffitte, at that time the best place to see Cézanne's work.

The untitled composition shows a sophisticated understanding of synthetic cubism, which first emerged in 1912 and remained current during the First World War. A still life featuring pears and grapes is centered on a tipped-up tabletop depicted in planes of pink and brown. These planes overlap or abut those of the room, in gray and beige, producing a radical spatial flattening. The central stippled plane suggests an awareness of the work of Picasso and Braque from 1914, probably seen by Dasburg on his four-month trip to Paris in the latter part of that year. The unique aspect of Dasburg's still life is its colorism, notably the use of pink, a color that would recur in the work of Stuart Davis (see, for example, page 197).

In one of the earliest American articles on cubism, Dasburg lists nineteen artists, himself included, who had learned from the movement "the formal materials for our art."[2] He goes on: "Almost everyone that can be called 'modern' has at one time or another shown an influence of Cubism in his art," with Max Weber developing it the most.[3] Nevertheless, at the time of the article, Dasburg's own work was taking a more realist turn.

In 1911, Dasburg had begun spending time in Woodstock, New York, where this painting was first owned by the Swedish writer Gustaf Hellström and his wife, Louise, who were also part of the Maverick art colony there; Louise, a colorful figure, kept the painting after divorcing Hellström in 1923.[4] Dasburg was one of the five painters who founded the Woodstock Artists Association in 1920.

1 Andrew Dasburg, "Notes," quoted in *Andrew Dasburg: The Artist and the Exhibition*, exhib. cat. by Jerry Bywaters, Dallas Museum of Fine Arts, March–April 1957, n.p.
2 Andrew Dasburg, "Cubism—Its Rise and Influence," *The Arts*, November 1923, quoted in *Picasso and American Art*, exhib. cat. by Michael FitzGerald, New York, San Francisco, and Minneapolis, 2007–08, p. 89.
3 Dasburg, "Cubism," p. 280.
4 Irving Drutman, "Professional Horror," *New York Woman*, March 10, 1937, p. 12.

Still Life—Fruit
c. 1912
Brush pen and ink on paper
12³⁄₈ x 10¹⁄₈ in. (31.4 x 25.7 cm)
2007.05.07

Andrew Dasburg

(1887–1979)

Untitled

(Still Life with Artist's Portfolio and Bowl of Fruit)
c. 1914–18
Signed lower left: "Dasburg"
Oil on canvas
20 x 24 in. (50.8 x 61 cm)
2004.03.01

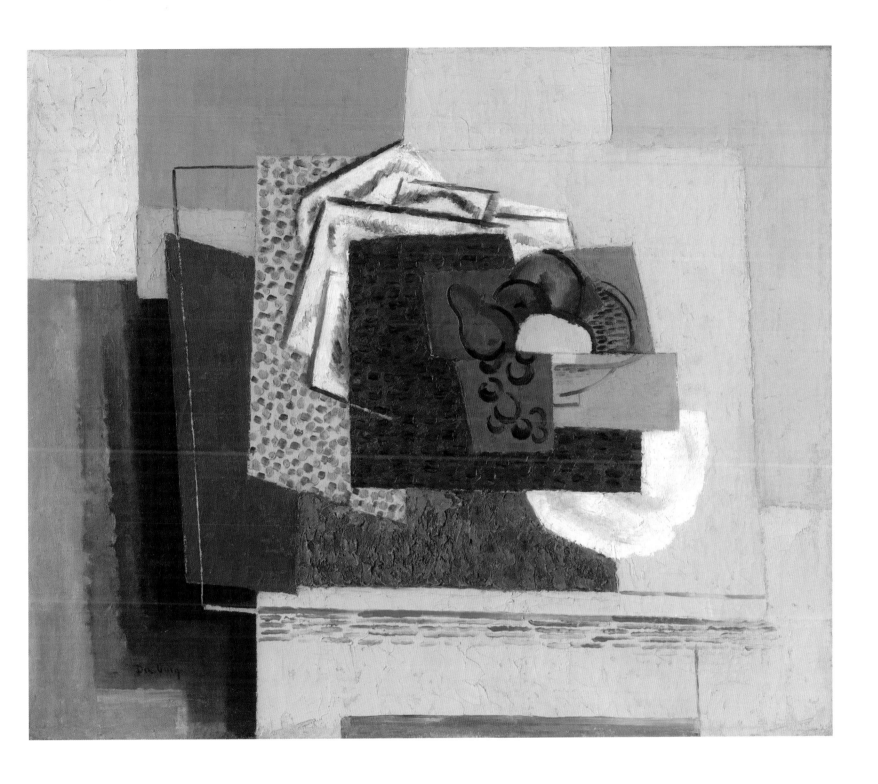

143

Andrew Dasburg
(1887–1979)

Portrait of Alfred
c. 1920
Signed lower left: "Dasburg"
Oil on canvas mounted on Masonite panel
22 x 17 in. (55.9 x 43.2 cm)
2012.06.02

Dasburg's son, Alfred, was born in Yonkers, New York, in 1911. This rather dour portrait of him would therefore have been painted when he was about nine. To judge from period photos, the likeness is good.[1] Yet this is also a study in shades of gray, from Alfred's eyes and sweater to the four shades in the background. It was painted in Woodstock, New York, where Dasburg was a leading light of the Maverick art colony.

Dasburg had originally painted a full-length portrait, a photograph of which was reproduced a few years later (see page 236, fig. 8).[2] In it, the boy is seated on a stool, his hands placed in his lap. To his left, a Cézannesque bowl of fruit and some papers populate a tipped-up tabletop. A folding screen stands in the background.

For the current version, Dasburg removed more than half of the original canvas, placing the focus on Alfred's face. Aside from the addition of a signature in red, however, the painting does not appear to have been otherwise changed. Dasburg's biographer tells us that Earl Stroh, Dasburg's student, rescued the painting "from total destruction by the artist."[3] Given the added signature, however, it appears that Dasburg was content with the cropped version.

1 Sheldon Reich, *Andrew Dasburg: His Life and Art*, Lewisburg, Pa. (Bucknell University Press) 1989, p. 50.
2 Alexander Brook, "Andrew Dasburg," *The Arts*, July 1924, p. 23.
3 Reich, *Andrew Dasburg*, p. 50.

Andrew Dasburg
(1887–1979)

Ledoux Street, Taos, New Mexico
(Harwood)

Placita Sanctuario

Dasburg first traveled to Taos, New Mexico, in January 1918, at the invitation of the arts patron Mabel Dodge Luhan. He spent five months there, and would return every year from 1919, finally settling in the town in 1930. Both *Ledoux Street, Taos, New Mexico (Harwood)* (opposite) and the later *Placita Sanctuario* (page 151) date from his first few visits to the area.

In *Ledoux Street*, Dasburg focuses on a modest streetscape whose blocky adobe structures in the foreground give way to a tall central building, a telephone pole, and a winding road that leads to distant mountains. The sky, which occupies approximately half the canvas, is painted with a palette knife and appears almost as solid as the adobe structures.

Ledoux Street is a central, historic thoroughfare located to the southwest of Taos Plaza. At the time of Dasburg's painting, it formed the heart of Taos's emergent art colony. Its residents included Burt and Elizabeth Harwood, art patrons whose collection is now a museum on the same street (see page 236, fig. 10).

The buildings clustered around an unpeopled plaza in *Placita Sanctuario* display a hint of Giorgio de Chirico–style mystery. Yet the blocky, overlapping structures, defined by strong light and deep shadows, recall those of Cézanne. They also bring to mind Picasso's depictions of the landscape around the Catalan village of Horta de Ebro, painted in 1909.

Dasburg inventoried this work as *Placita*, "painted near Chimayó,"[1] which makes it likely that it reflects a visit to El Santuario de Chimayó, a noteworthy old mission-style church in New Mexico, as well as, perhaps, to the nearby chapel of Santo Niño Penitente. El Santuario is located just outside Chimayó, a village between Taos and Santa Fe. The church is famous for the story of its founding, and is today the most significant Catholic pilgrimage site in the United States. It is entered through a courtyard, the walls of which are similar to those in the foreground of Dasburg's painting. Built of adobe with a bell tower on each side, the modest church is 60 feet (18.3 meters) long and 24 feet (7.3 meters) wide.[2]

1 "Oil Paintings by Andrew Dasburg (List Dictated by Dasburg at Ranchos, December 21, 1947)," Andrew Dasburg and Grace Mott Johnson Papers, Archives of American Art, Smithsonian Institution, Washington, D.C.
2 "Santuario de Chimayó," William H. Wroth, newmexicohistory.org/filedetails.php?fileID=505, accessed November 2012. This website also includes a period photo of the church; for the Santo Niño chapel, see New Mexico's Digital Collections, University of New Mexico University Libraries, econtent.unm.edu/u?/acpa,7962, accessed November 2012. Visually, the buildings in Dasburg's painting seem closer to the Santo Niño chapel, which suggests that he may have based the work on memories of both structures.

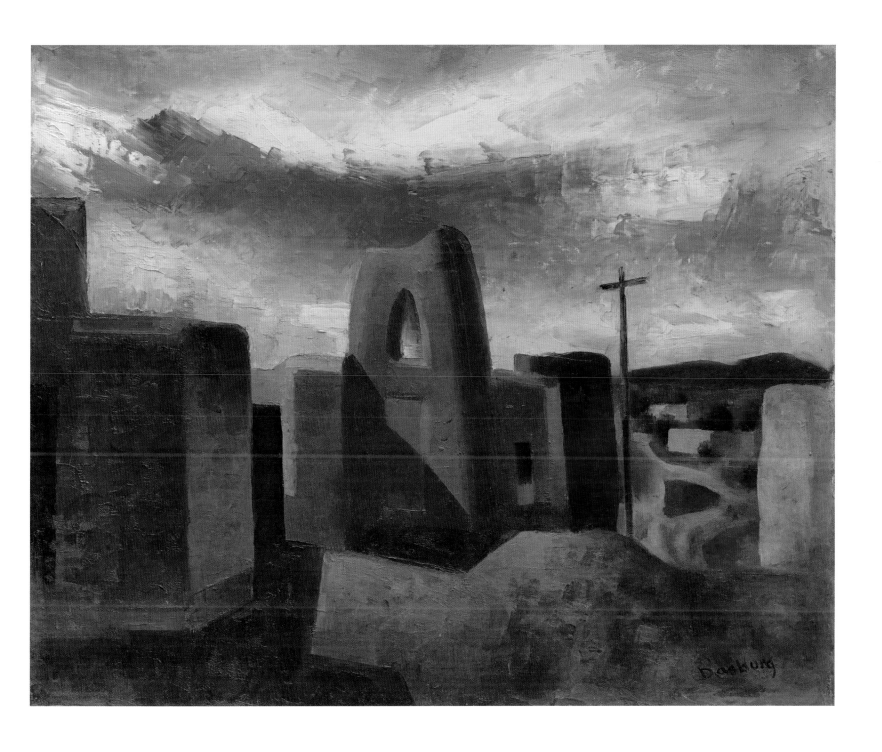

Ledoux Street, Taos, New Mexico
(Harwood)
c. 1922
Signed lower right: "Dasburg"
Oil on paper board
12⁷⁄₈ x 16¹⁄₄ in. (32.7 x 41.3 cm)
2007.05.06

Andrew Dasburg

(1887–1979)

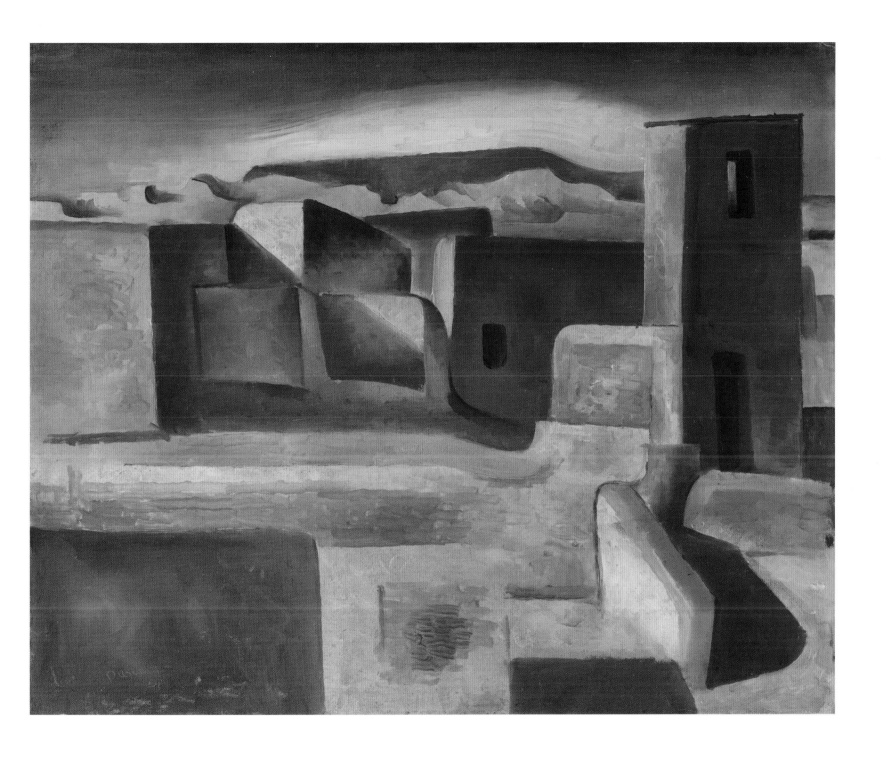

Placita Sanctuario
1924
Signed lower left: "Dasburg '24"
Oil on panel
13 x 16 in. (33 x 40.6 cm)
2008.01.01

Manierre Dawson
(1887–1969)

Bare Branches Behind Outbuildings
1910
Signed on verso: "Manierre Dawson 1910"
Oil on panel
9⅞ x 14⅞ in. (25.1 x 37.8 cm)
2007.05.08

Unusually for an American exponent of modernism, Manierre Dawson was Chicago-based for part of his career. He was primarily self-taught, and had trained as a civil engineer. A turning point was his European tour in the latter half of 1910, during which he met John Singer Sargent in Siena and, more significantly, visited Gertrude Stein's collection in Paris. He had brought a small panel painting to show her, which she unexpectedly purchased on the spot, his first sale. In common with Marsden Hartley, Max Weber, and others, he especially admired Cézanne, although in the Stein collection he would also have seen early cubist works by Picasso.

Bare Branches Behind Outbuildings bears the year of Dawson's European tour. It is a flattened and abstracted vision of nature, which nevertheless retains vestiges of a horizon and sky. The negative space between the branches is almost flesh-colored, giving these areas a quasi-bodily presence. Interrupting the branch-forms are triangular and rectangular outbuildings, which appear to stand at the edge of a green field.

In a journal entry written in the spring before his trip, Dawson notes a lack of local understanding of such experimental paintings on panel: "This spring has been a prolific one. Paintings mainly on wood. Canvas from last year almost run out. The basswood sheets from the crate factory and a little of the Meteer chicken sheathing is still on hand. Some of the paintings are far out and viewers laugh at them, but I am dead serious about every picture."[1]

1 Manierre Dawson, journal entry, April 3, 1910, quoted in *Manierre Dawson: American Pioneer of Abstract Art*, exhib. cat. by Abraham Davidson, New York, Hollis Taggart Galleries, October 1999, p. 162.

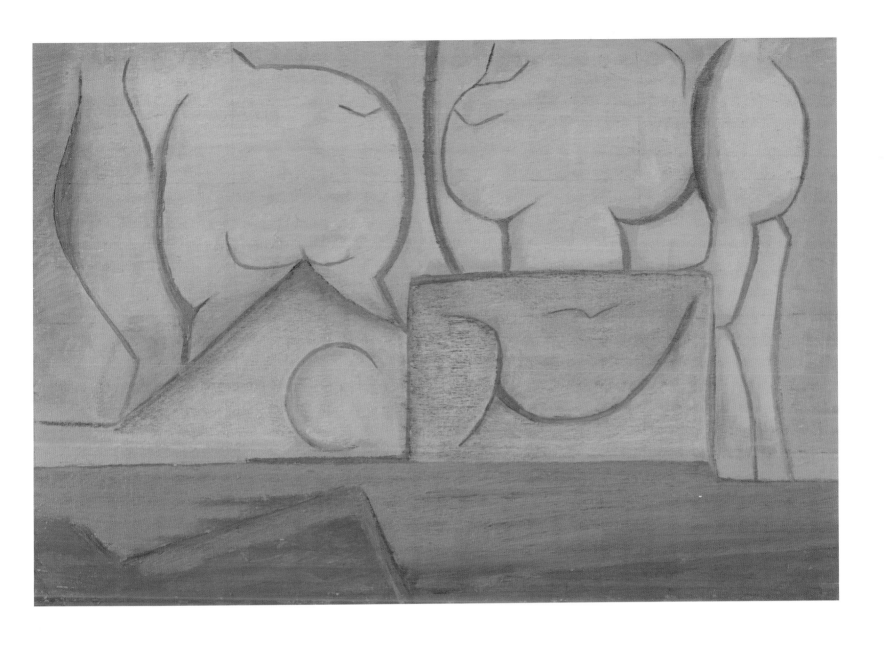

Manierre Dawson
(1887–1969)

Untitled
(Reclining Nude)
1913
Signed lower left: "M. Dawson"
Oil on panel
10⅛ x 14⅛ in. (25.7 x 35.9 cm)
2012.03.01

Reclining Nude hails from the period in Dawson's career when he experimented with cubism, even as he reflected on the Old Masters he had seen on his tour of Europe three years earlier. The resulting abstracted figuration is close to the works of the so-called salon cubists, such as Albert Gleizes and Jean Metzinger, who, in contrast to Picasso and Braque, exhibited in the annual salons.

Dawson's work dates from the year of the legendary *International Exhibition of Modern Art*, more commonly known as the Armory Show, which was held at the 69th Regiment Armory on Lexington Avenue, New York, from February 17 to March 15 before traveling to Chicago and Boston. One of its organizers, the artist Walter Pach, had seen Dawson's recent paintings, and borrowed one to include in the Chicago installation. Dawson spent time at the show closely studying the modernist works on display. Significantly, 1913 was the year in which he left his job at an architectural firm to devote himself to painting.

Dawson also made a purchase at the exhibition, Marcel Duchamp's *Nude (Study), Sad Young Man on a Train* (1911–12; Peggy Guggenheim Collection, Venice), one of the most advanced paintings of the era. In common with Duchamp's controversial *Nude Descending a Staircase (No. 2)* (1912; Philadelphia Museum of Art), which was exhibited at both the New York and the Chicago installations of the Armory Show, *Sad Young Man on a Train* combined cubism with Duchamp's interest in the stop-motion chronophotography of Étienne-Jules Marey and Eadweard Muybridge. Dawson felt that the painting had an influence on his subsequent work.[1]

In *Reclining Nude*, angular lines, discernible in the light browns grouped horizontally across the middle of the canvas, suggest the contours of the painting's subject. The light-brown planes are highlighted against a darker brown, perhaps representing a cloth. In common with Duchamp's *Nude Descending*, Dawson's work is uncertain as to the gender of the subject, although it is usually assumed to be female. As is typical in cubism, forms are clustered in the center of the canvas, and fade toward the edges. These outer areas are more brightly colored, a feature characteristic of Dawson's work.

1 See Randy J. Ploog *et al.*, *Manierre Dawson (1887–1969): A Catalogue Raisonné*, Jacksonville, Fla. (The Three Graces) 2011, pp. 34–36.

Georgia O'Keeffe
(1887–1986)

Lake George—Autumn
1922
Oil on canvas
16 x 27 in. (40.6 x 68.7 cm)
2010.03.01

By the late nineteenth century, Lake George was attracting the era's rich and famous as a tourist destination of choice, thanks in part to a direct rail link from New York City. Located in upstate New York on the eastern fringe of the Adirondack Mountains, the lake is more than 32 miles (51.5 kilometers) long and up to 3 miles (4.8 kilometers) wide. O'Keeffe's view is elevated, looking west to the majestic Adirondacks, and deemphasizing the lake in the middle ground. Alfred Stieglitz took a photograph of the same view (see page 235, fig. 7). The colorful foliage in the foreground reflects the autumn season.

Stieglitz's family owned a large, 40-acre (16-hectare) property at Lake George, and O'Keeffe first visited with Stieglitz in 1918. In early 1923, Stieglitz organized a large O'Keeffe show at the Anderson Galleries in New York, which proved a great success, with twenty of her paintings selling for more than $3000. One of the works on display was *Lake George—Autumn*.

In the fall of 1922, Stieglitz was beginning to make his photographs of clouds, "Songs of the Sky" (later called *Equivalents*; 1922–29). When a selection of these works was shown in early 1924, also at the Anderson Galleries, O'Keeffe described them as "way off the earth," referring to her own work of the past year as "very much on the ground," almost as if the two artists had divided their spheres of interest.[1] This could be said of *Lake George—Autumn*, where the sky is limited and the mountains loom large. Their wine-colored mass takes up almost half of the picture, and glows with a halo of light.

1 Georgia O'Keeffe, letter to Sherwood Anderson, February 11, 1924, quoted in Sarah Whitaker Peters, *Becoming O'Keeffe: The Early Years*, New York (Abbeville Press) 1991, p. 224.

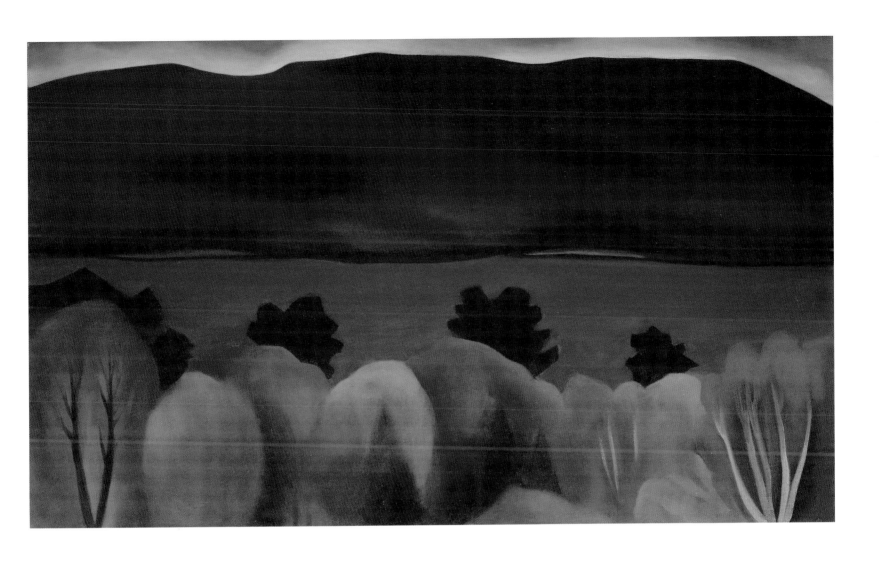

Georgia O'Keeffe
(1887–1986)

Kachina
1931
Signed on verso: "Georgia O'Keeffe/1931"
Oil on wood panel
20⅝ x 16 in. (52.4 x 40.6 cm)
2012.02.01

This is the first of some seven Hopi kachina dolls painted by O'Keeffe over a period of fifteen years. It represents a Ho-te (sometimes Aho-te) kachina that was given to her by the photographer Paul Strand. She also painted a close-up "portrait" of the doll's head on a small circular panel, a work entitled *Paul's Kachina* (1931; Georgia O'Keeffe Museum, Santa Fe, New Mexico). Both works were painted in New York, at around the time a large exhibition of Native American art organized by the artist John Sloan and others was being hailed for its "Americanness."[1]

A kachina is a spirit being found in the religious beliefs and practices of the Native American peoples of the pueblos, including the Hopi; the same term is also used to refer to members of the tribe who dress up as kachinas for ceremonial purposes. More than 400 different types of kachina, which can represent anything in the natural world or cosmos, have been identified. Typically, the Ho-te kachina has a yellow helmet-like head, with pronounced eyes, a snout, and red and yellow crosses that stand for stars; it also has a plain feather headdress. The Ho-te dancer is mostly covered in red body paint, with yellow shoulders, forearms, and lower legs. He carries a rattle and a bow and arrow, and appears in a variety of kachina dances.[2]

In a letter of 1931, O'Keeffe wrote "of the small kachina with the funny flat feather on its head and its eyes popping out—it has a curious kind of live stillness. When I leave the landscape it seems I am going to work with these funny things that I now think feel so much like it."[3] She did indeed capture the "live stillness" of the doll, animating it in a way appropriate to Native American culture. Viewed head on, the kachina fills the canvas, and is thus monumentalized. In common with the subject of O'Keeffe's famous *Cow's Skull: Red, White, and Blue* (1931; The Metropolitan Museum of Art, New York), the doll is placed in front of an abstract background, with flat, slightly overlapping vertical stripes of color on either side. It follows the traditional type closely, with its yellow head, popping-out eyes, and painted stars.

O'Keeffe began spending her summers in New Mexico in 1929, and often attended Native American ceremonies.[4] In finding inspiration in the native cultures of New Mexico, she was following in the footsteps of fellow artists Marsden Hartley, Jan Matulka, and Andrew Dasburg. O'Keeffe later wrote to a previous owner of the kachina, "I had the doll and made up what's behind it in the painting. It's the first painting of an Indian doll that I made."[5]

1 W. Jackson Rushing, 'Pictures of Katsina Tithu: Georgia O'Keeffe and Southwest Modernism," *Georgia O'Keeffe in New Mexico: Architecture, Katsinam, and the Land*, exhib. cat. by Barbara Buhler Lynes and Carolyn Kastner, Montclair, NJ, Denver, Santa Fe, N. Mex., and Phoenix, 2012–14, p. 34. Rushing identifies *Paul's Kachina* as referring to O'Keeffe's friend Paul Jones (*ibid.*, p. 35).
2 Harold S. Colton, *Hopi Kachina Dolls: With a Key to Their Identification,* Albuquerque (University of New Mexico Press) 1949, p. 44.
3 Georgia O'Keeffe, letter to Henry McBride, July 1931, reprinted in *Georgia O'Keeffe, Art and Letters*, exhib. cat. by Jack Cowart and Juan Hamilton, Washington, D.C., National Gallery of Art, then traveling, 1987–89, pp. 202–203 and 283 n. 56.
4 It is known that she attended two dances in 1930, and another, near Taos, in 1931. See *Georgia O'Keeffe in New Mexico*, exhib. cat., p. 130 n. 9.
5 Georgia O'Keeffe, letter to Otto Jarislowsky, February 19, 1972, Vilcek Foundation, New York.

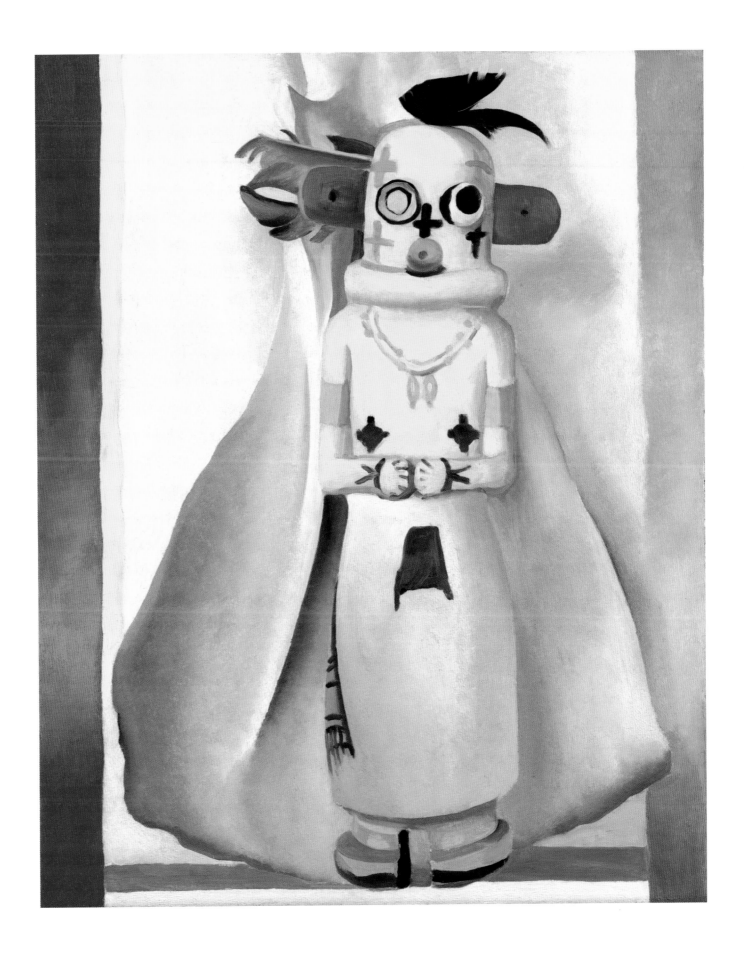

Georgia O'Keeffe
(1887–1986)

Black Place II
1945
Oil on canvas
24 x 30 in. (61 x 76.2 cm)
2011.08.01

"Black Place" is the name given by O'Keeffe to a stretch of desolate hills in the Bisti Badlands of northwestern New Mexico. Despite her name for the area, she described its appearance after a storm in terms of tones of gray: "It was a pale dawn, as dismal as anything I've ever seen—everything grey, grey sage, grey wet sand underfoot, grey hills, big gloomy looking clouds."[1] Some of her earlier paintings of the area were actually titled *Grey Hills* (for example, 1941; Indianapolis Museum of Art).

Black Place I (1944; San Francisco Museum of Modern Art) shows the same site, but is focused more tightly on the central cleft. There is an earlier *Black Place II* (1944; page 20), which is quite different, a more angular, stylized version, seen as if from above.

After discovering the area in the late 1930s, O'Keeffe visited it repeatedly, traveling there from her New Mexico home some 150 miles (240 kilometers) to the east. "As you come to it over a hill," she wrote, "it looks like a mile of elephants—gray hills all about the same size with almost white sand at their feet. When you get into the hills you find that all the surfaces are evenly crackled so walking and climbing are easy."[2] O'Keeffe made several camping trips there in the 1940s with her assistant Maria Chabot, and painted its unusually organic rock formations approximately a dozen times. She would reverse the front seat of her Ford Model A and paint a canvas as large as 30 x 40 inches (76.2 x 101.6 centimeters) propped on the back seat. Later, she also did a version in red from memory (*Black Place IV*, 1944; private collection).

This canvas shows geological striations in the foreground, succeeded by overlapping, undulating hills. The central cleft is the darkest point, as well as a focus. While some versions feature white snow caps, this one has only bare gray hills, which pile up to the top of the canvas, blocking the horizon and flattening the space. Several critics have sensed an abstracted bodily presence in these works.[3]

In 1945, O'Keeffe exhibited a series of four "Black Place" paintings as part of a show at Alfred Stieglitz's An American Place gallery. The following year, she showed a new *Black Place I* (1945; private collection) and the present *Black Place II* in what would be her last show at An American Place in Stieglitz's lifetime. The critic Robert M. Coates had reservations about the exhibition, but found this work a "brilliant performance."[4]

1 Georgia O'Keeffe, quoted in Sharyn Rohlfsen Udall, *Contested Terrain: Myth and Meanings in Southwest Art*, Albuquerque (University of New Mexico Press) 1996, p. 120. Udall also discusses photos by Eliot Porter of the same area. See, in particular, fig. 50, p. 126.
2 Georgia O'Keeffe, quoted in *Georgia O'Keeffe: Selected Paintings and Works on Paper*, exhib. cat., intro. by Robert Pincus-Witten, New York, Hirschl & Adler Galleries, April–June 1986, n.p.
3 See, for example, Theodore Stebbins in Udall, *Contested Terrain*, p. 123.
4 Robert M. Coates, "The Art Galleries—Contemporaries, Including the Whitney," *New Yorker*, 22, February 16, 1946, p. 84.

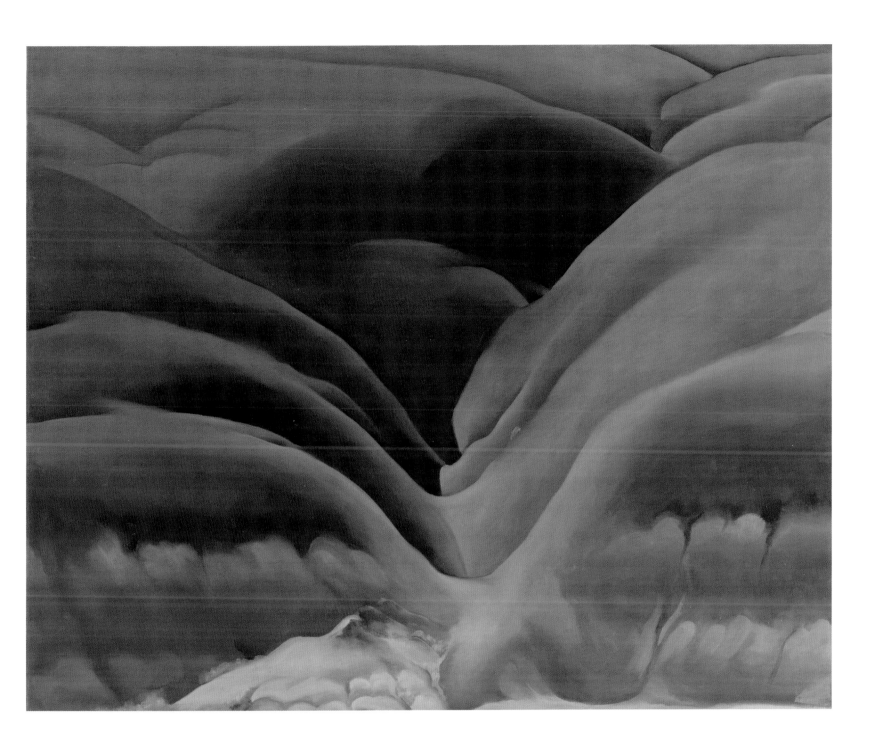

Georgia O'Keeffe
(1887–1986)

In the Patio IX
1950
Oil on canvas mounted on panel
30 x 40 in. (76.2 x 101.6 cm)
2012.05.01

The series *In the Patio* was started in 1946, a year after O'Keeffe had acquired her house in Abiquiu, New Mexico, to use as a winter residence (she would continue to spend her summers at her property on Ghost Ranch until 1949, when she moved into the new house permanently). The first work in the series (*In the Patio I*, 1946; The San Diego Museum of Art) shows a double doorway, with a geometrically abstracted pattern of light and shadow.

When O'Keeffe bought the Abiquiu house in 1945, it was in desperate need of repair, and she spent the next few years restoring it. She later recalled her first sight of the property: "It was a ruin with an adobe wall around the garden broken in a couple places by fallen trees . . . I found a patio with a pretty well house. It was a good-sized patio with a long wall with a door on one side. That wall with a door in it was something I had to have. It took me ten years to get it—three more years to fix the house so I could live in it—and after that the wall with a door was painted many times."[1]

In a sense, O'Keeffe explores and takes possession of her new property pictorially, beginning with the next four works in the *Patio* series, painted in 1948. All are images of the long, flat wall of the patio parallel to the picture plane, complete with the doorway that fascinated her. When the series resumed with four canvases in 1950, there was more variety in the views. *In the Patio VIII* (Georgia O'Keeffe Museum, Santa Fe, New Mexico) shows the corners of the patio wall, with a view of the cloud-filled sky above. *In the Patio IX*, the final work in the series, is more simplified, its smaller slice of sky, in two shades of blue suggesting different strata (or perhaps the curvature of the horizon), arcing above a shadowed corner, and no door. Adobe color gives way to a black-on-white/white-on-black effect. Here, O'Keeffe approaches a kind of hard-edge abstraction that is rare in the art of this period, although one could look to the work of Ralston Crawford (such as *Construction #7*, c. 1958; page 231) or, a little later, to that of Ellsworth Kelly.

The shadow in the painting takes on a tangible form somewhat suggestive of open wings. O'Keeffe amplified this suggestion when, in her autobiography of 1976, she gave the work an alternative title: *Black Bird Series (In the Patio IX)*.[2] This was after she had bought back the canvas at auction in 1973, some two decades after it had first been sold.[3] It was later owned by the potter Juan Hamilton.

In a related series started in 1955, *Patio with Black Door*, O'Keeffe presents oblique rather than straight-on views of the door.

1 Georgia O'Keeffe, *Georgia O'Keeffe*, New York (Viking) 1976, opp. plate 82.
2 *Ibid.*, opp. plate 87.
3 The auction was of the estate of Edith G. Halpert. Sotheby Park Bernet, Inc., New York, March 15, 1973, lot 1082.

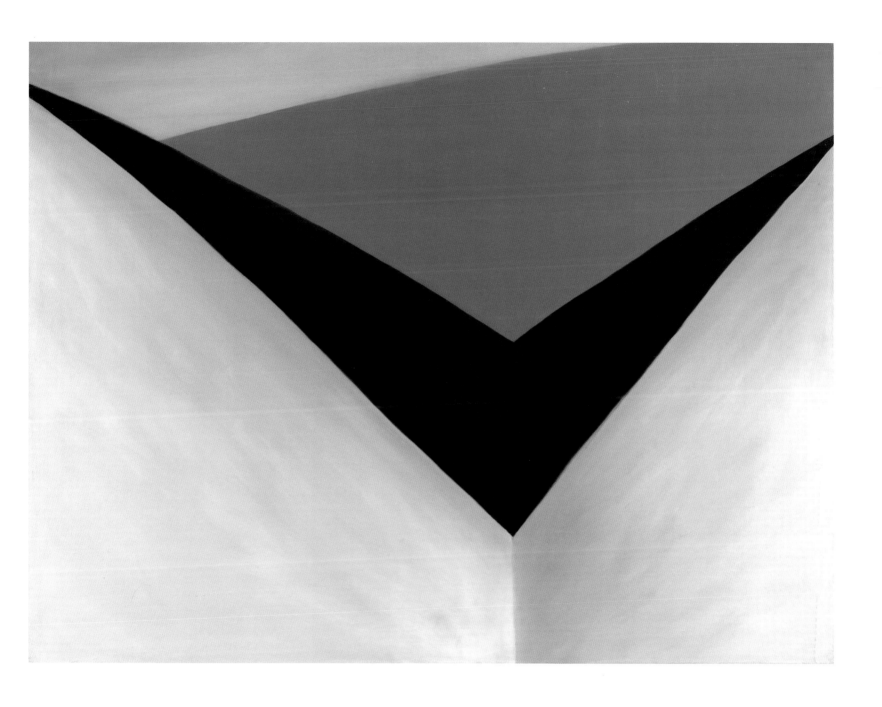

Georgia O'Keeffe
(1887–1986)

Abstraction
c. 1980 (modeled 1946)
Inscribed underneath base, in black: "1/3"
White cast epoxy
36 x 36 x 4 in. (91.4 x 91.4 x 10.2 cm)
2007.04.01

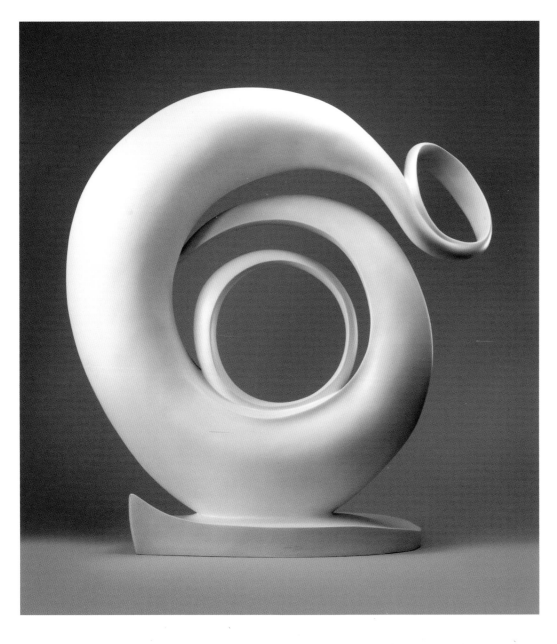

This sculpture resulted from O'Keeffe's encounter with the American sculptor Mary Callery. In September 1945, Callery visited O'Keeffe at Ghost Ranch—a dude ranch near Abiquiu, New Mexico, on which O'Keeffe owned a property—where she sculpted the artist's portrait from life. The American photographer Eliot Porter documented the sitting,[1] while the sculpture was cast in bronze the following year (one such cast is held by the Metropolitan Museum of Art in New York). Meanwhile, in March 1946, O'Keeffe visited Callery's studio in New York, where she reported, "All day I was at Mary Callery's, working on my sculpture."[2] As the art historian and O'Keeffe expert Barbara Buhler Lynes notes, it translates into three dimensions a spiral motif, and is especially close to the pastel *Goat's Horns with Blue* (1945; private collection).[3] Not surprisingly, it is a highly pictorial sculpture.

Perhaps it was O'Keeffe's engagement with pottery-making under the tutelage of Juan Hamilton in the 1970s that led her to revisit her experiments with sculpture: an untitled work from 1916 and *Abstraction*. Both were cast at Johnson Atelier in Mercerville, New Jersey, in 1979–80, the latter in four versions: the 3-foot-high (91.4 centimeters) epoxy version shown here, cast in an edition of three; a small, 10-inch (2.5-centimeter) version, cast in white-lacquered bronze in an edition of ten; another 3-foot version, cast in white-lacquered bronze in an edition of ten; and a monumental, 118-inch (3-meter) version, cast in aluminum in an edition of three. One of the aluminum versions stands in the courtyard of the Georgia O'Keeffe Museum in Santa Fe, New Mexico.

1 Sharyn Rohlfsen Udall, *Contested Terrain: Myth and Meanings in Southwest Art*, Albuquerque (University of New Mexico Press) 1996, pp. 130–31.
2 Georgia O'Keeffe, letter to Maria Chabot, March 4, 1946, quoted in Barbara Buhler Lynes, *Georgia O'Keeffe: Catalogue Raisonné*, 2 vols., New Haven, Conn. (Yale University Press in association with the National Gallery of Art, Washington, D.C.) 1999, vol. 2, pp. 710–11.
3 Barbara Buhler Lynes, *Georgia O'Keeffe Museum Collections*, New York (Harry N. Abrams, Inc., in association with the Georgia O'Keeffe Museum) 2007, p. 68.

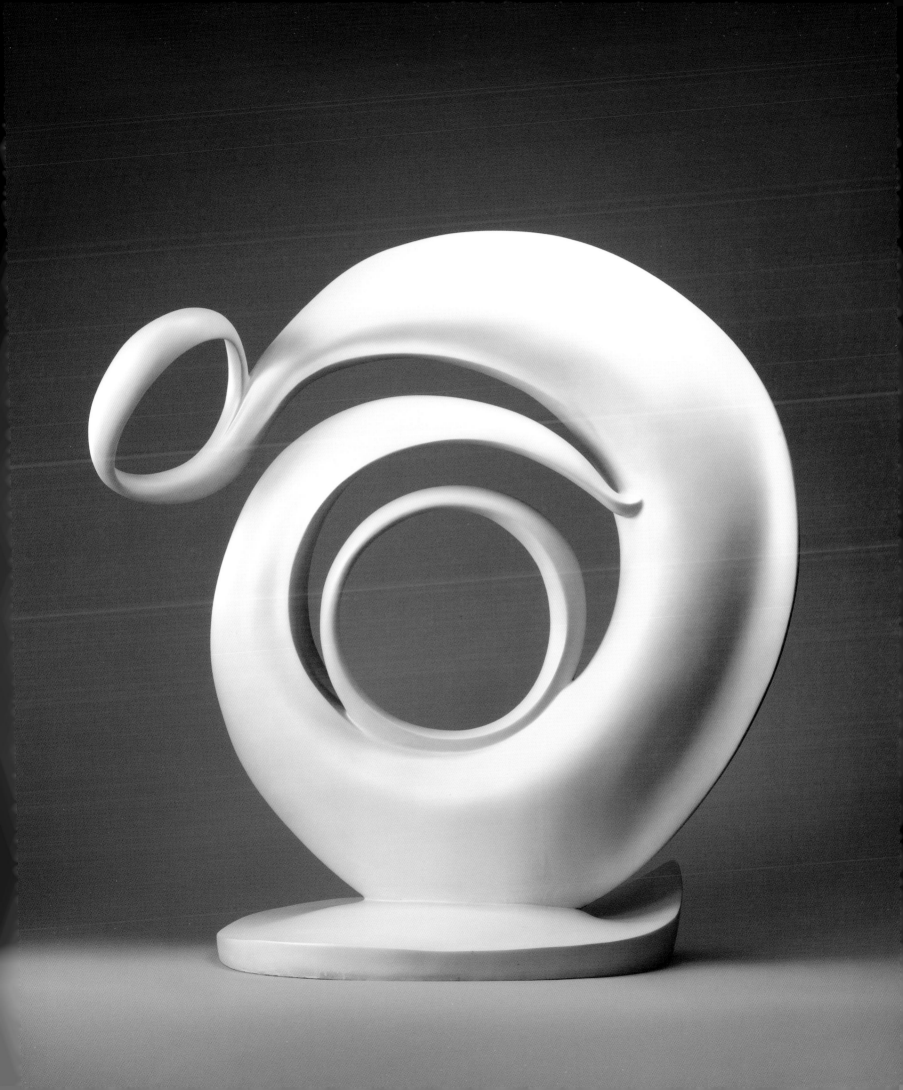

Stanton Macdonald-Wright

(1890–1973)

Gestation #3
1963
Signed upper right: "S. Wright"
Oil on plywood
23½ x 19⅝ in. (59.7 x 50 cm)
2007.05.10

Stanton Macdonald-Wright met Morgan Russell in an art class in Paris in 1911. Together, the two artists launched the synchromism movement in 1913, with exhibitions in Munich and Paris (see page 128). Through synchromism (a term coined by Macdonald-Wright and Russell themselves, meaning "with color"), the artists aimed to explore high-keyed hues within a shallow space, on a cubist-like scaffolding. After relocating to Los Angeles in 1919, Macdonald-Wright became increasingly interested in oriental art and philosophy, subjects that he later taught at the University of California, Los Angeles. In the late 1950s, he began spending five months each year at Kenninji, a Zen monastery in Kyoto, Japan, where he painted this work. It is partly inscribed in Japanese on the reverse.

In many ways, the colorful *Gestation #3* relates to Macdonald-Wright's early synchromist work. A chromatic range from yellow–orange to blue–green is arrayed in overlapping shapes, which seem to glow. As Macdonald-Wright wrote, "Form to me is color . . . As the juxtaposition of two or three colors produces a sensation of luminosity, I find it useless to further occupy myself with light per se."[1] Circles and triangles balance one another to form a calm whole. The work also relates to Macdonald-Wright's interest in the Chinese concept of chi (or 'vital energy'), which he found in the art of the Southern Song dynasty (1127–1279). According to Macdonald-Wright, the brushwork in such art becomes "something beyond itself . . . a harmonization, an unstatic balance of opposing abstract forces."[2]

1 Stanton Macdonald-Wright, quoted in *The Art of Stanton Macdonald-Wright*, exhib. cat., intro. by David W. Scott, Washington, D.C., National Collection of Fine Arts, Smithsonian Institution, May–June 1967, p. 11.
2 Stanton Macdonald-Wright, 1949, quoted in *The Third Mind: American Artists Contemplate Asia, 1860–1989*, exhib. cat. by Alexandra Monroe, New York, Solomon R. Guggenheim Museum, January–April 2009, p. 92.

Jan Matulka
(1890–1972)

Indian Dancers
c. 1917–18
Oil on canvas
26 x 16 in. (66 x 40.6 cm)
2008.03.01

This dense, colorful canvas features three Native American dancers in profile: one, on the right, is wearing a headdress; the other two, on the left and in the center, are wearing animal masks, one with horns; all three are facing and moving to the left. Their forms are overlaid with shards of contrasting color belonging to the yellow–orange to blue–violet range of the spectrum. The style of the work has been linked to the impact of the synchromist movement, founded in 1913 by Stanton Macdonald-Wright and Morgan Russell (see page 128).[1]

Matulka's sojourn in the Southwest in 1917 (see page 170) enabled him to be one of the first modernists to observe and sketch pueblo ceremonies. Those sketched at the Rio Grande Pueblos in New Mexico have not been preserved, but two dynamic drawings of Hopi snake dancers, based on ceremonies he saw in Arizona in August 1917, do still exist (*Hopi Snake Dance, Number I*, 1917–18, and *Hopi Snake Dance, Number II*, 1917–18; both Whitney Museum of American Art, New York).

In accordance with the hunting, gathering, and agricultural society of their ancestors, the ceremonies of the pueblo peoples follow a calendar based on the seasons.[2] This scene has been identified as "a hunting ceremonial called the Mixed Animal Dance."[3] The horned dancer bears some resemblance to the long-snouted Natacka Man of the Hopi.[4]

1 *Synchromism and American Color Abstraction, 1910–1925*, exhib. cat. by Gail Levin, New York, Whitney Museum of American Art, January–March 1978, p. 35.
2 Joseph H. Suina and Laura B. Smolkin, "The Multicultural Worlds of Pueblo Indian Children's Celebrations," *Journal of American Indian Education*, 34, Spring 1999, available online at jaie.asu.edu/v34/V34S3mul.htm, accessed November 2012.
3 W. Jackson Rushing, *Native American Art and the New York Avant-Garde: A History of Cultural Primitivism*, Austin (University of Texas Press) 1995, p. 71. Rushing also illustrates a more colorful, painterly oil-on-paper study for the canvas (*ibid.*, p. 73).
4 Virginia More Roediger, *Ceremonial Costumes of the Pueblo Indians: Their Evolution, Fabrication, and Significance in the Prayer Drama*, Berkeley (University of California Press) 1991, p. 197.

Jan Matulka
(1890–1972)

Rodeo Rider
c. 1917–20
Oil on canvas
29½ x 23½ in. (74.9 x 59.7 cm)
2008.05.01

Born in Bohemia, now part of the Czech Republic, Jan Matulka emigrated to the United States in April 1907, aged sixteen. Ten years later, with the help of a twelve-month traveling scholarship from the National Academy of Design in New York, he spent time in the Southwest, where he had his first encounter with cowboy life. At least two other paintings by Matulka feature cowboy subjects.

Here, a cowboy on a ranch holds on with one hand to the reins of a bucking horse. The bronco rears up on its hind legs, creating a strong compositional diagonal from corner to corner. The cowboy raises his free hand as he turns toward the viewer. The white highlights and strong shadows suggest a bright day. The presence of a second, watching cowboy is indicated only by his shadow cast on the left.

Color areas are blocky, and the body of the horse is broken into varied patterns. Although thus stylized, *Rodeo Rider* is a less abstracted and more touristic vision of the Southwest than *Indian Dancers* (c. 1917–18; page 169).

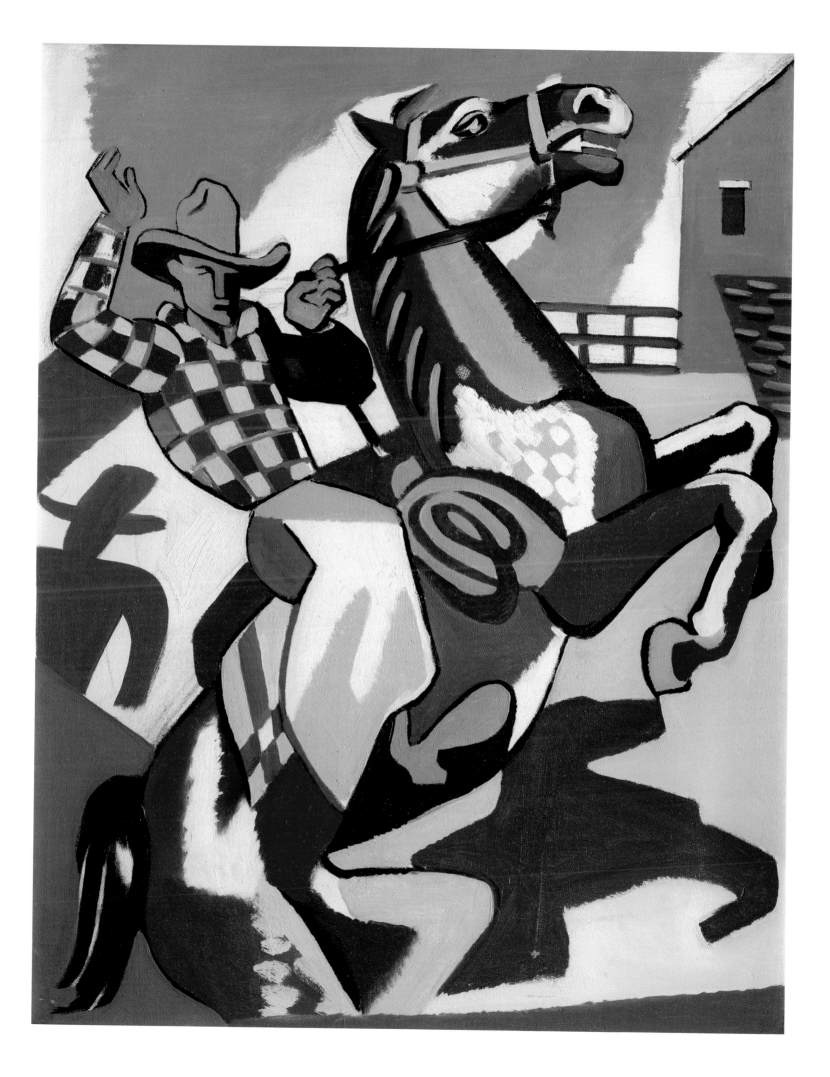

George Copeland Ault
(1891–1948)

View from Brooklyn
1927
Signed lower left: "G.C. Ault '27"
Oil on canvas
18¼ x 21½ in. (46.4 x 54.6 cm)
2007.01.03

View from Brooklyn (also known as *Brooklyn Backyards, Winter*) looks west toward the gray-profiled skyscrapers of lower Manhattan. Third from the left is the domed Singer Building at Broadway and Liberty Street (now the site of 1 Liberty Plaza). For a year after its completion in 1908, the Singer Building was the tallest in the world. That title was later held by the Gothic-spired, fifty-seven-story Woolworth Building, seen here on the far right, built five blocks to the north on Broadway between Barclay Street and Park Place, opposite City Hall. The Woolworth was still the tallest building in the world at the time of Ault's painting. Together, the Woolworth and Singer buildings embodied the dynamic urbanism of lower Manhattan's financial district.

The focus of *View from Brooklyn*, however, is the neighborhood of Brooklyn Heights, on the other side of the East River. The scene is drab and unpeopled. The snow-covered ground and bare trees belong to a small park, which is considerably elevated above the waterfront warehouse building with arched windows that stretches the entire width of the view.

Ault's Brooklyn Heights viewpoint has been identified by the writer Zachary Ross, despite the dominating presence today of the elevated Brooklyn–Queens Expressway, which cut through the neighborhood in 1936.[1] The actual park in which Ault was most likely positioned is still in existence, although it is now closed to the public.

The warehouse building pictured here also appears on the left-hand side of a painting by Ault of the previous year, *Brooklyn Ice House* (1926; Newark Museum, New Jersey). The Newark Museum acquired this and a lower, more dockside view by Ault, *From Brooklyn Heights* (1925), in 1928, important early recognition for the artist. In around 1930, the photographer Samuel M. Gottscho photographed the lower Manhattan skyline from a similar viewpoint, but from farther south (see page 238, fig. 18).

1 Zachary Ross, "The 'Absolute Stillness' of a View from Brooklyn," *Ephemeral New York* (blog), May 2, 2012, ephemeralnewyork.wordpress.com/2012/02/05/the-absolute-stillness-of-a-view-from-brooklyn, accessed November 2012.

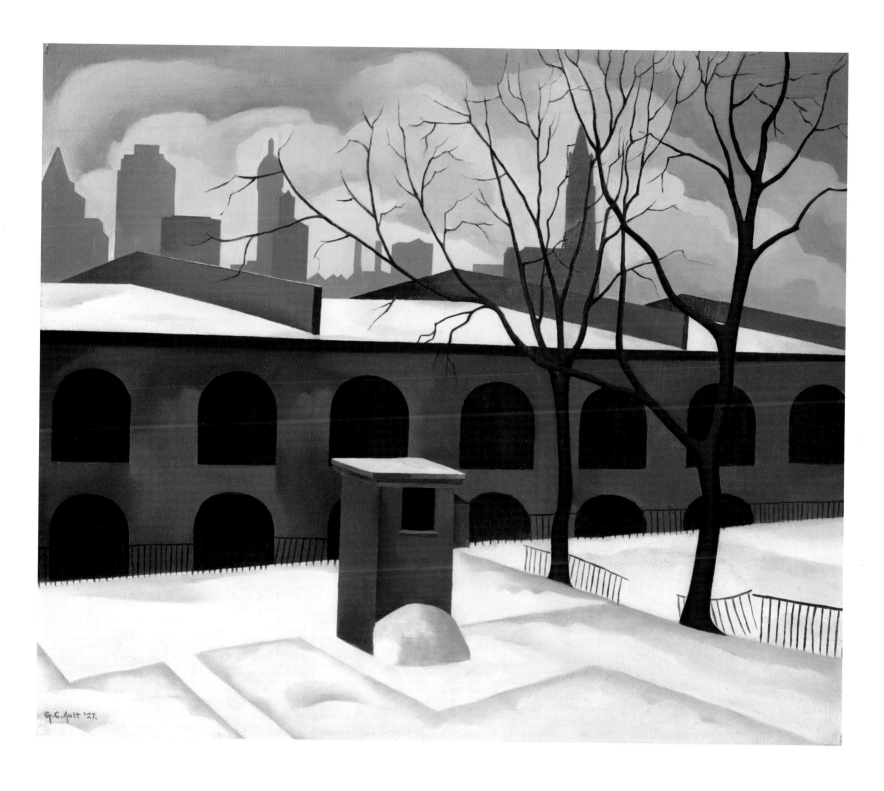

George Copeland Ault
(1891–1948)

Driveway: Newark
1931
Signed lower left: "G.C. Ault '31" (visible only under black light)
Oil on canvas
21½ x 15½ in. (54.6 x 39.4 cm)
2011.02.01

In *Driveway: Newark*, a claustrophobic space is created by the low-rise buildings that occupy both sides of the canvas. A more spatial, sunny landscape opens up in the center, beyond the shadowy foreground. The whole has an artificial stillness, like a theatrical backdrop.

The New Jersey location seems to refer to an earlier period of Ault's life. In 1911, he and his family had settled in Hillside, a township close to Newark, on their return to the United States from London, where they had been living since 1899. Yet in 1931, Ault was living at 50 Commerce Street in Greenwich Village, and generally painting views of urban rooftops.

In the years immediately preceding *Driveway: Newark*, Ault's family suffered a series of tragedies, beginning with the death of Ault's father in 1929 and the stock-market crash of that year, which wiped out much of the family's wealth. Then, between 1930 and 1931, two of Ault's brothers, Donald and Charles, committed suicide. Could this work be a reminiscence of the driveway to one of the family's homes in Newark? In 1931, as the art historian Alexander Nemerov has noted, Ault began to show the effects of these recent stresses: "His behavior—drunken, neurotic—alienate[d] many fellow artists."[1]

Such sharp-edged pictures by Ault have been associated with the precisionist movement. Yet there is also an uneasy, Giorgio de Chirico–like quality to the foreground of the painting that one is tempted to relate to Ault's family setbacks, perhaps mitigated by the hope for a sunnier future represented by the blue skies in the distance.

[1] *To Make a World: George Ault and 1940s America*, exhib. cat. by Alexander Nemerov, Washington, D.C., Smithsonian American Art Museum, March–September 2011, then traveling, p. 132.

Stuart Davis
(1892–1964)

Sword Plant
(From the Shore)

Tree

Garden Scene

Tree and Urn

In this group of four modestly scaled landscapes from 1921 (see also pages 178–79), Davis takes on the reduced palette, painterly touch, and compressed shallow space of the early cubist landscapes of Picasso and Braque (*c.* 1908–09). *Tree* is especially pared down, featuring only a leafless, fork-like tree at the terminus of a curving path. A similar tree appears on the left-hand side of *Garden Scene* (page 178), with additional elements on the right, including a structure of some kind. A more fully grown tree fills *Tree and Urn* (page 179), the stoneware urn implying that this is also a garden view. Only *Sword Plant (From the Shore)* includes a body of water suggestive of Gloucester, Massachusetts, where Davis spent numerous summers from 1915.

Of the four paintings in the group, only *Garden Scene* was shown at the time, in the artist's retrospective at the Whitney Studio Club, New York,

in 1926; otherwise, the paintings remained with the artist. Following the development of his "color-space" theory in 1940, Davis revisited all of them. *Sword Plant* was amped up to the frenetic *Arboretum by Flashbulb* (1942; The Metropolitan Museum of Art, New York), while *Garden Scene* metamorphosed into the equally busy *Ursine Park* (1942; location unknown). A little later, *Tree* spawned the first two paintings of the *Pad* series, *Pad #1* (1946; Honolulu Academy of Art) and *Pad #2* (1946; private collection), in which the tree is colored salmon and turquoise, respectively. Finally, *Tree and Urn* also produced two offspring, an unfinished version of the same title, worked in 1942 and again in about 1950–52 (private collection), and the jazzy color blocks of *Leroy's Shift* (1952; private collection). In this way, Davis gave his stance against novelty in art a visual form, and enacted the concept that any subject matter is suitable for art, including one's own compositions.

Sword Plant
(From the Shore)
1921
Signed lower center: "STUART DAVIS 1921"
Oil on canvas
15 x 30 in. (38.1 x 76.2 cm)
2005.01.01

Tree
1921
Signed lower left: "STUART DAVIS 1921"
Oil on canvas
19⁷⁄₈ x 25¹⁄₈ in. (50.5 x 63.8 cm)
2003.01.01

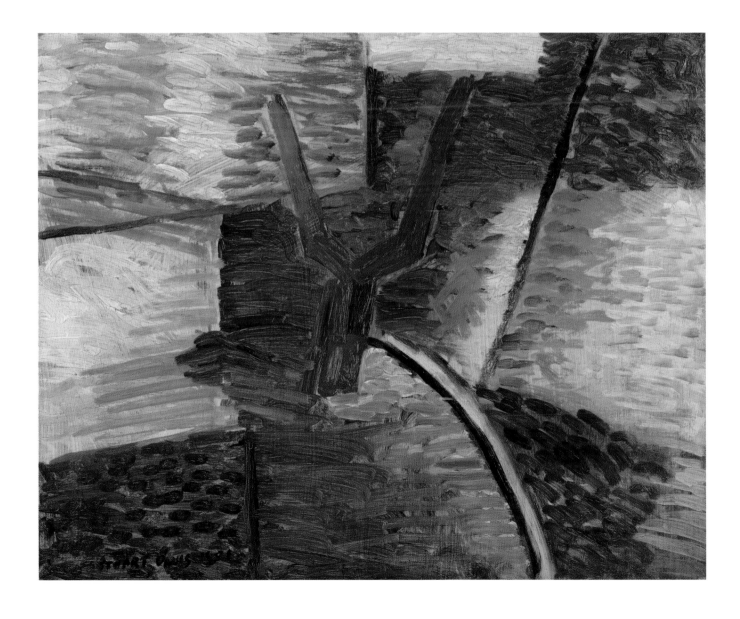

Stuart Davis
(1892–1964)

Garden Scene
1921
Signed lower left: "STUART DAVIS 1921"
Oil on canvas
20 x 40 in. (50.8 x 101.6 cm)
2004.01.01

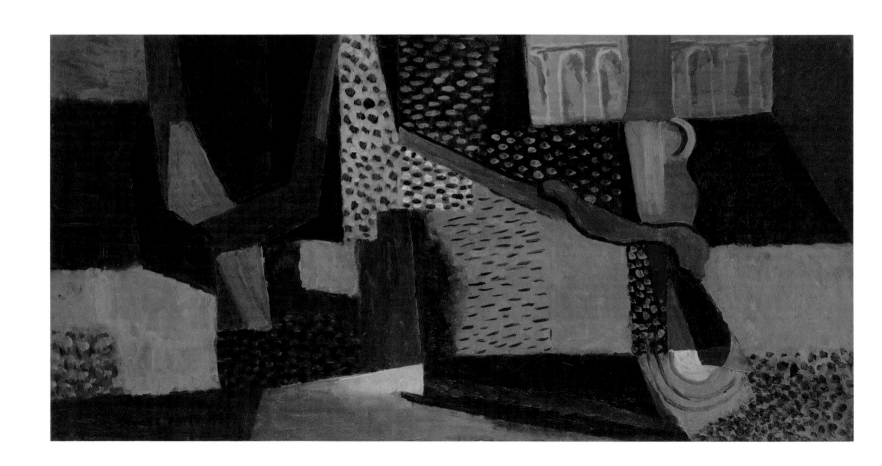

Stuart Davis
(1892–1964)

Tree and Urn
1921
Signed lower right: "STUART DAVIS 1921"
Oil on canvas
30⅛ x 19 in. (76.5 x 48.3 cm)
2006.02.01

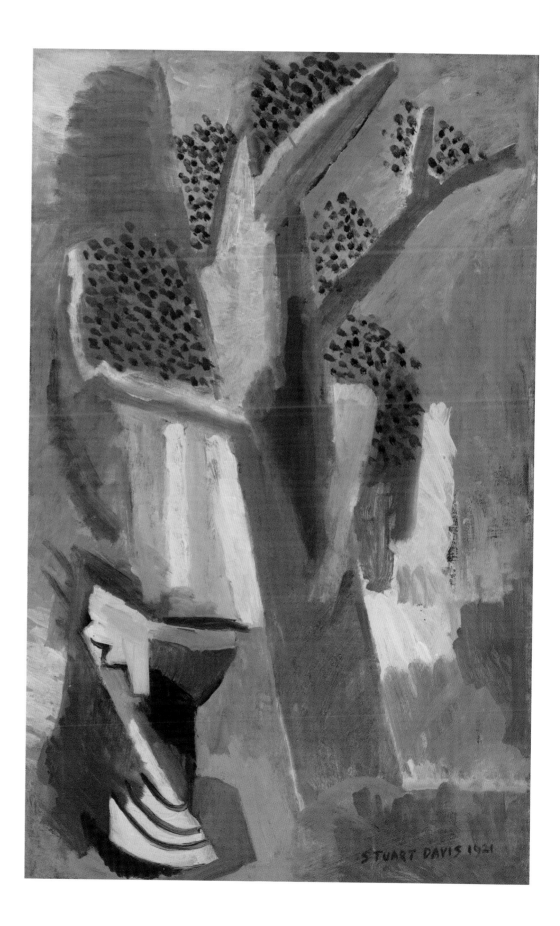

Stuart Davis
(1892–1964)

Man and Lemon
c. 1922
Signed lower right: "Stuart Davis"
Graphite and watercolor on paper
15¼ x 18½ in. (38.7 x 47 cm)
2005.07.01

This watercolor raises a number of questions, not least of which is whether it does indeed feature a lemon, as described in a receipt of 1936 presented to the artist by the Downtown Gallery in New York;[1] given its stem, the piece of fruit equally resembles a pear. The work's date and purpose are also uncertain.

Man and Lemon juxtaposes a human figure and a still life, two of the most common subjects of art. The man—perhaps a mannequin, apparently in a seated position—is rendered in black and white, while the fruit and table are depicted in the primary colors of red, yellow, and blue. Davis produced two other versions of the work, which also have a programmatic basis, as well as the same title: one (1922; Birmingham Museum of Art, Alabama) examines contours and coloring, while the other (1922; location unknown) seemingly focuses on textures and color application.[2] Thus, the three works form a kind of didactic set. The last two include the suggestion of a horizontal ledge, on which the figure sits.

Interestingly, the versions not shown here were both acquired in September 1942 by the artists Charles and Alice Beach Winter, whom Davis had met through the artist John Sloan. They were of an older generation, impressionist painters and illustrators, for whom these cubist-era stylizations would have been adventurous acquisitions.

1 Ani Boyajian and Mark Rutkoski, eds., *Stuart Davis: A Catalogue Raisonné*, 3 vols., New Haven, Conn. (Yale University Press) 2007, vol. 2, p. 520, cat. no. 1069.
2 See *ibid.*, cat. nos. 1068 and 1070, respectively.

Stuart Davis
(1892–1964)

Still Life with Dial

Still Life, Brown

Still Life, Red

Davis's notebooks from 1922 indicate that he was girding himself for a major effort. "Starting now," he wrote, "I will begin a series of paintings that shall be rigorously logical American, not French. America has had her scientists, her inventors, now she will have her artist."[1] As William C. Agee has noted, Davis seems to refer to six large still lifes of 1922.[2] The four largest, all 50 x 32 inches (127 x 81.3 centimeters), act as an ensemble, for they were shown together in Davis's retrospective at the Whitney Studio Club, New York, in 1926. Three of these are in the Vilcek Collection (opposite and pages 186–87; the fourth, *Blue Still Life*, is privately owned). Their scale is monumental, making them appear even larger.

Still Life, Brown and *Still Life, Red* are essentially pendants. In both works, a central table, set at an angle and tipped toward the viewer, supports a fluted glass vase, a bottle, and a bowl of fruit. *Brown* also features a pipe in a bowl, a sign of the reflective artist, and melds the objects and space along vertical axes. *Red* includes an as-yet-unidentified item of printed matter on the wall, featuring the partial text "Se Q / Lo / cera," and has a shifting perspective, including overhead views of the bowl and a goblet.

Most observers see the still lifes of 1922 as the moment of Davis's engagement with the paintings of Braque and Picasso, what the art critic Roberta Smith has called "The Apprenticeship of Stuart Davis as a Cubist": "As the work of a young American painter who had never been to Europe, these paintings are very impressive."[3] To several critics, they seem similar to Braque's "Guéridon" still lifes, those featuring that particular type of pedestal table.[4] Yet only two of the Guéridon series had been completed by this time. Davis may have seen the one in the Arensberg Collection (*The Table*, 1918; Philadelphia Museum of Art), but it is more likely that he had seen the profusion of "mantelpiece" still lifes that Braque produced between 1917 and the early 1920s.

Likewise, a Picasso scholar has made a strong case for the influence on Davis of two earlier Picasso still lifes that were exhibited and sold to much notice at the time. In 1921–22, when Picasso's art had not been extensively exhibited in New York, Davis's "engagement with the art of Picasso was the most intense among American artists since Weber of around 1915, and it is remarkable that both artists concentrated on the same set of works: Picasso's still lifes of 1914 and '15 . . . Davis's [engagement] laid the foundation of his career and introduced a generation of American artists to Cubism."[5]

The table in *Still Life with Dial*, different from those in *Brown* and *Red*, is indeed a guéridon, and is seen straight on. Davis emphasizes the knob of the drawer, as in certain still lifes of Cézanne. This fulfills Davis's view that "the surface should be a head on view of an incised plane and not an exaggerated symbolizing of forms in perspective."[6] The painting also has stronger planes of color than the pendants: the purple of the inkwell and the pink of the printed material, both planes extending beyond the contours of the objects. A copy of *The Dial*, one of the most important little

magazines of the 1920s, is a notable inclusion (see also detail, pages 184–85). Among its illustrious contributors was the journalist Paul Rosenfeld, who had published a long essay on American painting in the issue of December 1921. Davis himself was among the magazine's artist-illustrators, first contributing four "literary" portraits to the issue of August 1920. In 1922, he provided sketches of James Joyce (June issue) and Stravinsky (August). His contributions continued into 1923. His inclusion of the magazine in his still life is thus personal, as well as a nod toward the avant-garde publication.

In his notebook of the time, Davis proclaimed that "The hint of 'Journal' in Cubism should be carried on."[7] He was referring to the presence of the French newspaper *Le Journal* in some of Picasso's still lifes, such as the above-mentioned works of 1914 and 1915, as well as their hint of the quotidian and use of the word as image. By including a copy of *The Dial* in his still life, Davis thus continues the "hint of 'Journal'" in cubism in his unique New York accent.

1 Stuart Davis, notebook entry, March 1922, quoted in *Stuart Davis, 1892–1964: The Breakthrough Years, 1922–1924*, exhib. cat. by William C. Agee, New York, Salander-O'Reilly Galleries, November–December 1987, n.p.
2 *Stuart Davis, 1892–1964*, exhib. cat., n.p.
3 Roberta Smith, "Art: The Apprenticeship of Stuart Davis as a Cubist," *New York Times*, November 27, 1987, p. C26.
4 See both Karen Wilkin and Lowery S. Sims in *Stuart Davis: American Painter*, exhib. cat. by Lowery S. Sims *et al.*, New York, The Metropolitan Museum of Art, November 1991 – February 1992; San Francisco Museum of Modern Art, March–June 1992, pp. 46, 163. The Braque Guéridon illustrated in Wilkin's essay (p. 47), *Guitar and Still Life on a Guéridon* (1922; The Metropolitan Museum of Art, New York), was being finished in Paris at the same time as Davis was beginning his series.
5 *Picasso and American Art*, exhib. cat. by Michael FitzGerald, New York, San Francisco, and Minneapolis, 2007–08, p. 77.
6 Stuart Davis, notebook entry, April 20, 1923, quoted in Diane Kelder, ed., *Stuart Davis*, New York and London (Praeger) 1971, pp. 47–48.
7 Stuart Davis, notebook entry, March 12, 1921, artist's estate.

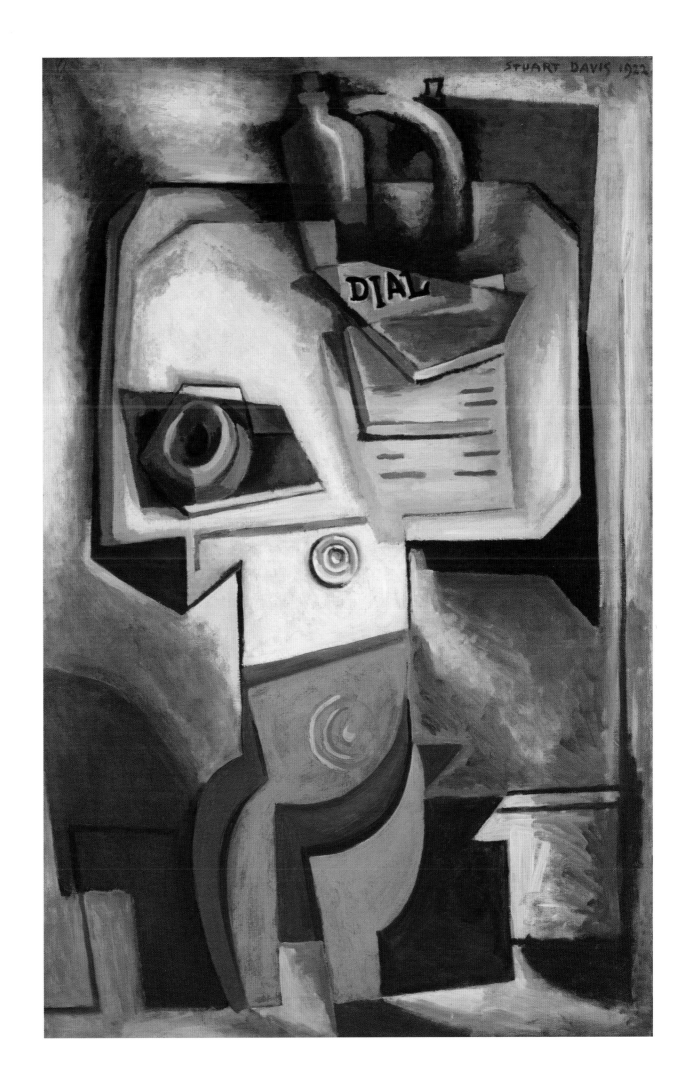

Still Life with Dial
1922
Signed upper right:
"STUART DAVIS 1922"
Oil on canvas
50 x 32 in. (127 x 81.3 cm)
2003.02.01

Stuart Davis
(1892–1964)

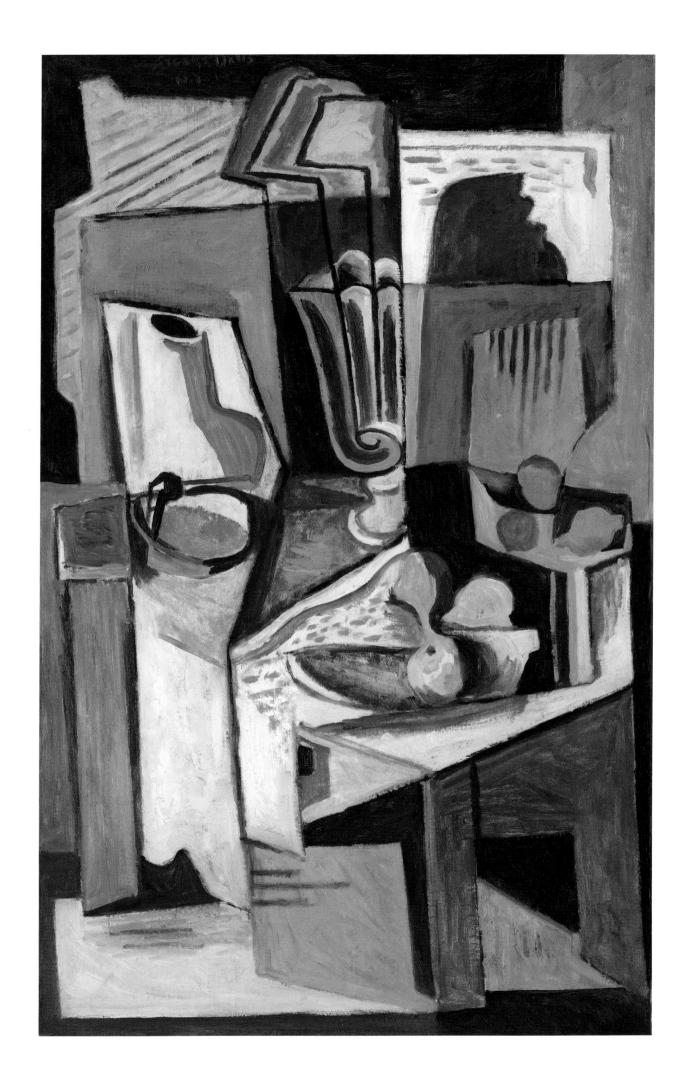

Still Life, Brown
1922
Signed upper left:
"STUART DAVIS / N.Y. 1922"
Oil on canvas
50 x 32 in. (127 x 81.3 cm)
2005.06.02

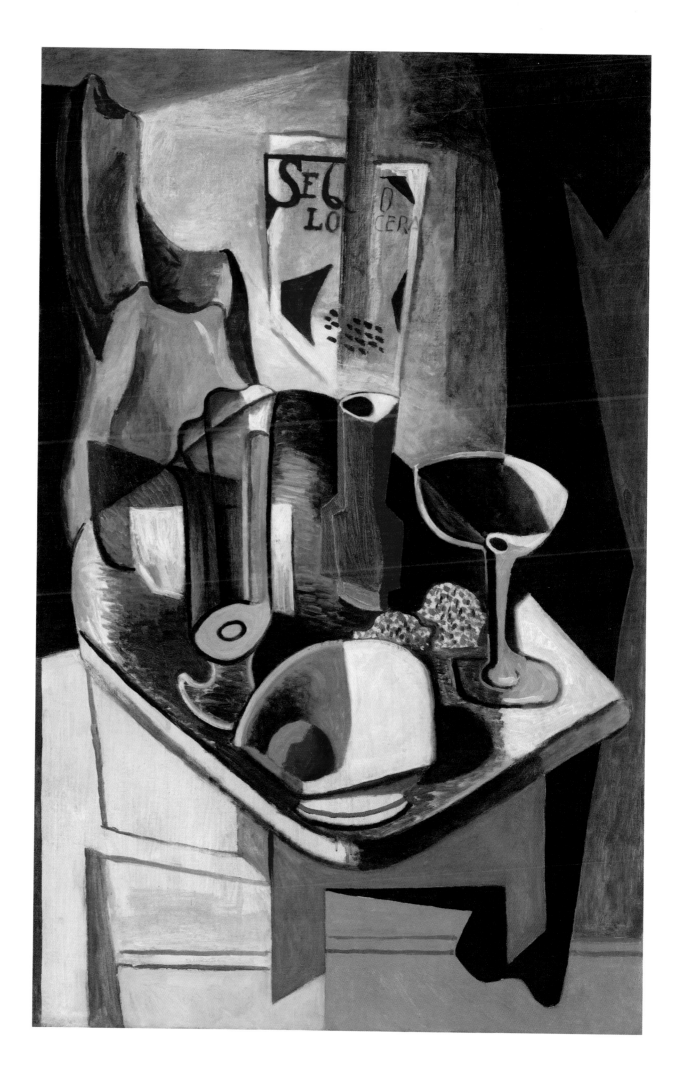

Still Life, Red
1922
Signed upper right:
"STUART DAVIS / N.Y. 1922"
Oil on canvas
50 x 32 in. (127 x 81.3 cm)
2005.06.01

Stuart Davis
(1892–1964)

Still Life with Vase
(Still Life with Egg Beater)
1922
Signed lower left: "STUART DAVIS 1922"
Oil on canvas
12 x 19¼ in. (30.5 x 48.9 cm)
2004.02.01

The holdings of the Vilcek Collection are unparalleled in charting Davis's absorption of cubism in 1921–22. Together with *Still Life with Dial* (page 183), *Still Life, Brown* (page 186), and *Still Life, Red* (page 187), *Still Life with Vase (Still Life with Egg Beater)*, a small, experimental work, belongs to the landmark group of some twelve still lifes produced by the artist at this time.

The black-lined white form is an open book, perhaps the most frequently occurring object in the paintings. The brown form at the right may be a stylization and melding of separate items: a fluted glass vase atop three pieces of fruit on a cloth, as in *Still Life with Book, Compote and Glass* (1922; artist's estate). The table, an irregular black plane, has no visible legs, and floats free in the "head-on" space.

According to the Davis catalogue raisonné, in which the work is titled *Still Life with Vase*, the painting is "the most abstracted version of the 1922 compositions of a vase, a book, and a plate of three round pieces of fruit."[1]

1 Ani Boyajian and Mark Rutkoski, eds., *Stuart Davis: A Catalogue Raisonné*, 3 vols., New Haven, Conn. (Yale University Press) 2007, vol. 3, p. 118.

Stuart Davis
(1892–1964)

Indian Family
1923
Signed lower right: "STUART DAVIS"
Oil on canvas board
19 1/2 x 15 5/8 in. (49.5 x 39.7 cm)
2004.02.03

Indian Family features a man and what may be his young daughter: she, looking surprised, holds a key, while he pulls at his moustache. They are rendered in grisaille (a method of painting in gray monochrome), whereas the horse and church in the background are depicted in shades of blue.

The picture was conceived during the summer of 1923, when, at the invitation of the artist John Sloan, Davis drove to Santa Fe, New Mexico. Joining him on the journey were Wyatt Davis, his brother, and Dolly, Sloan's wife. The place had an impact on Davis, and he mostly painted landscapes, driving around the countryside with Sloan in the scorching sun. He also produced some gray still lifes, done in his studio in the Palace of the Governors, the former seat of government of the Spanish colony of Nuevo México. Finally, he made three figure groups, including *Indian Family*, also using extensive shades of gray. They bring to mind Fernand Léger's and Juan Gris's figural cubism of the 1920s.

Here, as in most of his New Mexico paintings, Davis establishes an irregular border just inside the actual borders of the canvas. Davis did not return to New Mexico after his visit of 1923, and later complained, "I don't think you could do much work there except in a literal way, because the place is there in such a dominating way."[1]

1 Stuart Davis, quoted in *Stuart Davis: American Painter*, exhib. cat. by Lowery S. Sims *et al.*, New York, The Metropolitan Museum of Art, November 1991 – February 1992; San Francisco Museum of Modern Art, March–June 1992, p. 166.

Stuart Davis

(1892–1964)

Indian Corn
1924
Signed lower left: "Stuart Davis '24"
Oil on board
18⅝ x 24⅜ in. (47.3 x 61.9 cm)
2012.06.01

In *Indian Corn*, Davis delights in the red and purple of the maize against the striated lime-green tablecloth. The yellow ear completes the triad of offbeat, near-primary colors, which, together with the crinkly contours, add a note of whimsy. The tipped-up and truncated bowl recalls those in Davis's still lifes of 1922 (pages 182–87). Overall, however, *Indian Corn* has a greater color intensity. It is as if Davis decided to add fauvist color to the cubist structure of the earlier, somber paintings.

The year 1924 was another key moment in Davis's exploration of still life, capped by the iconic *Odol* (The Museum of Modern Art, New York). Where the still lifes of 1922 were dense and complex, the eleven from 1924 are smaller in scale (approximately 18 x 24 inches/45.7 x 61 centimeters), simplified, and consist of just one or two monumentalized objects, as in *Apples and Jug* (Museum of Fine Arts, Boston) and *Edison Mazda* (The Metropolitan Museum of Art, New York), which features a 75-watt lightbulb.

These eleven works form the prelude to Davis's renowned *Egg Beater* series and other still lifes of 1927–28. *Indian Corn* was included in the artist's retrospective of December 1926, held at the Whitney Studio Club in New York. It may be that the numerous still lifes gathered there inspired him to undertake the *Egg Beater* paintings.

Stuart Davis
(1892–1964)

Roses
1927
Signed lower center: "STUART DAVIS '27"
Watercolor, gouache, and graphite underdrawing
on paper
13¼ x 13 in. (33.7 x 33 cm)
2007.05.01

The year 1927 is a landmark in Davis's œuvre, a time when he systematically turned to still life to consolidate his cubist experiments. He famously wrote of "nailing an electric fan, a rubber glove, and an eggbeater to a table and [using] them as . . . exclusive subject matter for a year."[1]

Yet despite this discipline, a few other motifs appear in the work of this time: a coffee pot, matches, and this more traditional arrangement of roses. Davis applies his planar reductions to a uniquely organic and curving subject: two flowers set in a glass bottle.

In *Flowers* (1914; private collection), Juan Gris had likewise created a striking collage contrasting naturalistic roses, rounded forms, and cubist fragmentation. However, Davis would not see it until 1928, when he visited Gertrude Stein's collection while in Paris.

In 1924, Davis had painted the more naturalistic *Roses in a Vase* (artist's estate). He would make a similar ink drawing in early 1928.[2]

1 Stuart Davis, in *Stuart Davis*, exhib. cat. by James Johnson Sweeney, New York, The Museum of Modern Art, 1945, p. 16.
2 Ani Boyajian and Mark Rutkoski, eds., *Stuart Davis: A Catalogue Raisonné*, 3 vols., New Haven, Conn. (Yale University Press) 2007, vol. 2, pp. 545–46, ill. p. 545, cat. no. 1110; see also cat. nos. 239, 1505.

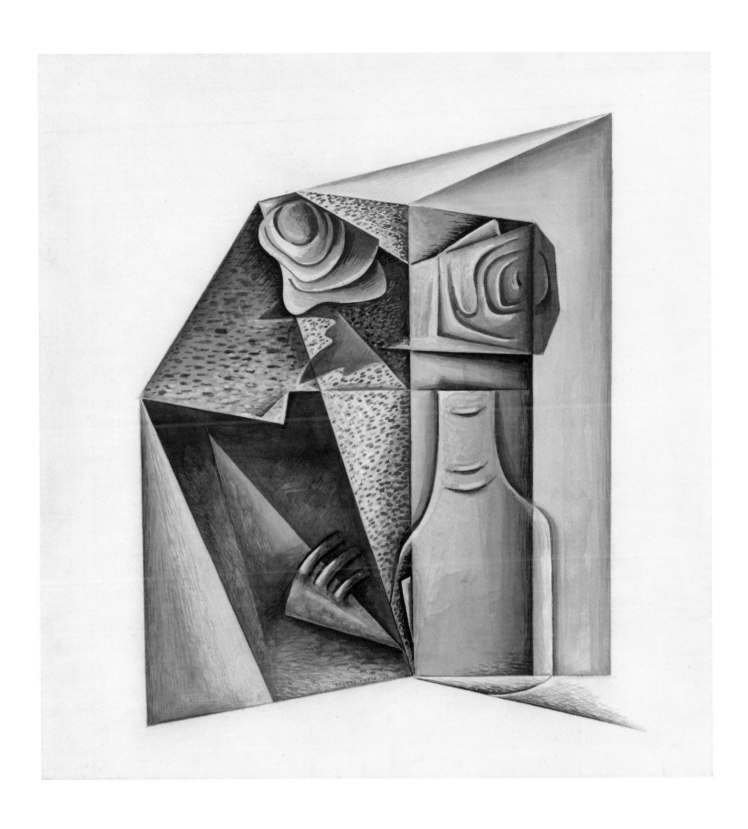

Stuart Davis
(1892–1964)

Music Hall
1930
Signed lower right: "STUART DAVIS"
Oil on canvas
16 x 18 in. (40.6 x 45.7 cm)
2009.03.01

Stuart Davis's only trip to Paris took place between May 1928 and August 1929. There, he produced numerous cityscapes with a flat, stage-like space, taken from pencil sketches of ordinary scenes, especially around Montparnasse, the neighborhood in which he was living. This painting combines two such drawings, the first two pages of "Sketchbook 7," used in Paris.[1] The works often included pastel blues and pinks, as in the present picture, a rare Paris view actually painted after the artist had returned to New York.

On the right-hand side is a typical Stuart Davis café, complete with outside seating, an advertisement for *tabac* (tobacco), and the distinctive red sign indicating that the establishment is licenced to sell such products. Davis enjoyed sitting and sketching in such cafés, at least in warmer weather, as well as other activities. As he wrote in a letter home, "The pauper can go to The Coupole [a brasserie on boulevard du Montparnasse] . . . and sit all night for a 6 cent coffee-cream, write all the letters he wants to on café stationery and play chess or cards into the bargain . . . There is nothing like it in America."[2] In the center is Davis's only representation of the Bobino, a historic music hall located at 20, rue de la Gaîté, close to the Théâtre Montparnasse and just down the street from where Davis had his studio. In the 1920s and 1930s, the Bobino was one of the most popular entertainment venues in France, playing host to such legendary acts as the American-born dancer, singer, and actress Josephine Baker.

1 Ani Boyajian and Mark Rutkoski, eds., *Stuart Davis: A Catalogue Raisonné*, 3 vols., New Haven, Conn. (Yale University Press) 2007, vol. 2, p. 122, cat. nos. 255–56. Sketchbook 7, which contains sixteen pages of drawings of Paris, is one of at least twenty-six sketchbooks used by the artist during his career. The extant sketchbooks are published in the Davis catalogue raisonné.
2 Stuart Davis, letter to his mother, January 25, 1929, quoted in *Stuart Davis: An American in Paris*, exhib. cat., intro. by Lewis Kachur, New York, Whitney Museum of American Art, October–December 1987, pp. 2–5.

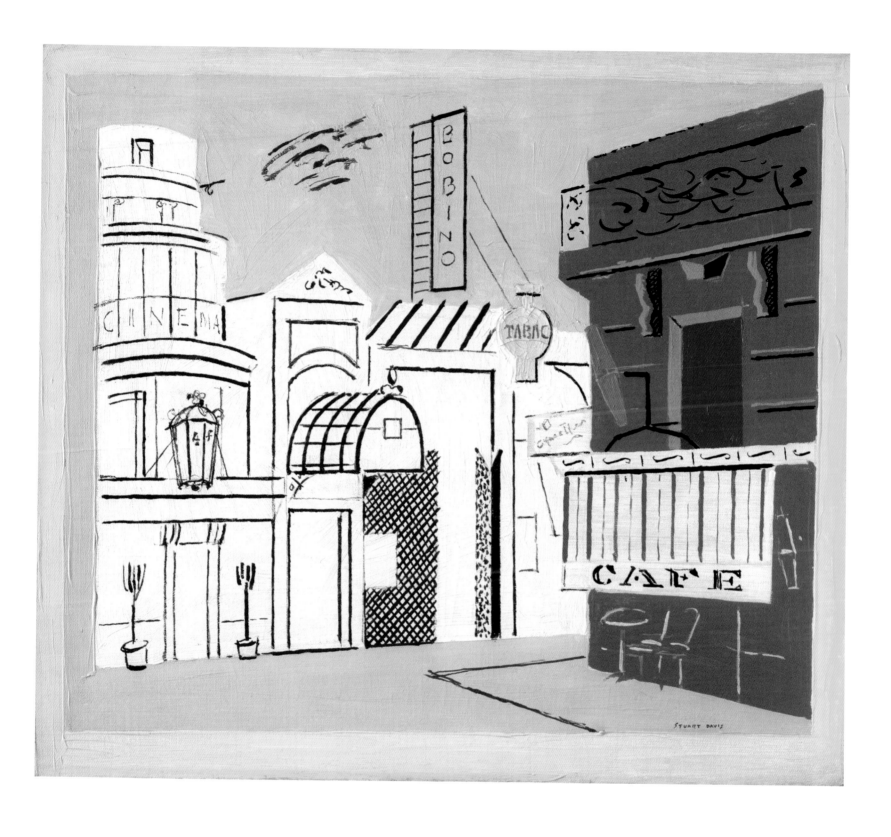

Stuart Davis

(1892–1964)

Ship's Rigging
(Coordinates II)
1932
Signed middle right: "Stuart Davis"
Gouache on paper
20⅛ x 27½ in. (51.1 x 69.9 cm)
2005.05.03

In terms of his drawing, especially with brush and ink, 1932 was a major year for Davis. Most of his linear scaffolds of this time are uncolored, and resolutely two-dimensional. In some cases, he combines a foreground still life with a distant seascape view, as in *Study for Radio City Music Hall* (1932; page 201).

Davis does something similar here. Most of the composition consists of the rigging and masts of a schooner—a sailing vessel native to Gloucester, Massachusetts—whose "architectural beauties" made it one of Davis's favorite motifs. "The schooner is a very necessary element in coherent thinking about art," Davis wrote, ". . . the fact that its masts define the often empty sky expanse. They function as a color-space coordinate between earth and sky."[1] The masts thus lock nature into a Cartesian order.

To the right of the main mast, however, Davis jump-cuts to another scale and spatial level with a close-up of a rotary fan, its blades housed behind a metal guard. Thus exterior becomes interior. The parallel horizontals in the bottom left-hand corner of the work seem to flip between denoting the wooden planks of the schooner's hull and the cornice at the top of a building; behind them, the ship's upper rigging and rope ladder come into view.

On the left-hand side, Davis reverses positive and negative, with white lines continuing the suggestion of rigging. Elsewhere, he includes some discrete areas of color, although only the patch of blue with horizontal dashes is readily identifiable: a glimpse of a body of water.

Davis based *Ship's Rigging* on two separate drawings from one of his sketchbooks, "Sketchbook 13." One drawing makes clear that the curving shape at the center of the work is a cloud; the other features two studies of a fan on a shelf. An inscription on the former conveys Davis's spartan attitude toward color at this time: "The color is never the cause of the interest because it is only the Means by which ideal space relations are made visible."[2]

Davis revisited this work seven years later on a much larger scale, and in oil, using it as the basis for the large gray plane at the center of his mural for Studio B of the WNYC Municipal Broadcasting Company (1939; The Metropolitan Museum of Art, New York), a radio station in New York. The distant building is eliminated, while the patch of water is enlarged. To the right of the mast, connecting lines remain, but they link not to a fan but to an electronic console appropriate to a radio station. The schooner thus acts as a symbol of the countryside amid references to the urban sounds of jazz.

1 Stuart Davis, "Autobiography" [1945], in *Stuart Davis*, ed. Diane Kelder, New York and London (Praeger) 1971, p. 25.
2 Ani Boyajian and Mark Rutkoski, eds., *Stuart Davis: A Catalogue Raisonné*, 3 vols., New Haven, Conn. (Yale University Press) 2007, vol. 2, p. 240, cat. no. 509; see also cat. nos. 510, 512.

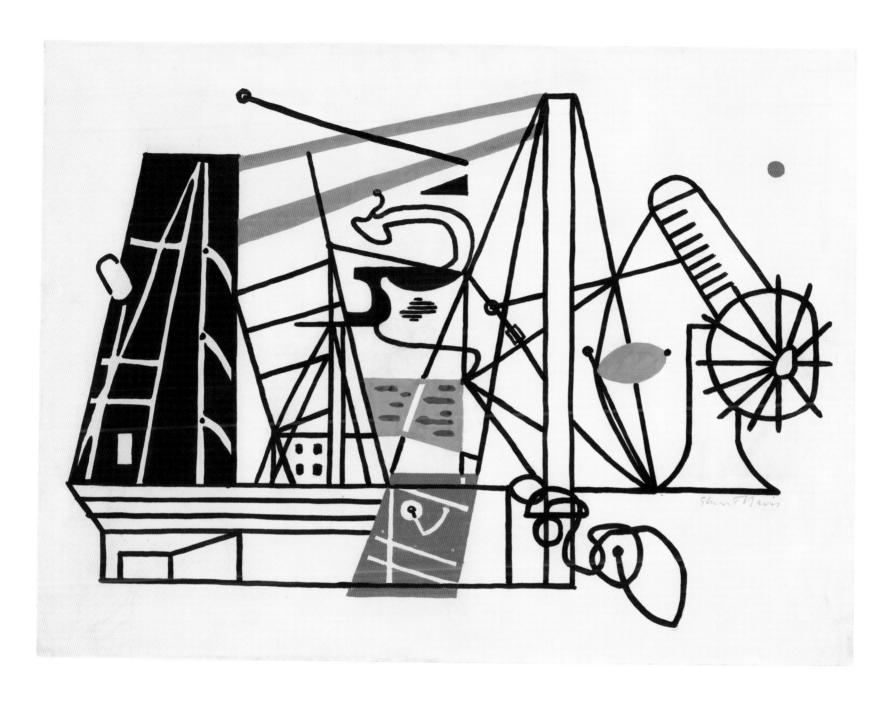

Stuart Davis
(1892–1964)

Study for Radio City Music Hall
1932
Graphite on paper
10½ x 16¾ in. (26.7 x 42.5 cm)
2006.03.03

In 1932, Davis was commissioned by the interior designer Donald Deskey to paint a large mural, 11 x 17 feet (3.4 x 5.2 meters) in size, for the men's smoking lounge at the newly built Radio City Music Hall in New York, part of the Rockefeller Center. The building had been designed by the American architect Edward Durell Stone, with art deco interiors by Deskey. It opened to the public on December 27, 1932, with a lavish stage show.

Before starting work on the mural, Davis made some eight ink and/or pencil studies, which, for the most part, are remarkably crisp and worked out.[1] The area that underwent the most revision was the far left-hand side. In two of the studies, Davis included boats and an American flag; in the other six, including this one, these elements were replaced by a gas pump. Four of the studies, again including this one, feature an added grid—two, as here, in blue crayon— as if in preparation for transferring the work. The Vilcek study may have been used as the basis for the one held by the Museum of Modern Art, New York, which is of the same size, but more crisply painted in ink over pencil; there, certain details, such as the tobacco on the rolling paper, are closer to the final version.[2] The Vilcek study is unique in that dots have been placed along the lines of each object, as if also in readiness for committing the work to paint. The "Final Study" is also gridded, and is twice the size of the Vilcek and MoMA drawings.[3] It includes the city buildings, car, street sign, cigarette pack, and matches that appear in the left-hand side of the finished mural.

The imagery mostly reflects some of the pleasures and pursuits then associated with men, as befitted the ultimate setting of the mural: from left, motoring, smoking, sailing, card playing, and getting a haircut (represented by the barber's pole). In the upper center is a tobacco pouch featuring the rearing-horse logo of Stud loose tobacco, for men who rolled their own cigarettes. In a separate study of the pouch, Davis obscured the final letter of the word "Stud" to create a pun on his own nickname.[4]

1 Ani Boyajian and Mark Rutkoski, eds., *Stuart Davis: A Catalogue Raisonné*, 3 vols., New Haven, Conn. (Yale University Press) 2007, vol. 2, pp. 267–73, cat. nos. 556–63.
2 *Ibid.*, cat. no. 559.
3 *Ibid.*, cat. no. 561.
4 *Ibid.*, cat. no. 410.

Stuart Davis
(1892–1964)

Drugstore Reflection
c. 1932
Ink and pencil on paper
Image: 7⅝ x 9½ in. (19.4 x 24.1 cm)
2010.05.01

Drugstore Reflection is, literally, a mirror image, what one might see in the rearview mirror of a car while driving through the city. Thus, the lettering is reversed, the images abstracted. The word "Opp," above the "Dru[g] / Sto[re]" sign, is the beginning of a proper name. To the right is a fence and balustrade below another sign bearing partially legible text.

This is, however, only a fragment of a rearview mirror, for it is excerpted from a pen-and-ink sketch of 1932 that has two rounded edges, like those of such a mirror.[1] It features a wider view in which another car, a boxy Ford Model T look-alike, can be seen following; one can identify a windshield wiper and a single headlight. The right half of the sketch contains the drugstore motif that Davis excerpted and enlarged here, using the thickened lines of brush and ink over a preliminary pencil drawing. Davis also painted a larger gouache based on the pen-and-ink sketch, *Windshield Mirror* (1932; Philadelphia Museum of Art).

1 Ani Boyajian and Mark Rutkoski, eds., *Stuart Davis: A Catalogue Raisonné*, 3 vols., New Haven, Conn., (Yale University Press) 2007, vol. 2, p. 239, cat. no. 507.

Stuart Davis
(1892–1964)

Untitled
(Black and White Variation on Windshield Mirror)
c. 1954–64
Casein on canvas
54 x 76 in. (137.2 x 193 cm)
2005.08.01

Some twenty-three years after producing *Windshield Mirror*, a gouache of his pen-and-ink sketch of a rearview mirror (see page 202), Davis painted a much-enlarged version—more than 6 feet (1.8 meters) wide—in casein on canvas. His desk calendars record work on the painting in June 1955 and, more than a year later, in July–August 1956. Davis's intent was to explore the "sound" of additional words and shapes: "Studied the Windshield drawing on the 54 x 76 canvas with relation to the Tone-Calligraphy concept in which color is a figure."[1] By this last phrase, Davis was referring to the color areas on the right-hand side of *Windshield Mirror*, which have become black-and-white "figures" here.

In the 1950s, Davis formulated a considered response to "action painting," or abstract expressionism, in which words and word shapes often played a central role. That is also true here, especially on the left-hand side, where some nine block letters and the word "any" overlap the original gouache of 1932. These are recorded as the elements Davis added when he reworked the canvas in July–August 1956. His notes refer to the jazz parlance "easy" and "cat," which can be discerned on the left-hand side of the painting, although other words and associations are also suggested.[2] Indeed, the "c" of "cat" looks more like a "G," especially when compared to the "cat" in *Package Deal* (1956; Lawrence B. Benenson Collection) and *Pochade* (1956–58; Museo Thyssen-Bornemisza, Madrid). The word "any" is clearer (see also detail, pages 206–207), denoting Davis's long-standing belief that any subject matter is suitable for art, including one's own compositions. Below that is an "X," an equally long-standing shorthand for the cancellation of apparent subject matter.

1 Stuart Davis, quoted in Ani Boyajian and Mark Rutkoski, eds., *Stuart Davis: A Catalogue Raisonné*, 3 vols. New Haven, Conn. (Yale University Press) 2007, vol. 3, p. 412, cat. no. 1694.
2 *Ibid.*, p. 413.

Stuart Davis
(1892–1964)

Abstraction
c. 1932
Signed lower right: "Stuart Davis"
Watercolor and gouache on paper with
graphite underdrawing
14 x 20 in. (35.6 x 50.8 cm)
2005.03.03

The non-representational use of line and form recurs throughout Davis's career, as in *Study for Flying Carpet* (1942; page 212) and in works from the 1950s. The motif of a line ending in a dot begins around 1932, as in *Ship's Rigging (Coordinates II)* (page 199), and occurs thereafter. Here, a few curving elements, notably the red line and the green ovoid, contrast with the generally rectilinear shuffle of interlocking planes. These include half-a-dozen areas of blank space, which become positive forms as a result of being surrounded by areas of color.

Davis drew extensively in 1932, often in black and white. He also theorized on drawing: "There are two kinds of drawing, imitative and creative. The imitative records perception of art and nature as closely as possible. The creative transposes perception into a coherent intellectual system."[1]

Abstraction appears to be an independent work, not a study. It was first owned by Arthur Dudley Emptage, an artist and member of the American Artists' Congress in the 1930s. He also owned Davis's gouache *New York Attic Window* (1928), which he bequeathed to the Robert Hull Fleming Museum of Art at the University of Vermont, Burlington.

1 Stuart Davis, quoted in *The Drawings of Stuart Davis: The Amazing Continuity*, exhib. cat. by Karen Wilkin and Lewis Kachur, Chicago, Terra Museum of American Art, December 1992 – February 1993, then traveling, p. 132.

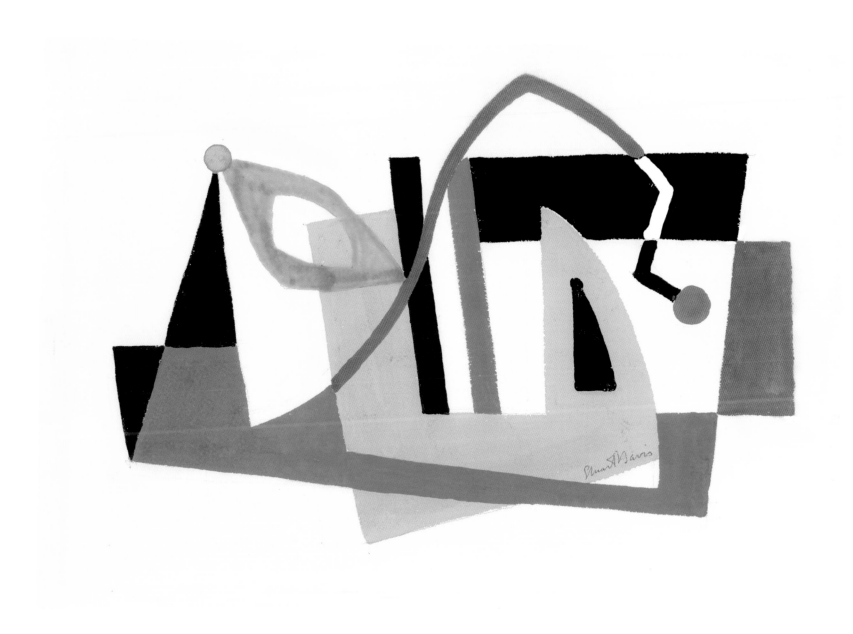

Stuart Davis
(1892–1964)

Sketchbook Page
(Gloucester Dock Scene 16-8)
1933
Graphite and ink on paper
7½ x 9¾ in. (19.1 x 24.8 cm)
2004.02.02

This sketchbook page, one of Davis's most renowned, was the basis for a series of variations on the same Gloucester, Massachusetts, scene. The subject is Smith's Cove, a dock in East Gloucester, just off the inner harbor. In the same year, Davis made a brightly colored painting of the same scene, *Smith's Cove* (private collection), which is only slightly larger in scale than the sketchbook page.

In the foreground, the dockside is littered with a variety of objects, including a lobster pot, and ends on the right in two tall pylons. Across the harbor, the middle ground is occupied by buildings and two schooners. Hills and sky make up the background. The whole is irregularly framed, and linked to the border by a "hinge" in the top left-hand corner. These elements survive in each version of the scene, while the colors and details vary.

The sketchbook page also contains two fascinating marginalia. One is an extensive inscription, written sideways from bottom to top, which includes the disclaimer, "The drawing was made by impulse and observance of the adjacent angles only." The other, located beneath the inscription, is, surprisingly, a vignette of a Mayan god, probably adapted from a codex;[1] the god appears to be taking part in a sacrificial ritual. Further on in the same sketchbook, Davis has drawn some pre-Columbian architectural details. His interest in pre-Columbian culture may have been stimulated by *American Sources of Modern Art (Aztec, Mayan, Incan)*, an exhibition staged at the Museum of Modern Art in New York between May and July 1933.

In 1937, Davis infused the foreground of his Gloucester dock scene with two collage elements, including a rectangular piece of paper printed with the words "Art to the People Get Pink Slips" and pasted face down, such that the text appears reversed. This phrase, which also forms the title of the work (private collection), was an expression of Davis's objections to cutbacks in the Works Progress Administration's Federal Art Project.[2]

A year later, Davis depoliticized the subject of the work with the brightly colored *Gloucester Harbor* (1938; The Museum of Fine Arts, Houston, Texas). He also returned to it in 1940–41, at a time when he was repainting many of his earlier works in terms of his new "color-space" theory. That gouache (*Smith's Cove*, 1941; private collection) is limited to the primary colors, to reinforce what the artist called an "abstract sense of reality."[3] Although Davis recycled his images more than most artists, it is unprecedented to find five versions of the same subject created within eight years, beginning with this drawing.

1 The most likely candidate is the Madrid Codex (Museo de América, Madrid). See Lewis Kachur, "The Language of Stuart Davis: Writing/Drawings," in *The Drawings of Stuart Davis: The Amazing Continuity*, exhib. cat. by Karen Wilkin and Lewis Kachur, Chicago, Terra Museum of American Art, December 1992 – February 1993, then traveling, pp. 37, 136 n. 25. In the inscription immediately above the vignette, what appears to be the word "Wharf" may in fact be "Whorf," in reference to the linguist and Maya scholar Benjamin Whorf; the other words may refer to the red and black ink used in codices.
2 *Ibid.*, pp. 38, 136 n. 27.
3 *Ibid.*, p. 38 and plate 64, where it is dated 1940. It is dated 1941 in Ani Boyajian and Mark Rutkoski, eds., *Stuart Davis: A Catalogue Raisonné*, 3 vols., New Haven, Conn. (Yale University Press) 2007, vol. 2, pp. 655–57, cat. no. 1260.

This drawing is made on the theory
That the Real Form is unknowable
even after it is drawn. That it
has being thro' The Ideal Form
whose laws we know.
The drawing was made by
impulse and observance of the
adjacent angles only.
August 26, 1933

Wharf
Black. White. Red

Stuart Davis
(1892–1964)

Study for Flying Carpet
February 1, 1942
Signed lower right: "Stuart Davis 2/1/42"
Gouache and pencil on paper
Image: 5 x 7 in. (12.7 x 17.8 cm)
2010.04.01

In 1942, the Museum of Modern Art in New York invited ten artists, most of whom were working in the field of abstraction, to design a rug for the exhibition *New Rugs by American Artists*. Davis was one of those approached, as was his friend Arshile Gorky. The rugs would be made by V'Soske of Grand Rapids, Michigan.

For his design, Davis painted three gouache studies of increasing size, each wittily titled "The Flying Carpet"; this is the second. He explained his approach, and his choice of title, thus: "My rug design is a pure invention, but its shapes, colors and composition are directly related to sensations connected with airplane views."[1]

Compared to the first study, this one thickens the lines of the central shape that wends its way from top to bottom. This same shape is set against a more uniform, mostly lime-green background. The curlicue that overlaps it has been heightened to a bright orange, which matches that of the rectangle in the bottom left-hand corner. For the final design, Davis would keep the basic structure, but add many more irregular patterns and forms.[2]

In the margins of the study are numerous color tests, as well as a penciled art-theory notation: "The 3 dim[ensiona]l position in Color-Space. The particular meanings of the shape-color-texture." Interestingly, Davis adds the concept of texture (i.e. that of the wool) to the reference to his "color-space" theory, which he applied to his art from 1940.

The finished rug (1942; The Museum of Modern Art, New York) measures approximately 7 x 10 feet (2.1 x 3 meters), and has been produced in more than fifty exemplars.

1 Stuart Davis, quoted in undated press release for *New Rugs by American Artists*, The Museum of Modern Art, New York, June 30 – August 9, 1942.
2 Ani Boyajian and Mark Rutkoski, eds., *Stuart Davis: A Catalogue Raisonné*, 3 vols., New Haven, Conn. (Yale University Press) 2007, vol. 2, p. 660, cat. no. 1264; see also cat. nos. 929, 1263, 1265.

Stuart Davis
(1892–1964)

Town and Country

1959
Signed lower right: "Stuart Davis"
Oil on canvas
10 x 10 in. (25.4 x 25.4 cm)
2010.02.01

Town and Country features a green background on which have been placed shapes of red, white, and black. This particular group of colors is often seen in Davis's paintings of this period, such as *Pochade* (1956–58; Museo Thyssen-Bornemisza, Madrid) and *Int'l Surface #1* (1960; Smithsonian American Art Museum, Washington, D.C.).

The flattened and incised contours of *Town and Country* are adapted from a contemporary abstract painting by Willem de Kooning, *Suburb in Havana* (1958; page 17). Davis made a small ballpoint-pen sketch of the de Kooning, as well as of a painting by Franz Kline.[1] In January 1959, the de Kooning and Kline paintings were shown together in the exhibition *8 American Painters* at the Sidney Janis Gallery in New York; they were also reproduced on facing pages in the exhibition's catalogue. Davis finished *Town and Country* in the same month, noting "its mysterious balance—good."[2]

In his sketch of de Kooning's painting, Davis does not attempt to capture its speed and broad brushstrokes, but rather makes a selective recording of its main contours. Davis then follows the outlines of his sketch fairly closely for the final painting, using colors that are very different from those of de Kooning. Davis thus translates "action painting" into his own cubist vocabulary of carefully painted shapes without visible brushstrokes.

Most of Davis's works of the 1950s are variants of pre-existing images, but from his own œuvre. It is rare, and interesting, therefore, to see his attention directed toward the younger abstract expressionists, whose reputations were well established by 1958.

1 Ani Boyajian and Mark Rutkoski, eds., *Stuart Davis: A Catalogue Raisonné*, 3 vols., New Haven, Conn. (Yale University Press) 2007, vol. 2, pp. 373–74, cat. no. 762. The Kline painting was *Delaware Gap* (1958; Hirshhorn Museum and Sculpture Garden, Smithsonian Institution, Washington, D.C.).
2 Stuart Davis, calendar entry, January 15, 1959, quoted in Emily Schuchardt Navratil, "Stuart Davis and Abstract Expressionism: 1938–1963," unpublished paper, 2006.

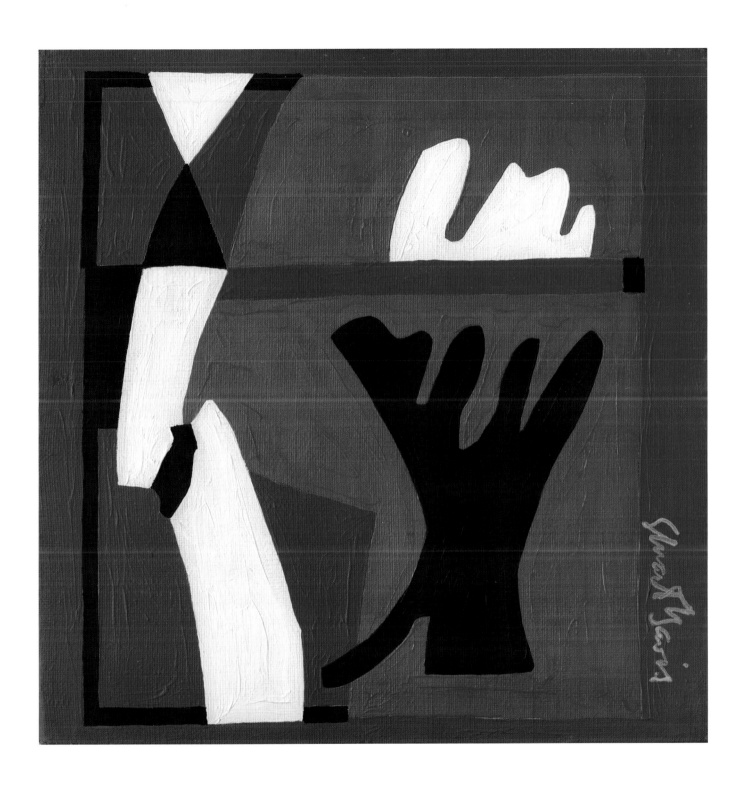

215

Stuart Davis
(1892–1964)

Letter and His Ecol
(Black and White Version)
1962–64
Casein on canvas
24 x 30 in. (61 x 76.2 cm)
2006.03.04

This is one of two black-and-white versions of a red, orange, and green canvas of the same size called *Letter and His Ecol* (1962; Pennsylvania Academy of the Fine Arts). Its lines are somewhat thicker and more painterly than those of the other black-and-white version. Both feature all the forms, but not all the lettering, found in the color painting. That work includes, in its upper part, the words "Inst" (for "Institute" or "Instant") and "ecol" (for "*école*," the French for "school").

The "School of Letter" concept implied by the title of these works reflects Davis's long-standing belief in the importance of words and letter shapes to his art. He referred to the textual elements of his work as his "alphabet syntax." Here, for example, the word "any" in the bottom right-hand corner embodies Davis's view that any subject matter is appropriate for art. "Words & phrases, and their Meaning," he wrote, "are part of the Form-Shape of Drawing even if they appear only in the title. They are integral with the unanalyzed Given Any content."[1]

From the 1950s, Davis, a self-avowed practitioner of "Colonial Cubism" (as he titled a painting of 1954), sometimes used French titles, or, as here, a combination of French and English. In thus affirming his origins in Parisian modernism, Davis was swimming against the tide of artists eager to establish the uniqueness of the new American painting.

1 Stuart Davis, undated note [1963–64], quoted in Lewis Kachur, "Stuart Davis's Word-Pictures," in *Stuart Davis: American Painter*, exhib. cat. by Lowery S. Sims *et al.,* New York, The Metropolitan Museum of Art, November 1991 – February 1992; San Francisco Museum of Modern Art, March–June 1992, pp. 106–107.

Howard N. Cook
(1901–1980)

Complex City
c. 1956
Signed lower right: "HOWARD COOK"
Oil on canvas
32 x 44 in. (81.3 x 111.8 cm)
2001.01.01

The compressed space of *Complex City* is filled with earth tones and the whites of tall structures. The equal emphasis applied to all parts approaches the "allover" strategy of the abstract painters. Glimpses of peaks, pediments, classical columns, and stairs are scattered throughout (see also detail, pages 220–21). Some of these architectural features suggest the "Tower of Light" at the top of the Con Edison tower, the twenty-six-story structure added to the New York headquarters of the energy company Consolidated Edison in 1926–29.

When this work was shown at the Grand Central Moderns gallery in New York, Cook wrote in the catalogue: "I grew up in the exciting early '30's in New York, when many new skyscrapers reached up to the clouds. Their ascending rhythms and horizontal bands have colored the atmosphere, thrilling to watch."[1]

Cook first achieved recognition as a printmaker, then for the murals he was commissioned to produce for a number of US federal buildings in the 1930s. After the Second World War, he began to turn to painting, and to abstraction in particular, as in this work. He also painted landscapes and Native American ceremonies around Taos, New Mexico.

Cook's New York is that of the era of the Empire State and Chrysler buildings, as well as the grand buildings of Central Park West, with their eclectic detail. In the 1950s, he was living in Talpa, New Mexico, having bought a house there in 1939, from where he made frequent trips to New York.

1 *Howard Cook, Recent Paintings and Drawings*, exhib. cat., New York, Grand Central Moderns, November – December 1956, n.p.

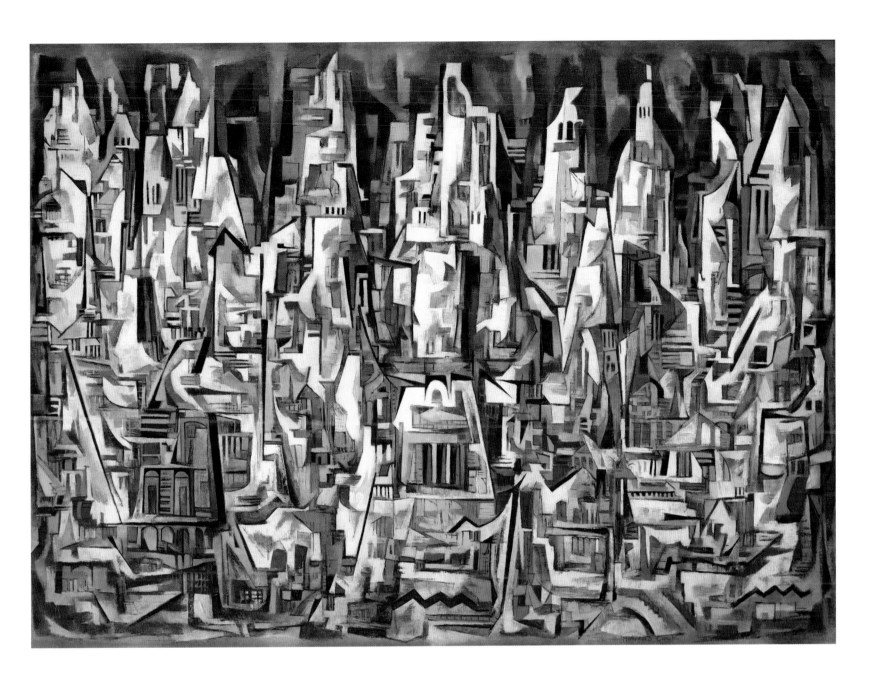

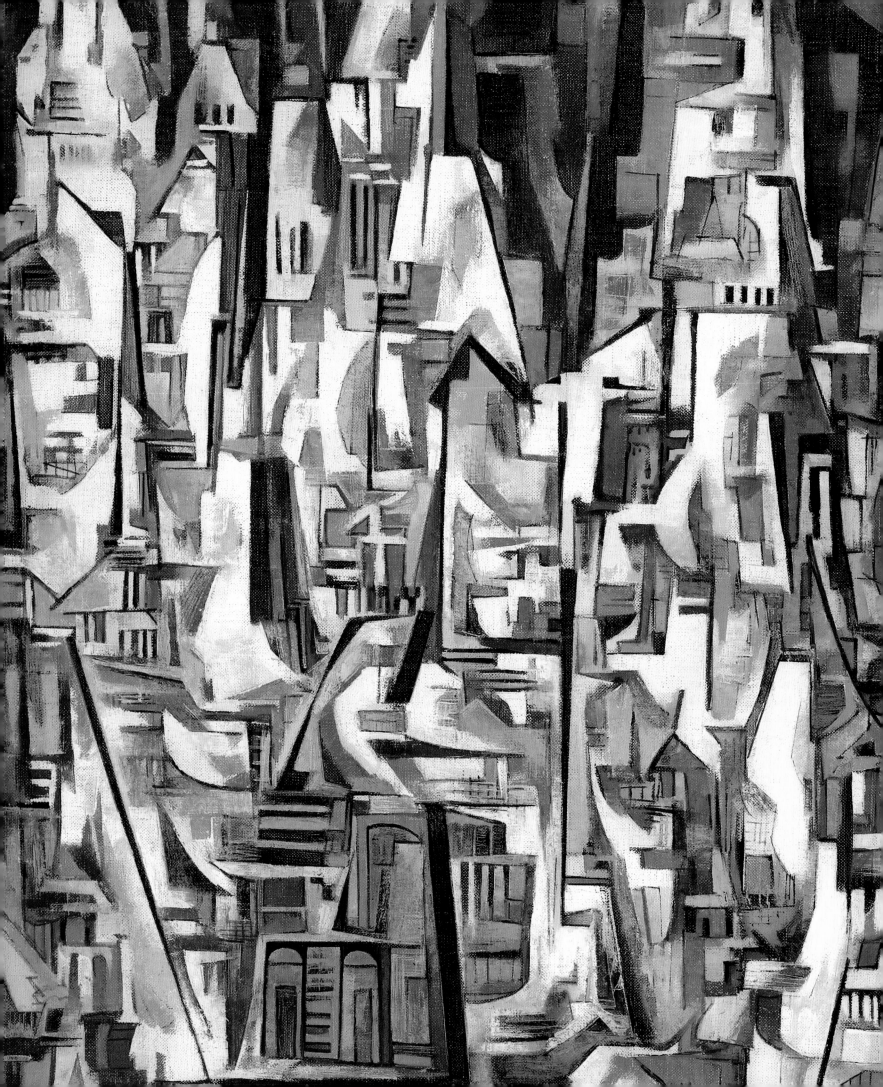

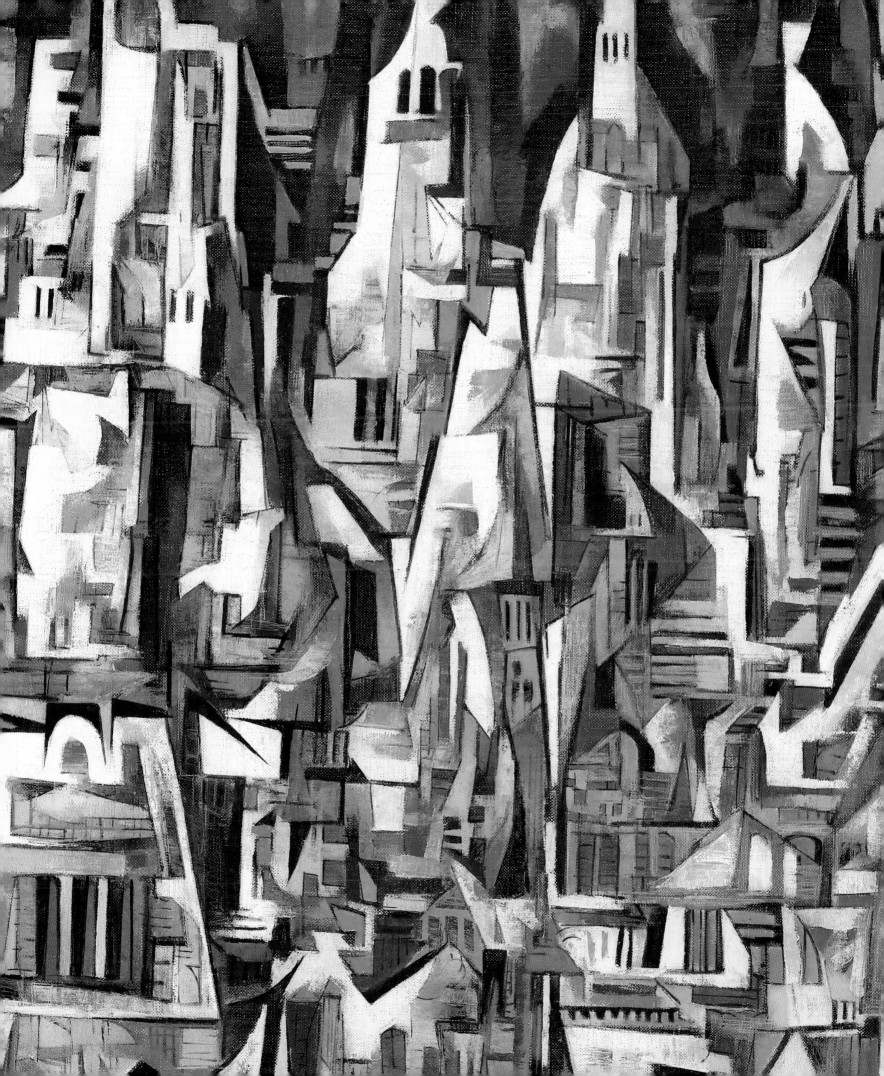

Ralston Crawford
(1906–1978)

Rockefeller Center

1939
Signed lower right: "RALSTON CRAWFORD 1939"
Upper right: "ROCKEFELLER CENTER"
Ink and gesso on paper
7½ x 10 in. (19.1 x 25.4 cm)
2007.02.01

The Rockefeller Center is a New York landmark, covering 22 acres (8.9 hectares) between Forty-Eighth and Fifty-First streets, west of Fifth Avenue. At the time of its construction, it was the largest private building project ever undertaken. Work on its fourteen original art deco buildings began in May 1930 and was completed in 1939, the year of Crawford's drawing.

Crawford's *Rockefeller Center* is a linear scaffolding with some thicker lines, suggesting the cranes and wires of a construction site. Their upper portions are seen silhouetted against the sky, with hoarding running horizontally across the bottom. It is a modest example of the precisionist fascination with machine technology. The precisionist trend emerged in the United States in the 1920s as an outgrowth of cubism. It angularizes form, is linear rather than painterly, and is impersonal in surface. Its exponents included George Copeland Ault (pages 172–75), Charles Demuth, and Joseph Stella (pages 78–79), as well as Crawford somewhat later, in the late 1930s.

On February 24, 1939, the American writer and photographer Carl Van Vechten took a photo of the Rockefeller Center construction site, *Radio City and St. Patrick's from 48th Street, Manhattan*, a view very similar to Crawford's (see page 240, fig. 21).

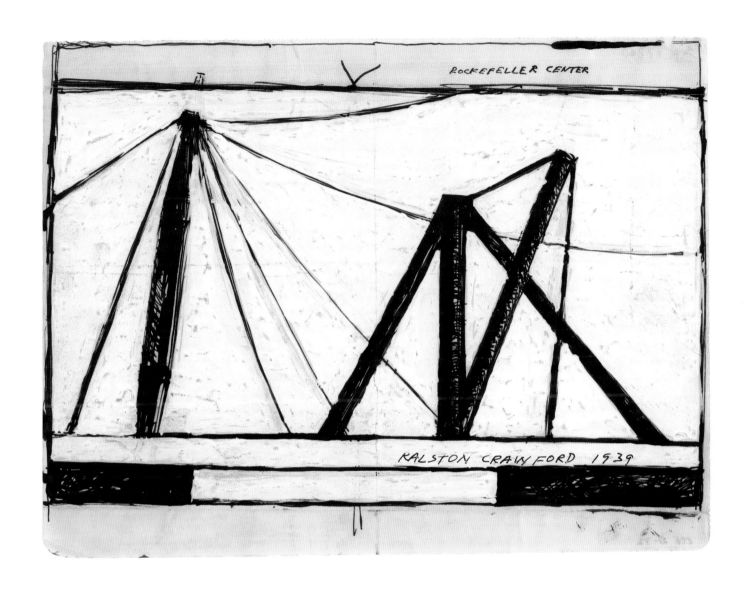

ROCKEFELLER CENTER

RALSTON CRAWFORD 1939

Ralston Crawford

(1906–1978)

Study Detail for St. Petersburg to Tampa
1939
Gouache on paper
10¾ x 8⅜ in. (27.3 x 21.3 cm)
2007.05.05

The original Gandy Bridge was the first to cross Old Tampa Bay in Florida, connecting St. Petersburg to Tampa. The steel-and-concrete bridge opened on November 20, 1924. With a span of 2½ miles (4 kilometers), it was then the world's longest automobile toll bridge.

This clean-edged vignette, black, white, and gray on a blue ground, appears to be either an excerpt from or a study for Crawford's larger painting *St. Petersburg to Tampa* (1938; Hirshhorn Museum and Sculpture Gardens, Smithsonian Institution, Washington, D.C.). Compared to that work, however, the vignette is more removed from any context, with a higher viewpoint and a sharper recession. It becomes a flattened logo for a highway.

In 1939, Crawford painted the related *Overseas Highway* (Curtis Galleries, Minneapolis), one of the artist's best-known works. It is a low-level, road's-eye view of a spatial plunge toward a vanishing point on the horizon. The subject is also a Florida highway, US Route 1, which begins in Key West and runs north all the way to the Canadian border.

Both the vignette and *Overseas Highway* are unpeopled, less about traffic or any human presence than about spatial recession and, perhaps, the "industrial sublime," technology as an awe-inspiring force.

The year 1939 was also that of Crawford's first solo exhibition in New York. The works on display were recognized for their "precision of line" and the "almost classical severity" of their industrial subjects.[1] They are considered the height of Crawford's affiliation with precisionism.

1 *Precisionism in America, 1915–1941: Reordering Reality*, exhib. cat. by Gail Stavitsky *et al.*, Montclair, NJ, West Palm Beach, Fla., Columbus, Oh., and Lincoln, Nebr., 1994–95, p. 29.

Ralston Crawford
(1906–1978)

Bomber
1944
Signed lower right: "RALSTON CRAWFORD"
Oil on canvas
28 x 40 in. (71.1 x 101.6 cm)
2008.02.01

Bomber, one of only a handful of works completed by Crawford during the Second World War, depicts the remains of a downed aircraft in the foreground of a scene of devastation. The airplane's riveted tail section dominates the left-hand side of the painting (see also detail, pages 228–29). A bombed-out building lies behind, all charred beams and blasted walls. Propped against the remains of the building, a twisted bicycle hints at the human cost of war. Most lines are jagged, while other elements are punctured or broken. The sky is as gray as the bomber, which features red gashes suggestive of wounds.

When exhibited at the Downtown Gallery, New York, in the fall of 1944, *Bomber* was welcomed as "a healthy stride further away from [Crawford's] rigid abstractions to a new style, integrating his sense of design with a fluid motion of form, line and color."[1]

Drafted by the US Army in February 1942, Crawford served as Master Sergeant, Chief of the Visual Presentation Unit of the Weather Division, with the Army Air Force. He was stationed in Washington, D.C. In 1944, he had just begun to paint again; and in addition to *Bomber*, he produced a gouache of a similar scene with the same title (*c.* 1945; artist's estate), heightening the juxtaposition of the bicycle and the (now numbered) tail fin.[2] He also produced the thematically related *Air War* (1944; artist's estate).

1 A.B.L., "Brisk and Brighter: An October Opening," *Art News*, October 1–14, 1944, p. 24.
2 Illustrated in *Ralston Crawford,* exhib. cat. by Barbara Haskell, New York, Washington, D.C., Portland, Ore., and Akron, Oh., 1985–86, p. 60.

Ralston Crawford
(1906–1978)

Construction #7
c. 1958
Signed lower center: "CRAWFORD"
Oil on canvas
24 x 18 in. (61 x 45.7 cm)
2007.05.09

In the late 1950s, Crawford was among ten artists commissioned by Wolfson Construction Company to interpret the office building it was erecting at 100 Church Street in lower Manhattan, near Park Place. Crawford's response, the "bare sinews" of *Construction—Steel* (c. 1958; University of Cincinnati Fine Arts Collection), was shown at the Downtown Gallery in New York, and is very similar in formal vocabulary to the present painting.[1]

Crawford's *Construction* series, described as "some of the most formally intricate work in his œuvre," grew out of this commission.[2] Here, the subdued, grayed primary colors recall Mondrian's abstract response to New York. Although Crawford's painting is highly abstracted, its rectilinearity gives a general sense of scaffolding, while the different-width bars anticipate the varied horizontal and vertical metallic strips on the building's façade (see page 242, fig. 26). Crawford spoke of working from observed reality, but also of painting "from memory and from the thoughts about things I have remembered. In these recollections the last instant and many years ago are important."[3]

In the 1950s, Crawford worked increasingly in series, including thirteen works on New Orleans, reflecting his travels and interest in jazz. The crisp, hard-edged forms of *Construction #7* opposed the prevailing painterly trend of the mid-1950s, yet anticipated later developments. "As it became apparent that Crawford's art shared common characteristics with the art of the sixties," notes William C. Agee, "it also became clear that his painting was part of a long, unbroken tradition of linear, hard-edged art in [the United States]."[4]

1 Martica Sawin, "Portrait of a Building," *Arts Magazine*, 32, June 1958, p. 56.
2 *Ralston Crawford*, exhib. cat. by William C. Agee, New York, Robert Miller Gallery, November–December 1983, p. 16.
3 Ralston Crawford, quoted in *Ralston Crawford*, exhib. cat., p. 13.
4 *Ralston Crawford*, exhib. cat., p. 13.

Timeline

Emily Schuchardt Navratil

1912

February 12–24
Exhibition of Paintings and Drawings by Max Weber at the Murray Hill Galleries in New York (fig. 1) includes *Mexican Statuette* (1910; page 105) and *Women and Trees* (1911; page 107). The statuette in the former is a pottery figure from the Cochiti Pueblo in New Mexico (fig. 2).

1909

May 8–18
Exhibition of Paintings in Oil by Mr. Marsden Hartley of Maine at Alfred Stieglitz's Little Galleries of the Photo-Secession (known as "291") in New York includes *Silence of High Noon—Midsummer* (c. 1907–08; page 45). Weber has a solo exhibition at 291 in 1911, Arthur Dove in 1912, Bluemner in 1915, Georgia O'Keeffe in 1916, and Stanton Macdonald-Wright in 1917.

FIG. 1

FIG. 2

| 1891–1907 | 1909 | 1912–13 | 1914 |

1891

Andrew Dasburg emigrates from Germany to the United States. Max Weber emigrates from Russia and settles in Brooklyn.

1892

October 15
Oscar Bluemner emigrates from Germany.

1896

Joseph Stella emigrates from Italy.

1899

March 20
Bluemner becomes a US citizen.

1905

Weber becomes a US citizen.

1907

April 30
Jan Matulka emigrates from Bohemia and settles in the Bronx.

1913

February 17 – March 15
International Exhibition of Modern Art (known as the "Armory Show"), held at the 69th Regiment Armory in New York, includes works by Alexander Archipenko, Bluemner, Dasburg, Stuart Davis, Hartley, Morgan Russell, Morton Livingston Schamberg, and Stella. A painting by Manierre Dawson is included in the Chicago installation of the exhibition (March 24 – April 16, 1913).

1914

March 2–16
Exhibition of Synchromist Paintings by Morgan Russell and S. Macdonald-Wright is held at the Carroll Galleries, New York.

1915

John Storrs travels through the Canadian Rockies to the Southwest and begins collecting Native American art (blankets, pottery, and baskets); references to the serrated patterns of Navajo blankets (fig. 3) appear in *Abstraction* (1924; page 123).[1]

FIG. 3

1916

March 13–25
The Forum Exhibition of Modern American Painters at the Anderson Galleries in New York includes Hartley's *Portrait Arrangement No. 2* (1912–13; page 53) and *Symbol IV* (c. 1913–14; page 58), as well as works by Bluemner, Dasburg, Dove, Macdonald-Wright, and Russell.

1917

August
O'Keeffe visits Santa Fe, New Mexico, with her sister Claudia.

1917–18

Matulka wins the Joseph Pulitzer Traveling Scholarship from the National Academy of Design, New York, and uses the money to travel to New Mexico and Arizona, where he creates works inspired by Native American ceremonies, including *Indian Dancers* (c. 1917–18; page 169).

1918

June
O'Keeffe moves to New York.

June – November 1919
Hartley travels to New Mexico and attends Native American ceremonies (figs. 5 and 6). He writes about his experiences in articles published in the *Dial*, *El Palacio*, and *Art and Archaeology*.

FIGS. 5 AND 6

1915 **1916–18**

1915

January – February 9
Paintings by Marsden Hartley: The Mountain Series at the Daniel Gallery in New York includes *Silence of High Noon—Midsummer* (c. 1907–08; page 45).

February 1–13
Paintings and Drawings by Max Weber at the Print Gallery (under the direction of the Ehrich Galleries) in New York includes *Mexican Statuette* (1910; page 105).

1918

January
Dasburg travels to Taos, New Mexico, at the invitation of Mabel Dodge Luhan. He returns in 1919, and by 1922 is spending most of the year there (fig. 4).

FIG. 4

Stella receives a commission for industrial-themed drawings from *Survey*, a social-reform journal. These drawings may have inspired his watercolors and oils of the period, including *Brooklyn Bridge Abstraction* (c. 1918–19; page 79).

1918–28

O'Keeffe and Stieglitz spend each summer and fall at the Stieglitz family farm on Lake George, New York. The lake becomes a common motif in both O'Keeffe's paintings, such as *Lake George—Autumn* (1922; page 157), and Stieglitz's photography, including *Lake George (View to the Lake)* (undated; fig. 7).

FIG. 7

c. 1920

Dasburg paints a full-length portrait of his son, *Portrait of Alfred*, which is reproduced in the *Arts* in July 1924 (fig. 8). At some point, Dasburg cuts the composition down to create a more focused version (page 147). Dasburg's student Earl Stroh saves the work from being totally destroyed by the artist.

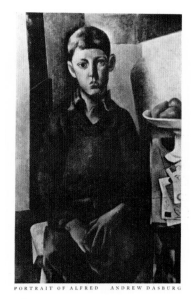

PORTRAIT OF ALFRED ANDREW DASBURG

FIG. 8

1921

Dove and Helen Torr move on to a houseboat on the Harlem River at Sputyen Duyvel in the Bronx. In 1922, they buy a new boat, the *Mona* (fig. 9, shown with a photo of Dove and Torr), on which they live for the next five years, sailing around Long Island Sound. They moor at Halesite, Long Island, in 1924. In 1927, they begin spending winter on land.

FIG. 9

1923

In Germany, Hartley paints a series of Southwestern landscapes, which become known as the *New Mexico Recollections* series. They include *New Mexico Recollection* (1923; pages 66–67) and *New Mexico Recollection #14* (c. 1923; page 68), which may in fact include references to the Petrified Forest National Park in Arizona (fig. 11).

FIG. 11

1920 1921 1922 1923

1921

May 10–17
Seventy-Five Pictures by James N. Rosenberg and 117 Pictures by Marsden Hartley at the Anderson Galleries includes Hartley's *Atlantic Window in the New England Character* (c. 1917; page 63).

1922

Dasburg becomes a US citizen. At around the same time, he paints *Ledoux Street, Taos, New Mexico (Harwood)* (c. 1922; page 149), a view of the street in front of the home of Burt and Elizabeth Harwood, now the Harwood Museum of Art (fig. 10).

FIG. 10

1923

January 29 – February 10
O'Keeffe Exhibition at the Anderson Galleries (fig. 12) includes *Lake George—Autumn* (1922; page 157).

FIG. 12

1923

October
Archipenko and his wife, Angelica, move to the United States from Germany (fig. 15).

Stella becomes a US citizen.

FIG. 15

1924

January 23 – February 6
Exhibition of Paintings and Drawings Selected and Arranged by Mr. W.E. Hill at the Whitney Studio Club in New York includes Davis's *Indian Family* (1923; page 191).

1924

1923

June – late autumn
At the invitation of John Sloan, Davis travels to Santa Fe, New Mexico (fig. 13). Struck by the landscape and the Native American culture, he attends several dances (fig. 14), which he describes as "marvelous."[2]

FIG. 13

FIG. 14

1926

Dasburg, the poet Witter Bynner, John G. Evans (Mabel Dodge Luhan's son), and the artists W.E. Mruk and B.J.O. Nordfeldt form the Spanish and Indian Trading Company for the sale and promotion of Southwestern art (fig. 17).[3] The company's store was located across the street from the La Fonda Hotel in Santa Fe (fig. 16).

FIG. 16

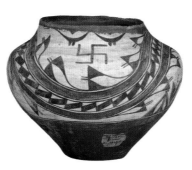

FIG. 17

1927

April 23 – May 12
Exhibition—Paintings and Watercolors: Glenn Coleman and Stuart Davis at the Valentine (originally Dudensing) Gallery in New York includes Davis's *Roses* (1927; page 195).

November 26 – December 9
Stuart Davis and Frank Osborn exhibition at the Downtown Gallery in New York includes Davis's *Indian Family* (1923; page 191).

| 1926 | 1927 | 1929 |

1926

Fall
Forum magazine sends Howard N. Cook to New Mexico. He spends time in Santa Fe and attends Native American ceremonies in Taos. He meets and marries Barbara Latham, and they move into an outbuilding on the grounds of the Harwoods' property.

December 8–22
Retrospective Exhibition of Paintings by Stuart Davis at the Whitney Studio Club includes *Garden Scene* (1921; page 178), *Still Life with Dial* (1922; page 183), *Still Life, Brown* (1922; page 186), *Still Life, Red* (1922; page 187), *Indian Family* (1923; page 191), and *Indian Corn* (1924; page 193).

1927

February 16 – March 5
12th Annual Exhibition of Paintings and Sculpture by the Members of the Club at the Whitney Studio Club includes George Copeland Ault's *View from Brooklyn* (1927; page 173), one of several of Ault's paintings of the Manhattan skyline as seen from Brooklyn (fig. 18).

FIG. 18

1929

José de Creeft moves to the United States from France.

April 27
O'Keeffe and the artist Rebecca Salsbury Strand, wife of the photographer Paul Strand, spend the summer in Santa Fe and Taos with Mabel Dodge Luhan and her husband, Tony Lujan. They attend the San Felipe Pueblo Corn Dance. O'Keeffe will split her time between New York and New Mexico until 1949.

May 6
Archipenko becomes a naturalized US citizen.

November 4–23
20 New Oils on Panel by Oscar Bluemner at the Whitney Studio Galleries in New York includes *Red Night, Thoughts* (1929; page 43).

1930

Matulka becomes a US citizen.

Dasburg moves permanently to Taos.

March 13 – April 2
Max Weber Retrospective at the Museum of Modern Art in New York includes *Still Life with Bananas* (1909; page 103).

March 22 – April 22
Arthur G. Dove: 27 New Paintings at An American Place in New York includes *Colored Drawing, Canvas* (1929; page 83) and *Below the Flood Gates—Huntington Harbor* (1930; page 87).

1931

March 31 – April 19
Stuart Davis: Recent Painting in Oil and Watercolor at the Downtown Gallery includes *Music Hall* (1930; page 197).

1932

April
Dove and Torr marry at New York City Hall.

1930 1931 1932 1933–34

1931

O'Keeffe begins painting kachina dolls (fig. 19), including a Ho-te kachina given to her by Paul Strand. It appears in *Kachina* (1931; page 159) and *Paul's Kachina* (1931; Georgia O'Keeffe Museum, Santa Fe).

FIG. 19

1932

Davis receives a commission to create a mural for Radio City Music Hall in New York (fig. 20). He makes several preparatory sketches, including *Study for Radio City Music Hall* (1932; page 201).

FIG. 20

1933

March 20 – April 15
Arthur G. Dove, Helen Torr, New Paintings and Watercolors at An American Place includes Torr's *Impromptu* (1929; page 137).

1934

April 25 – May 12
Stuart Davis: Recent Paintings: Oil and Watercolor at the Downtown Gallery includes *Ship's Rigging (Coordinates II)* (1932; page 199).

1939

In *Rockefeller Center* (1939; page 223), Ralston Crawford documents the construction of New York's famous building complex (fig. 21).

FIG. 21

1944

O'Keeffe and her assistant Maria Chabot camp in the "Black Place," a group of hills in the Bisti Badlands of northwestern New Mexico (fig. 22). First discovered by O'Keeffe in 1936, it is a frequent subject of her work, including *Black Place II* (1945; page 161), until 1949.

FIG. 22

1945

Cook and O'Keeffe travel from New York to New Mexico on the Santa Fe "Chief" passenger train, spending time together in the observation car.

1946

January 29 – February 16
Stuart Davis Retrospective Exhibition: Gouaches, Watercolors, Drawings 1912–1941 at the Downtown Gallery includes *Ship's Rigging (Coordinates II)* (1932; page 199). Later that year (February 5 – March 13), the same work is shown in *1946 Annual Exhibition of Contemporary American Sculpture, Watercolors and Drawings* at the Whitney Museum of American Art, New York.

February 4 – March 27
Georgia O'Keeffe, an exhibition at An American Place, includes *Black Place II* (1945; page 161).

1939 1940 **1944** **1945–46** **1948–49**

1940

March 30 – May 14
Arthur G. Dove, Exhibition of Oils and Temperas at An American Place includes Dove's *Continuity* (1939; page 95).

November 18
Creeft becomes a naturalized US citizen.

1944

October 24 – January 14, 1945
Marsden Hartley, an exhibition at the Museum of Modern Art (fig. 23), includes *Silence of High Noon—Midsummer* (c. 1907–08; page 45).

FIG. 23

1948

April 5–17
Exhibition of Paintings by Marsden Hartley Before 1932 at the Bertha Schaefer Gallery in New York includes *Grapes—Berlin* (1922/23; page 65).

1949

February 5 – March 27
Max Weber Retrospective at the Whitney Museum of American Art includes *Still Life with Bananas* (1909; page 103), *Women and Trees* (1911; page 107), and *Figure in Rotation* (c. 1948; pages 110–11). The exhibition is then staged at the Walker Art Center in Minneapolis (April 17 – May 29).

1955

Creeft receives the commission for the bronze *Alice in Wonderland* sculpture in Central Park. The completed work is unveiled in 1959.

January 3–31
Marsden Hartley—The Berlin Period, 1913–1915: Abstract Oils and Drawings at the Martha Jackson Gallery in New York includes *Portrait Arrangement No. 2* (1912–13; page 53), *Symbol IV* (c. 1913–14; page 58), and *Symbol V* (c. 1913–14; page 59).

April 4–30
Paintings by Marsden Hartley at the Paul Rosenberg and Company gallery in New York includes *Three Shells* (c. 1941–43; page 77).

1950

October 16 – November 25
Georgia O'Keeffe: Paintings 1946–1950 at An American Place includes *In the Patio IX* (1950; page 163), the culmination of a series of works based on the enclosed patio of O'Keeffe's home in Abiquiu, New Mexico.

1950–51

By the Sea, a Museum of Modern Art "circulating exhibition," includes Hartley's *Three Shells* (c. 1941–43; page 77).

1950–51 1952 1955 1956

1952

April 22 – May 10
Arthur G. Dove, 1880–1946: Paintings at the Downtown Gallery includes *Colored Drawing, Canvas* (1929; page 83) and *Below the Flood Gates—Huntington Harbor* (1930; page 87).

1956

February 28 – March 24
Special Exhibition of Paintings by Dove at the Downtown Gallery includes *Colored Drawing, Canvas* (1929; page 83) and *Untitled* (c. 1929; page 81).

November 16 – December 5
Howard Cook, Recent Paintings and Drawings at the Grand Central Moderns gallery in New York includes *Complex City* (c. 1956; page 219). Described as a New York painting,[4] it also suggests the stepped adobe structures of Taos (fig. 25), a town well known by Cook (fig. 24, second from right, pictured outside La Galería Escondida in Taos), who had a home in nearby Talpa.

FIGS. 24 AND 25

1976

March 16 – May 25
Morgan Russell: Synchromist Studies 1910–1922 at the Museum of Modern Art (fig. 27) includes *Study for Synchromy in Blue-Violet* (1912/13; page 133) and *A Synchromy* (1913/14; page 135).

FIG. 27

1958

September 30 – October 11
Dove: First Public Presentation/Group of Watercolors, 1929–1946 at the Downtown Gallery includes *Centerport XIV* (1942; page 98).

1958 1976 1978 1980

1958

October 28 – November 15
Ralston Crawford at the Grace Borgenicht Gallery in New York includes *Construction #7* (c. 1958; page 231), part of a series inspired by a commission to document the construction of an office building at 100 Church Street in New York (fig. 26).

FIG. 26

1978

January 24 – March 26
Synchromism and American Color Abstraction, 1910–1925 at the Whitney Museum of American Art includes Hartley's *Portrait Arrangement No. 2* (1912–13; page 53) and Matulka's *Indian Dancers* (c. 1917–18; page 169).

c. 1980

O'Keeffe casts the *Abstraction* series (page 165 and fig. 28), which relates to her earlier images of goat horns, a recurring motif in her work.

FIG. 28

Notes

1 *John Storrs: Machine-Age Modernist*, exhib. cat. by Debra Bricker Balken, Boston, West Palm Beach, Fla., and New York, 2010–11, pp. 35–36. Although Balken states that the collection remains with the artist's granddaughter, it was actually sold in the 1970s. Valerie Carberry, e-mail to author, July 19, 2012.

2 Stuart Davis, postcard to Myron Lechay, June 12, 1923, James Lechay Papers, Archives of American Art, Smithsonian Institution, Washington, D.C.

3 The founding of the company is given as 1926 in Van Deren Coke, *Andrew Dasburg*, Albuquerque (University of New Mexico Press) 1979, p. 134; Sharyn Rohlfsen Udall, *Modernist Painting in New Mexico, 1913–1935*, Albuquerque (University of New Mexico Press) 1984, p. 60; and Henry J. Tobias and Charles E. Woodhouse, *Santa Fe: A Modern History, 1880–1990*, Albuquerque (University of New Mexico Press) 2001, p. 92, but as 1924 in Sheldon Reich, *Andrew Dasburg: His Life and Art*, Lewisburg, Pa. (Bucknell University Press) 1989, p. 63.

4 Betty and Douglas Duffy, *The Graphic Work of Howard Cook: A Catalogue Raisonné*, Bethesda, Md. (Bethesda Art Gallery) 1984, p. 163.

Artists' Biographies

Emily Schuchardt Navratil

Opposite: Alexander Archipenko at work on *Seated Female Nude (Black Torso)* in Paris, 1909.

Alexander Archipenko
b Kiev, Ukraine, May 30, 1887
d New York, February 25, 1964

Ukrainian sculptor, active in France and the United States. He began his artistic education at the Kiev Art School, but was expelled for criticizing his teachers; according to his obituary in the *New York Times* (February 26, 1965), he saw them as "too old-fashioned and academic." He moved to Paris in 1908 to study at the École Nationale Supérieure des Beaux-Arts. He exhibited with the cubists at the Salon des Indépendants in 1910, and at the Salon d'Automne from 1911 to 1913. In 1912, he opened his own school in Paris. At the Armory Show in New York in 1913, he exhibited four sculptures and a group of five drawings. Both cubism and futurism influenced his breakout "sculpto-paintings," developed in 1914. In 1921, he moved to Berlin and established an art school. He emigrated to the United States on October 16, 1923, opening an art school in New York. The following year, he established a summer arts program in Woodstock, New York, which continued until 1964. He became a naturalized US citizen on May 6, 1929. In addition to starting the summer program at Woodstock, he taught and lectured throughout the United States and Canada.

George Copeland Ault
b Cleveland, Ohio, October 11, 1891
d Woodstock, New York, December 30, 1948

American painter. Ault's father was born in Canada, his mother in Illinois. In 1899 his family moved to London, where he studied at the Slade School of Fine Art and St. John's Wood Art School, and from where he made frequent trips to France. The family returned to the United States in 1911, moving to Hillside, New Jersey. He exhibited his work for the first time at the Society of Independent Artists Exhibition of 1920 in New York, to which he moved in 1922. His work, which had been English impressionist in style, became focused on unpeopled scenes of buildings in New York and New Jersey. He had his first solo exhibition in 1927 at New York's Downtown Gallery, where he exhibited almost yearly until 1934, when he broke with the gallery. That same year, Ault began spending summers in Woodstock, New York, to which he moved permanently in 1937.

Oscar Bluemner

b Prenzlau, Germany, June 21, 1867
d South Braintree, Massachusetts, January 12, 1938

American painter and architect. He began his
formal art training in 1876 in Hildesheim, Germany.
From 1886 until 1892, he studied at the Königliche
Technische Hochschule, Berlin, graduating with a
degree in architecture. He emigrated to the United
States on October 15, 1892. Over the next few years,
he moved back and forth between New York and
Chicago, working occasionally as an architect. He
became a naturalized US citizen on March 20, 1899.
In 1902, he was hired to design the Bronx Borough
Courthouse, New York. He spent seven months in
Europe, in 1912, where he traveled to Germany,
France, and Italy. He exhibited five watercolors at
the Armory Show in New York in 1913, while his
review of the exhibition, the first of several articles,
was published in *Camera Work*. He had a solo
exhibition at Alfred Stieglitz's 291 gallery in 1915,
and the following year exhibited four works at the
Forum Exhibition of Modern American Painters.
Between 1916 and 1926, he moved around New
Jersey, painting the buildings and landscape in
brilliant color. In 1926, following the death of his wife,
he moved to Braintree, Massachusetts.

Howard Norton Cook

b Springfield, Massachusetts, July 16, 1901
d Santa Fe, New Mexico, June 24, 1980

American painter, engraver, and printmaker.
From 1919 to 1921, he attended the Art Students
League (ASL), where his instructors included
Andrew Dasburg (page 250). In 1922, he took his
first trip to Europe, visiting Scotland, England,
France, Switzerland, and Italy. He returned to the
ASL for the winter of 1922–23 before setting off for
Hawaii, Japan, China, and Hong Kong. In 1924, he
began working as an illustrator for *Forum* magazine,
which, in 1926, sent him to Santa Fe, New Mexico,
to produce some images of the region. He was
awarded two Guggenheim Fellowships in the 1930s,
the first in 1932 and the second in 1935. In the
same decade, he received commissions for public-
building murals in Springfield, Massachusetts;
Pittsburgh, Pennsylvania; and San Antonio, Texas.
During the Second World War, he served as a war
artist with US forces in the South Pacific. In the
1940s and 1950s, he made frequent road trips
from Talpa, New Mexico—where he had bought
a house in 1939—to New York in order to arrange
exhibitions of his work. His graphic landscapes
gradually became more abstracted amalgamations
of New York and New Mexico.

Ralston Crawford

b St. Catharines, Ontario, Canada, September 5, 1906
d New York, April 27, 1978

American painter, illustrator, and photographer.
Crawford's parents and grandparents were born
in Canada. His father, a ship's captain, was also
a naturalized US citizen, and Crawford grew up in
Buffalo, New York. In 1927, he attended the Otis
Art Institute in Los Angeles, working for a short time
at the Walt Disney Studio. Between 1928 and 1930,
he studied at the Pennsylvania Academy of the
Fine Arts in Philadelphia and the Barnes Foundation
in Merion, Pennsylvania. During a trip to Paris in
1932–33, he studied at the Académie Colarossi and
the Académie Scandinave. His paintings of the
urban, industrial landscape are marked by a flat
geometry and a restricted color palette. In 1937
he was awarded a Bok Fellowship to work at the
Research Studio, now the Maitland Art Center,
Florida. During the Second World War, he was
stationed in Washington, D.C., where he served as
Master Sergeant, Chief of the Visual Presentation
Unit of the Weather Division, with the Army Air
Force. In 1946, *Fortune* magazine sent him to
Bikini Atoll to witness the testing of atomic bomb
"Able." He traveled extensively, and held numerous
teaching positions and visiting-artist appointments
throughout his fifty-year career.

José de Creeft

b Guadalajara, Spain, November 27, 1884
d New York, September 11, 1982

Spanish sculptor, active in the United States. He
began sculpting at the age of eleven, and worked
in foundries and workshops in Barcelona and
Madrid before moving to Paris in 1905. There, on
the advice of Auguste Rodin, he studied at the
Académie Julian from 1905 to 1906; later, between
1911 and 1914, he trained at the Maison Gréber
workshop. In 1915, he took up direct carving into
stone, the technique for which he is best known
today. He emigrated to the United States in 1929
and settled in New York, where, in 1932, he started
teaching at the New School for Social Research.
That same year, he also began teaching at the
Art Students League, where he continued
working until 1978. Creeft became a naturalized
US citizen on November 18, 1940. In 1955, he
received the commission for the bronze *Alice in
Wonderland* sculpture in Central Park, which was
unveiled in 1959.

Opposite: Stuart Davis
working on a canvas for
the Federal Art Project,
January 25, 1939.

Andrew Dasburg
b Paris, France, May 4, 1887
d Taos, New Mexico, August 13, 1979

American painter and engraver. Dasburg lived in
Germany, the country of his parents' birth, until 1891,
when he emigrated to the United States with his
mother and aunt. In New York, he studied at the Art
Students League from 1902 to 1907; he also took
night classes, starting in 1904, with the artist Robert
Henri. In 1909, Dasburg traveled to Europe, where
he met Picasso and visited Matisse's studio. At the
Armory Show in New York (1913), he exhibited two
still lifes, a landscape, and a plaster work. He began
teaching in Woodstock, New York, in 1917, and was
a founding member of the Woodstock Artists
Association. In January 1918, he traveled to Taos,
New Mexico, at the invitation of the wealthy arts
patron Mabel Dodge Luhan, and began collecting
Native American art. He returned to New Mexico in
1919, and by 1922, the year in which he became a
US citizen, he was spending most of his time there.
The architecture and landscape of New Mexico
became the main subject of his work, which
revealed the influence of Cézanne. In 1930, he
moved permanently to Taos, where he continued
working and exhibiting.

Stuart Davis
b Philadelphia, Pennsylvania, December 7, 1892
d New York, June 24, 1964

American painter and printmaker. Davis, whose
parents were both artists, studied under Robert
Henri from 1909 to 1912. In 1913, he submitted five
watercolors to the Armory Show in New York,
making him one of the youngest exhibitors. In 1915,
he began spending the summers in Gloucester,
Massachusetts; the nautical surroundings would
become a frequent motif in his work. In the 1920s,
his work shifted to his own brand of American
cubism. In 1923, at the invitation of the artist John
Sloan, he traveled to Santa Fe, New Mexico, where
he attended Native American ceremonies. In 1928,
he went to Paris, where he rented the former studio
of Jan Matulka (page 255). During the 1930s, he
painted several murals, some under the auspices
of the Works Progress Administration's Federal Art
Project. From 1940, he often returned to earlier
motifs in his work, updating them to reflect his
evolving style. Davis painted until the very end of
his life, and was an important link between pre- and
post-Second World War art. He influenced, and was
influenced by, the younger artists of the New York
school, especially with regard to the large size of
their canvases and their allover painting.

Manierre Dawson

b Chicago, Illinois, December 22, 1887
d Sarasota, Florida, August 15, 1969

American painter. From 1906 to 1909, he studied civil engineering at the Armour Institute of Technology in Chicago. He then worked for three years at the architectural firm of Holabird & Roche, taking six months off in 1910 to travel around Europe, visiting England, France, Switzerland, Italy, and Germany. While in Paris, he made his first sale to the art collector, patron, and writer Gertrude Stein. In 1913, one of his paintings was included in the reduced version of the Armory Show held in Chicago, at which he purchased Marcel Duchamp's *Nude (Study), Sad Young Man on a Train* (1911–12). The following year, he moved to a fruit farm in Michigan. He exhibited his work in the Society of Independent Artists exhibitions of 1922 and 1923, both in New York; also in 1923, he had his first solo show, at the Milwaukee Art Society, Wisconsin. In the 1950s, he began spending part of the year in Sarasota, Florida. A retrospective of his work was held in 1966 at the Grand Rapids Art Museum, Michigan.

Arthur Dove

b Canandaigua, New York, August 2, 1880
d Long Island, New York, November 23, 1946

American painter. Dove, whose paternal grandparents were born in England, graduated from Cornell University in 1903. He then moved to New York, where he found work as an illustrator. Between 1907 and 1909, he traveled to Paris and the south of France, where he encountered the work of Cézanne and Matisse; the influence of both artists can be seen in many of Dove's abstractions of nature. He held his first solo exhibition at Alfred Stieglitz's 291 gallery in 1912, and exhibited at the *Forum Exhibition of Modern American Painters* in 1916. He stopped painting the following year, limiting his artistic output to charcoal drawings. In 1921, Dove resumed painting, separated from his first wife, and moved on to a houseboat with the artist Helen Torr (page 258); a year later, he and Torr replaced the houseboat with a yawl, the *Mona*. His second solo exhibition, during which he sold two works to the art collector and critic Duncan Phillips, was held in 1926 at Stieglitz's Intimate Gallery. In 1927, Dove and Torr began spending winter on land, staying on the *Mona* only in the summer. They were married at New York City Hall in April 1932, and lived in Geneva, New York, from 1933 to 1938, when they moved into an abandoned post office in Centerport, Long Island.

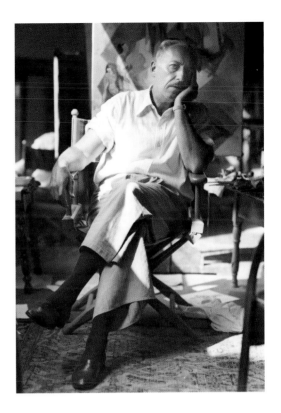

Marsden Hartley
b Lewiston, Maine, January 4, 1877
d Ellsworth, Maine, September 2, 1943

American painter and poet. Between 1898 and 1899, Hartley, who was born to parents of English descent, studied at the Cleveland School of Art, Ohio. He spent the next five years studying in New York, at the Chase School, in 1899, and at the National Academy of Design, from 1900 to 1904; he also attended the Art Students League. Beginning in 1900, he regularly spent his summers in Maine. In May 1909, shortly after moving to New York in the spring of that year, he had his first solo exhibition, at Alfred Stieglitz's 291 gallery. In 1912, he moved to Paris, where he met Picasso, befriended Gertrude Stein, and visited the Native American galleries of the Musée d'Ethnographie du Trocadéro. The following year, he traveled to Germany, visiting Berlin and Munich, and exhibited eight works at the Armory Show in New York. In 1916, he spent the summer in Provincetown, Massachusetts, and the winter in Bermuda. Between 1918 and 1919, he was in New Mexico, where he visited and photographed Native American ceremonies. In 1921, he returned to Europe, making a second trip to Berlin in November of that year, as well as visiting Austria and Italy. He was in New York in 1924, and lived in the south of France from 1925 until 1929. He returned to Maine in 1937.

Stanton Macdonald-Wright
b Charlottesville, Virginia, July 8, 1890
d Pacific Palisades, California, August 22, 1973

American painter, muralist, and aesthetician. Macdonald-Wright grew up in Santa Monica, California. He studied at the Art Students League in New York from 1904 to 1905. In 1907, he traveled to Paris, studying at the Sorbonne for four years, as well as at the École Nationale Supérieure des Beaux-Arts, the Académie Colarossi, and the Académie Julian. He met Morgan Russell (page 256) in 1911, and together they developed the theory of "synchromism," which states that color provides the basis for form and content, and that color and sound are similar phenomena. In 1913, the two artists held exhibitions at the Neue Kunstsalon, Munich, and at the Bernheim-Jeune gallery, Paris. In 1916, Macdonald-Wright returned to New York, contributing to the *Forum Exhibition of Modern American Painters*; the following year, he had a solo exhibition at Alfred Stieglitz's 291 gallery. In 1919, he moved to Los Angeles, where, in 1922, he was appointed director of the city's Art Students League. He became increasingly interested in Zen and oriental art, and in 1937 made his first trip to Japan. Between 1942 and 1954, he taught art history and oriental philosophy at the University of California, Los Angeles. In the late 1950s, he began spending five months of the year at a Zen monastery in Kyoto.

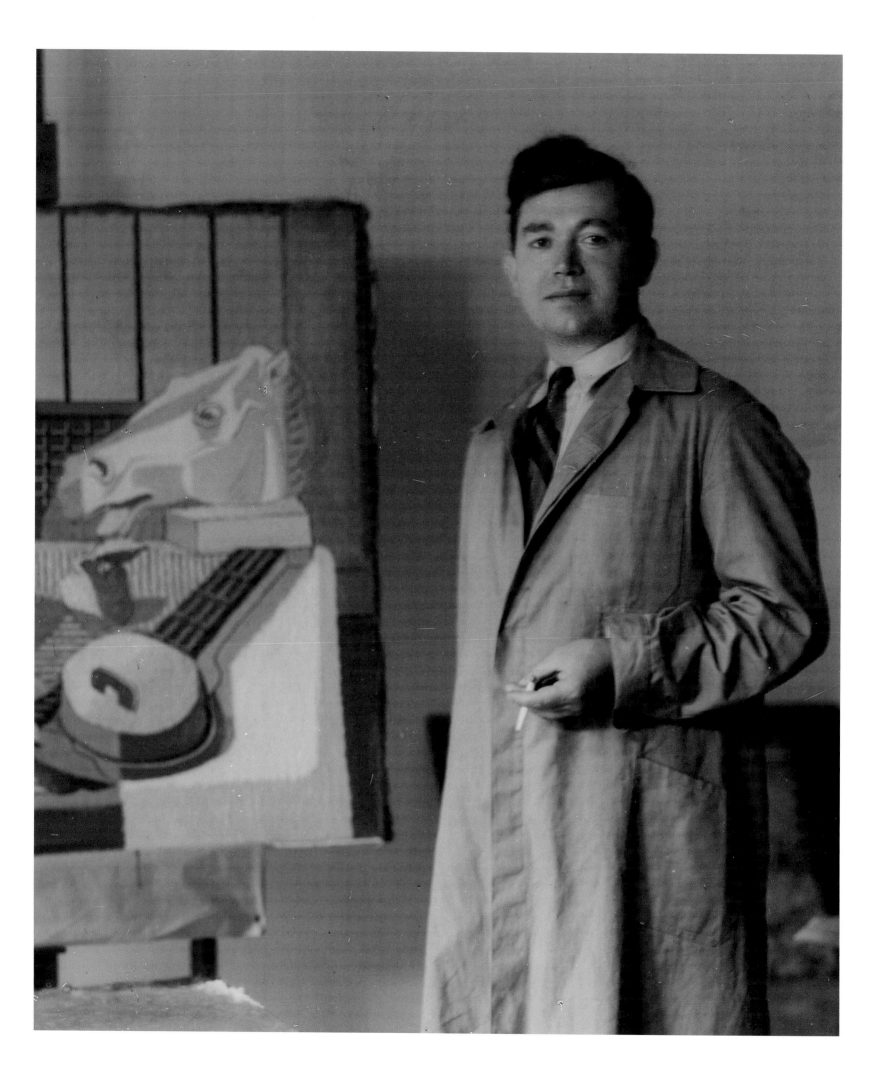

Jan Matulka

b Vlachovo Březí, Bohemia [Czech Republic],
 November 7, 1890
d Bronx, New York, June 24, 1972

American painter. Matulka emigrated to the United
States, together with his parents, in 1907. The
following year, he began studying at the National
Academy of Design, New York. In 1917, he was
awarded the academy's Joseph Pulitzer Traveling
Scholarship, using the money to visit New Mexico
and Arizona. In late 1919, he traveled to Paris. He
was abroad for most of the next four years, dividing
his time between New York and Paris. In 1924 and
1925, he took classes at the Art Students League,
New York. In 1929, he became a teacher there,
a position he held for two years. His students
included David Smith, George L.K. Morris,
Burgoyne Diller, and Dorothy Dehner. In the early
1930s, Matulka became involved with the Public
Works of Art Project (1933–34); in 1935, he joined
the Federal Art Project, run by the Works Progress
Administration, for which he created two murals.
In 1944, he had his last solo exhibition of new work
at the ACA Gallery, New York.

Georgia O'Keeffe

b Sun Prairie, Wisconsin, November 15, 1887
d Santa Fe, New Mexico, March 6, 1986

American painter. From 1905 to 1906, O'Keeffe
attended the School of the Art Institute of Chicago.
In 1907, she took classes at the Art Students
League in New York. The following year, she began
working as a commercial artist, a position she
held until 1910. For six months in 1914, she studied
with Arthur Wesley Dow at the Teachers College,
Columbia University, New York. Toward the end of
1915, she created a series of charcoal abstractions,
which Alfred Stieglitz exhibited at his 291 gallery
in 1916. Between 1918 and 1928, she and Stieglitz,
whom she married in 1924, spent each summer and
fall at the Stieglitz farm on Lake George, New York.
From 1929 to 1945, O'Keeffe spent her summers in
Santa Fe, New Mexico, which she had first visited
in 1917. In addition to painting the New Mexico
landscape, she frequently attended seasonal Native
American dances at the local pueblos. In 1934, she
paid her first visit to Ghost Ranch, a dude ranch
near Abiquiu, New Mexico, buying a property on
its grounds in 1940. In 1945, she purchased a house
in Abiquiu, to which she moved permanently in
1949. She received the American Medal of Freedom
in 1977, and the National Medal of Arts in 1985.

Morgan Russell

b New York, January 25, 1886
d Broomall, Pennsylvania, May 29, 1953

American painter. From 1904 to 1906, Russell worked as a model for the sculptor James Earle Fraser's class at the Art Students League (ASL), New York. In the spring of 1906, he traveled to Italy and Paris. On his return to New York later that year, he attended the ASL as a student. During the summer of 1907, Russell visited Andrew Dasburg (page 250) in Woodstock, New York; in the fall, he studied with Robert Henri at the New York School of Art. In 1908, he moved to Paris, where he met Leo and Gertrude Stein, Picasso, and Matisse. He met Stanton Macdonald-Wright in 1911, and together they developed the theory of "synchromism" (see Macdonald-Wright entry, page 253). Russell exhibited two works at the Armory Show of 1913, and fourteen at the *Forum Exhibition of Modern American Painters* of 1916, both in New York. From 1931 to 1932, he was in Los Angeles, where he taught at the city's ASL, the Stendahl Galleries, and the Chouinard School of Art. He returned to France in June 1932, and eventually moved back to the United States in 1946, settling in Ardsmore, Pennsylvania. After suffering a debilitating stroke in 1948, he taught himself to paint left-handed.

Morton Livingston Schamberg

b Philadelphia, Pennsylvania, October 15, 1881
d Philadelphia, Pennsylvania, October 13, 1918

American painter, photographer, and sculptor. Schamberg was the youngest child of German-Jewish parents. He trained as an architect at the University of Pennsylvania, Philadelphia, before studying under William Merritt Chase at the Pennsylvania Academy of the Fine Arts, also in Philadelphia, from 1903 to 1906. There he met Charles Sheeler, with whom he later shared a Philadelphia studio. In 1904, he took the first of what would become almost annual trips to Europe, where he met the art collector and writer Leo Stein, and saw the work of Picasso, Matisse, and Cézanne. In 1912, Schamberg and Sheeler took up photography as a means of supporting themselves. That same year, Schamberg conceived of the mechanical subject matter for which he is best known. In 1913, he exhibited five works—including his first "mechanical" painting, now lost—at the Armory Show in New York. Through the art collector and critic Walter Arensberg, he met Marcel Duchamp and Francis Picabia in New York in 1915. The following year, Schamberg organized *Philadelphia's First Exhibition of Advanced Modern Art* at the McClees Galleries. He died in the influenza epidemic of 1918.

Joseph Stella

b Muro Lucano, Italy, June 13, 1877
d New York, November 5, 1946

American painter and collagist. Stella emigrated
from Italy to the United States in 1896, settling in
New York. In 1897, he studied at the Art Students
League; the following year, he enrolled at the New
York School of Art. The everyday urban subject
matter of his early work was similar to that of
the artists of the Ashcan school. One of his first
commissions was to depict Pittsburgh's industrial
workers for *Survey,* a social-reform journal.
Returning to Italy in 1910, Stella spent the next
three years in Europe, where, in Paris, he saw the
work of Cézanne, Matisse, the futurists, and the
cubists, all of which had a huge impact on his art.
Back in New York in 1913, he exhibited two works
at the Armory Show. In 1918, he received a second
commission from *Survey,* for industrial drawings.
Stella balanced these industrial-themed works with
art that focused on flowers and fruit. In the early
1920s, he began creating collages; he also spent
part of that decade in Italy, where his work was
influenced by the art of Giotto.

John Storrs

b Chicago, Illinois, June 28, 1885
d Mer, France, April 22, 1956

American sculptor, painter, and printmaker. Storrs's
father was born in Massachusetts, his mother in
Canada. In 1906, he attended classes at the
Académie Montparnasse in Paris. Between 1908
and 1909, he studied in Chicago, at the School
of the Art Institute and the Academy of Fine Arts.
In 1909, he enrolled at the School of the Museum
of Fine Arts, Boston; the following year, he was in
Philadelphia, studying at the Pennsylvania Academy
of the Fine Arts, where he was awarded the
Stewardson Prize. He moved to Paris in 1911, and
began studying with Auguste Rodin there in 1912;
he also attended the Académie Colarossi and the
Académie de la Grande Chaumière. In 1915, he
traveled to California and the Southwest. His first
solo exhibition was held in December 1920 at the
Folsom Gallery in New York. In the late 1920s and
early 1930s, he received several commissions for
large-scale sculptures, producing works for, among
others, the Chicago Board of Trade Building (for
example, *Ceres,* 1928–30) and the Century of
Progress Exposition, also in Chicago (1932–33).
Throughout his life, he divided his time between
the United States and France.

Opposite: Max Weber
examining a sculpture,
April 22, 1956.

Helen Torr

b Roxbury, Pennsylvania, November 22, 1886
d Bayshore, New York, September 8, 1967

American painter. From 1902 to 1905, Torr studied
at Drexel University in Philadelphia. In the fall of
1905, she enrolled at the Pennsylvania Academy
of the Fine Arts, also in Philadelphia, studying
with Thomas Anshutz and William Merritt Chase.
She married the cartoonist Clive Weed in 1913, and
they spent the next few years dividing their time
between Philadelphia and New York. In 1919, they
moved to Westport, Connecticut, where Torr met
Arthur Dove (page 252). The two began sketching
together, and in 1921 moved on to a houseboat;
in 1922, they sold the houseboat and moved on to
a yawl, the *Mona*. Torr exhibited only twice during
her lifetime: first in 1927, when Georgia O'Keeffe
(page 255) included her in an exhibition at the
Opportunity Gallery, New York; and secondly in
1933, when Alfred Stieglitz gave Dove and Torr
a joint show at his An American Place gallery,
also in New York. Torr and Dove were married in
April 1932 at New York City Hall. They sold the
Mona in 1933 and lived in Geneva, New York, until
1938, when they moved into an abandoned post
office in Centerport, Long Island. Torr stopped
painting in 1943, to care for an ailing Dove, and
never painted again.

Max Weber

b Belostok, Russia [now Białystok, Poland],
** April 18, 1881**
d Great Neck, New York, October 4, 1961

American painter, printmaker, and sculptor. Weber
emigrated to the United States with his family in
1891, settling in Brooklyn, New York. There, from
1898 to 1900, he studied at the Pratt Institute under
Arthur Wesley Dow. Weber taught in public schools
in Lynchburg, Virginia, from 1901 to 1903, and then
at State Teachers College in Duluth, Minnesota,
from 1903 to 1905. In September 1905, he moved to
Paris, where he lived for three years. During that
time, he studied at the Académie Julian and helped
to organize a class led by Henri Matisse. In addition
to Matisse, Weber's early influences included
Picasso and Cézanne. His first solo exhibition
was held in 1909, at Haas Gallery in New York; his
second solo show came two years later, at Alfred
Stieglitz's 291 gallery. Weber taught at the Clarence
H. White School of Photography, New York, from
1914 to 1918, and at the Art Students League, New
York, in the 1920s. From the end of the First World
War until late in his career, his art focused on
Orthodox Jewish themes.

List of Works

Alexander Archipenko
(1887–1964)

Woman with a Fan
(page 139)
c. 1958 (modeled 1914)
Inscribed front, lower right: "Archipenko 1914
Variant 2"
Stamped front, lower right: "S 12 2/8 ©"
Polychromed bronze on wooden base
Height: 35½ in. (90.2 cm), excluding base
2009.03.02

George Copeland Ault
(1891–1948)

View from Brooklyn
(page 173)
1927
Signed lower left: "G.C. Ault '27"
Oil on canvas
18¼ x 21½ in. (46.4 x 54.6 cm)
2007.01.03

Driveway: Newark
(page 175)
1931
Signed lower left: "G.C. Ault '31" (visible only
under black light)
Oil on canvas
21½ x 15½ in. (54.6 x 39.4 cm)
2011.02.01

Oscar Bluemner
(1867–1938)

Young Tree in a Red Courtyard
(page 39)
1919
Signed lower left: "OBLÜMNER"
Watercolor on paper
19 x 14 in. (48.3 x 35.6 cm)
2010.05.02

Scales House, Soho
(page 41)
February 3, 1920
Signed lower left: "OFB—20"
Gouache on paper
4 x 5 in. (10.2 x 12.7 cm)
2009.02.01

Red Night, Thoughts
(page 43)
1929
Signed lower right: "OBLÜMNER"
Oil on board mounted on panel
8 x 10 in. (20.3 x 25.4 cm)
2008.04.01

Howard N. Cook
(1901–1980)

Complex City
(page 219)
c. 1956
Signed lower right: "HOWARD COOK"
Oil on canvas
32 x 44 in. (81.3 x 111.8 cm)
2001.01.01

Ralston Crawford
(1906–1978)

Rockefeller Center
(page 223)
1939
Signed lower right: "RALSTON CRAWFORD 1939"
Upper right: "ROCKEFELLER CENTER"
Ink and gesso on paper
7½ x 10 in. (19.1 x 25.4 cm)
2007.02.01

Study Detail for St. Petersburg to Tampa
(page 225)
1939
Gouache on paper
10¾ x 8 ⅜ in. (27.3 x 21.3 cm)
2007.05.05

Bomber
(page 227)
1944
Signed lower right: "RALSTON CRAWFORD"
Oil on canvas
28 x 40 in. (71.1 x 101.6 cm)
2008.02.01

Construction #7
(page 231)
c. 1958
Signed lower center: "CRAWFORD"
Oil on canvas
24 x 18 in. (61 x 45.7 cm)
2007.05.09

José de Creeft
(1884–1982)

Voyage to Africa
(page 113)
1927
Inscribed: "J. de Creeft"
Limestone
26 x 5 x 5 in. (66 x 12.7 x 12.7 cm)
2007.03.01

Andrew Dasburg
(1887–1979)

Still Life—Fruit
(page 141)
c. 1912
Brush pen and ink on paper
12³⁄₈ x 10¹⁄₈ in. (31.4 x 25.7 cm)
2007.05.07

Untitled
(Still Life with Artist's Portfolio and Bowl of Fruit)
(page 143)
c. 1914–18
Signed lower left: "Dasburg"
Oil on canvas
20 x 24 in. (50.8 x 61 cm)
2004.03.01

Portrait of Alfred
(page 147)
c. 1920
Signed lower left: "Dasburg"
Oil on canvas mounted on Masonite panel
22 x 17 in. (55.9 x 43.2 cm)
2012.06.02

Ledoux Street, Taos, New Mexico
(Harwood)
(page 149)
c. 1922
Signed lower right: "Dasburg"
Oil on paper board
12⁷⁄₈ x 16¹⁄₄ in. (32.7 x 41.3 cm)
2007.05.06

Placita Sanctuario
(page 151)
1924
Signed lower left: "Dasburg '24"
Oil on panel
13 x 16 in. (33 x 40.6 cm)
2008.01.01

Stuart Davis
(1892–1964)

Garden Scene
(page 178)
1921
Signed lower left: "STUART DAVIS 1921"
Oil on canvas
20 x 40 in. (50.8 x 101.6 cm)
2004.01.01

Sword Plant
(From the Shore)
(page 176)
1921
Signed lower center: "STUART DAVIS 1921"
Oil on canvas
15 x 30 in. (38.1 x 76.2 cm)
2005.01.01

Tree
(page 177)
1921
Signed lower left: "STUART DAVIS 1921"
Oil on canvas
19⁷⁄₈ x 25¹⁄₈ in. (50.5 x 63.8 cm)
2003.01.01

Tree and Urn
(page 179)
1921
Signed lower right: "STUART DAVIS 1921"
Oil on canvas
30¹⁄₈ x 19 in. (76.5 x 48.3 cm)
2006.02.01

Still Life, Brown
(page 186)
1922
Signed upper left:
"STUART DAVIS / N.Y. 1922"
Oil on canvas
50 x 32 in. (127 x 81.3 cm)
2005.06.02

Still Life, Red
(page 187)
1922
Signed upper right:
"STUART DAVIS / N.Y. 1922"
Oil on canvas
50 x 32 in. (127 x 81.3 cm)
2005.06.01

Still Life with Dial
(page 183)
1922
Signed upper right: "STUART DAVIS 1922"
Oil on canvas
50 x 32 in. (127 x 81.3 cm)
2003.02.01

Still Life with Vase
(Still Life with Egg Beater)
(page 189)
1922
Signed lower left: "STUART DAVIS 1922"
Oil on canvas
12 x 19¹⁄₄ in. (30.5 x 48.9 cm)
2004.02.01

List of Works

Man and Lemon
(page 181)
c. 1922
Signed lower right: "Stuart Davis"
Graphite and watercolor on paper
15¼ x 18½ in. (38.7 x 47 cm)
2005.07.01

Indian Family
(page 191)
1923
Signed lower right: "STUART DAVIS"
Oil on canvas board
19½ x 15⅝ in. (49.5 x 39.7 cm)
2004.02.03

Indian Corn
(page 193)
1924
Signed lower left: "Stuart Davis '24"
Oil on board
18⅝ x 24⅜ in. (47.3 x 61.9 cm)
2012.06.01

Roses
(page 195)
1927
Signed lower center: "STUART DAVIS '27"
Watercolor, gouache, and graphite underdrawing
on paper
13¼ x 13 in. (33.7 x 33 cm)
2007.05.01

Music Hall
(page 197)
1930
Signed lower right: "STUART DAVIS"
Oil on canvas
16 x 18 in. (40.6 x 45.7 cm)
2009.03.01

Ship's Rigging
(Coordinates II)
(page 199)
1932
Signed middle right: "Stuart Davis"
Gouache on paper
20⅛ x 27½ in. (51.1 x 69.9 cm)
2005.05.03

Study for Radio City Music Hall
(page 201)
1932
Graphite on paper
10½ x 16¾ in. (26.7 x 42.5 cm)
2006.03.03

Abstraction
(page 209)
c. 1932
Signed lower right: "Stuart Davis"
Watercolor and gouache on paper with
graphite underdrawing
14 x 20 in. (35.6 x 50.8 cm)
2005.03.03

Drugstore Reflection
(page 203)
c. 1932
Ink and pencil on paper
Image: 7⅝ x 9½ in. (19.4 x 24.1 cm)
2010.05.01

Sketchbook Page
(Gloucester Dock Scene 16-8)
(page 211)
1933
Graphite and ink on paper
7½ x 9¾ in. (19.1 x 24.8 cm)
2004.02.02

Study for Flying Carpet
(page 212)
February 1, 1942
Signed lower right: "Stuart Davis 2/1/42"
Gouache and pencil on paper
Image: 5 x 7 in. (12.7 x 17.8 cm)
2010.04.01

Untitled
(Black and White Variation on Windshield Mirror)
(page 205)
c. 1954–64
Casein on canvas
54 x 76 in. (137.2 x 193 cm)
2005.08.01

Town and Country
(page 215)
1959
Signed lower right: "Stuart Davis"
Oil on canvas
10 x 10 in. (25.4 x 25.4 cm)
2010.02.01

Letter and His Ecol
(Black and White Version)
(page 217)
1962–64
Casein on canvas
24 x 30 in. (61 x 76.2 cm)
2006.03.04

Manierre Dawson
(1887–1969)

Bare Branches Behind Outbuildings
(page 153)
1910
Signed on verso: "Manierre Dawson 1910"
Oil on panel
9⅞ x 14⅞ in. (25.1 x 37.8 cm)
2007.05.08

Untitled
(Reclining Nude)
(page 155)
1913
Signed lower left: "M. Dawson"
Oil on panel
10⅛ x 14⅛ in. (25.7 x 35.9 cm)
2012.03.01

Arthur Dove
(1880–1946)

Colored Drawing, Canvas
(page 83)
1929
Signed lower right: "Dove"
Oil on canvas
17½ x 21¾ in. (44.5 x 55.2 cm)
2012.09.01

Untitled
(page 81)
c. 1929
Oil on metal
28 x 20 in. (71.1 x 50.8 cm)
2007.07.01

Below the Flood Gates—Huntington Harbor
(page 87)
1930
Signed lower right: "Dove '30"
Oil on canvas
24¼ x 28⅛ in. (61.6 x 71.4 cm)
2007.01.01

Forms
(page 89)
1932
Signed lower center: "Dove"
Ink and crayon on paper
4¾ x 6¾ in. (12.1 x 17.1 cm)
2006.03.02

The Green House
(page 93)
1934
Signed lower center: "Dove"
Oil on canvas
25½ x 31¾ (64.8 x 80.7 cm)
2007.01.02

Sunrise
(page 90)
c. 1936
Signed lower center: "Dove"
Crayon on paper
5 x 7 in. (12.7 x 17.8 cm)
2007.02.02

Continuity
(page 95)
1939
Signed lower center: "Dove"
Tempera and encaustic on canvas
6⅛ x 8 in. (15.6 x 20.3 cm)
2009.02.04

Sunrise I
(Set of Three)
(page 97)
c. 1941
Signed lower center: "Dove"
Graphite, watercolor, and ink
on paper
4 x 5½ in. (10.2 x 14 cm)
2007.05.02

Sunrise II
(Set of Three)
(page 97)
c. 1941
Signed lower center: "Dove"
Graphite, watercolor, and ink
on paper
4 x 5½ in. (10.2 x 14 cm)
2007.05.03

Sunrise III
(Set of Three)
(page 97)
December 1, 1941
Signed lower center: "Dove 12.1.41"
Graphite, watercolor, and ink
on paper
4 x 5½ in. (10.2 x 14 cm)
2007.05.04

Untitled Drawing
(page 91)
c. 1941
Graphite on paper
9 x 11¾ in. (22.9 x 29.8 cm)
2006.02.02

Centerport XIV
(page 98)
1942
Gouache on paper
3 x 4 in. (7.6 x 10.2 cm)
2006.03.01

Marsden Hartley
(1877–1943)

Silence of High Noon—Midsummer
(page 45)
c. 1907–08
Oil on canvas
30½ x 30½ in. (77.5 x 77.5 cm)
2008.07.01

Untitled
(Maine Landscape)
(page 47)
1910
Signed lower right: "MARSDEN HARTLEY"
Oil on board
12⅛ x 12 in. (30.8 x 30.5 cm)
2010.01.01

Indian Pottery
(page 49)
c. 1912
Oil on canvas
20¼ x 20¼ in. (51.4 x 51.4 cm)
2006.05.01

*Oranges, Apples and Lemons
in a Bowl*
(page 51)
c. 1912
Signed on verso: "Marsden Hartley"
Oil on board
14 x 12 in. (35.6 x 30.5 cm)
2005.05.02

Portrait Arrangement No. 2
(page 53)
1912–13
Oil on canvas
39½ x 31¾ in. (100.3 x 80.6 cm)
2005.09.01

Berlin Series No. 1
(page 57)
1913
Oil on canvas board
18 x 15 in. (45.7 x 38.1 cm)
2012.01.01

Symbol IV
(page 58)
c. 1913–14
Charcoal on paper
24½ x 18⅞ in. (62.2 x 47.9 cm)
2005.03.01

Symbol V
(page 59)
c. 1913–14
Charcoal on paper
24½ x 18⅞ in. (62.2 x 47.9 cm)
2005.03.02

Provincetown
(page 61)
1916
Oil on canvas board
19 x 15½ in. (48.3 x 39.4 cm)
2008.05.03

*Atlantic Window in the
New England Character*
(page 63)
c. 1917
Inscribed on verso: "MARSDEN HARTLEY"
Oil on board
31⅝ x 25 in. (80.3 x 63.5 cm)
2005.04.01

Grapes—Berlin
(page 65)
1922/23
Oil on canvas
10⅝ x 18⅜ in. (27 x 46.7 cm)
2005.05.01

New Mexico Recollection
(pages 66–67)
1923
Oil on canvas
12¾ x 32¼ in. (32.4 x 81.9 cm)
2008.06.01

New Mexico Recollection #14
(page 68)
c. 1923
Oil on canvas
30 x 40 in. (76.2 x 101.6 cm)
2009.01.01

The Strong Man
(pages 70–71)
c. 1923
Oil on canvas
13 x 32¼ in. (33 x 81.9 cm)
2006.03.05

Mont Sainte-Victoire
(page 73)
c. 1927
Signed on verso: "Marsden Hartley"
Inscribed on stretcher: "Mt. St. Victoire Aix en
Provence"
Oil on canvas
20 x 24 in. (50.8 x 61 cm)
2007.06.01

Autumn Landscape, Dogtown
(page 75)
1934
Oil on Masonite
20 x 27¾ in. (50.8 x 70.5 cm)
2012.04.01

Three Shells
(page 77)
c. 1941–43
Oil on board
22 x 28 in. (55.9 x 71.1 cm)
2012.04.02

Stanton Macdonald-Wright
(1890–1973)

Gestation #3
(page 167)
1963
Signed upper right: "S. Wright"
Oil on plywood
23½ x 19⅝ in. (59.7 x 50 cm)
2007.05.10

Jan Matulka
(1890–1972)

Indian Dancers
(page 169)
c. 1917–18
Oil on canvas
26 x 16 in. (66 x 40.6 cm)
2008.03.01

Rodeo Rider
(page 171)
c. 1917–20
Oil on canvas
29½ x 23½ in. (74.9 x 59.7 cm)
2008.05.01

Georgia O'Keeffe
(1887–1986)

Lake George—Autumn
(page 157)
1922
Oil on canvas
16 x 27 in. (40.6 x 68.7 cm)
2010.03.01

Kachina
(page 159)
1931
Signed on verso: "Georgia O'Keeffe/1931"
Oil on wood panel
20⅝ x 16 in. (52.4 x 40.6 cm)
2012.02.01

Black Place II
(page 161)
1945
Oil on canvas
24 x 30 in. (61 x 76.2 cm)
2011.08.01

In the Patio IX
(page 163)
1950
Oil on canvas mounted on panel
30 x 40 in. (76.2 x 101.6 cm)
2012.05.01

Abstraction
(page 165)
c. 1980 (modeled 1946)
Inscribed underneath base, in black: "1/3"
White cast epoxy
36 x 36 x 4 in. (91.4 x 91.4 x 10.2 cm)
2007.04.01

Morgan Russell
(1886–1953)

Study for Synchromy in Blue-Violet
(page 133)
1912/13
Oil on paper
9¼ x 6⅞ in. (23.5 x 17.5 cm)
2010.04.04

*Bernheim-Jeune & Cie. Galleries
Exhibition Poster*
(page 131)
1913
Signed lower right, central panel: "Morgan Russell"
Commercial print with gouache painting
33⅜ x 20⅜ in. (84.8 x 51.8 cm)
2010.04.02

Der Neue Kunstsalon Exhibition Poster
(page 128)
1913
Commercial print with gouache painting
42¼ x 28⅛ in. (107.3 x 71.4 cm)
2010.04.03

A Synchromy
(page 135)
1913/14
Oil on paper
9 x 5⅞ in. (22.9 x 14.9 cm)
2010.04.05

Morton Livingston Schamberg
(1881–1918)

Abstraction
(page 101)
c. 1916
Signed lower right: "Schamberg"
Graphite and pastel on paper
9¼ x 6⅛ in. (23.5 x 15.6 cm)
2009.02.02

Joseph Stella
(1877–1946)

Brooklyn Bridge Abstraction
(page 79)
c. 1918–19
Signed lower center: "Joseph Stella"
Watercolor and gouache on paper
9¾ x 7 in. (24.8 x 17.8 cm)
2006.04.01

John Storrs
(1885–1956)

Abstraction
(page 117)
1919
Signed on the underside: "JOHN/STORRS/5-6-19"
Painted terra-cotta
4¾ x 2¾ x 2 in. (12.1 x 7 x 5.1 cm)
2011.01.01

Untitled
(Study for Figure)
(page 119)
1920
Wood
6¾ x 2½ x 2 in. (17.2 x 6.3 x 5.1 cm)
2011.06.01

Abstraction
(page 123)
1924
Incised signature and date underneath:
"1924/STORRS"
Limestone and marble inlay
17 x 13 x 4¾ in. (43.2 x 33 x 12.1 cm)
2011.03.01

Study in Pure Form
(Forms in Space No. 4)
(page 125)
c. 1924
Inscribed on lower edge of brass: "JS II/X"
Steel, copper, and brass
Height: 12¼ in. (31.1 cm)
2010.04.06

Man and Woman
(page 127)
1930
Signed lower right: "STORRS"
Oil on canvas
14⅛ x 12⅛ in. (35.6 x 30.5 cm)
2011.07.01

Untitled
(Study for Figure)
(page 119)
1935 (modeled 1920), unique
Polychromed steel
6¾ x 2½ x 1⅞ in. (17.3 x 6.4 x 4.8 cm)
2009.02.03

Untitled
(Study for Roullier Galleries Exhibition Invitation)
(page 121)
c. 1935
Crayon on paper
9⅜ x 4¼ in. (23.8 x 10.8 cm)
2009.04.01

Untitled
(Study for Roullier Galleries Exhibition Invitation)
(page 121)
c. 1935
Graphite and crayon on paper
9½ x 5⅞ in. (24.1 x 14.9 cm)
2009.04.02

Untitled
(Study for Figure)
(page 120)
c. 1935
Graphite on paper
9½ x 5⅞ in. (24.1 x 14.9 cm)
2009.04.03

Helen Torr
(1886–1967)

Impromptu
(page 137)
1929
Signed on verso: "Helen Torr/Halesite/N.Y."
Oil on canvas board
9½ x 15⅝ in. (24.1 x 39.8 cm)
2008.05.02

Max Weber
(1881–1961)

Still Life with Bananas
(page 103)
1909
Signed lower right: "MAX WEBER"
Oil on canvas
32¼ x 26 in. (81.9 x 66 cm)
2004.03.02

Mexican Statuette
(page 105)
1910
Signed lower right: "MAX WEBER 1910"
Gouache on paper
29 x 24 in. (73.7 x 61 cm) (sight)
2005.02.02

Women and Trees
(page 107)
1911
Signed lower left, twice: "MAX WEBER"
Oil on burlap
31½ x 25½ in. (80 x 64.8 cm)
2006.01.01

Figure in Rotation
(pages 110–11)
c. 1948 (modeled 1917)
Inscribed lower rear: "Max Weber /3"
Plaster and polychrome
25 x 7½ x 7 in. (63.5 x 19.1 x 17.8 cm)
2005.02.01

Further Reading

General Surveys and Art Movements

Patricia Janis Broder, *The American West: The Modern Vision*, Boston (Little, Brown) 1984

Wanda M. Corn, *The Great American Thing: Modern Art and National Identity, 1915–1935*, Berkeley (University of California Press) 1999

Abraham A. Davidson, *Early American Modernist Painting, 1910–1935*, New York (Da Capo) 1994

Erika Doss, *Twentieth-Century American Art*, Oxford (Oxford University Press) 2002

Robert Hughes, *American Visions: The Epic History of Art in America*, New York (Alfred A. Knopf) 1997

Gail Levin, "American Art," in *Primitivism in 20th Century Art: Affinity of the Tribal and the Modern*, exhib. cat., ed. William Rubin, New York, Detroit, and Dallas, 1984–85

Modern Art and America: Alfred Stieglitz and His New York Galleries, exhib. cat. by Sarah Greenough *et al.*, Washington, D.C., National Gallery of Art, January–April 2001

Over Here: Modernism, the First Exile, 1914–1919, exhib. cat. by Robert Brandfon *et al.*, Providence, David Winton Bell Gallery, Brown University, April–May 1989

Picasso and American Art, exhib. cat. by Michael FitzGerald, New York, San Francisco, and Minneapolis, 2007–08

Precisionism in America, 1915–1941: Reordering Reality, exhib. cat. by Gail Stavitsky *et al.*, Montclair, NJ, West Palm Beach, Fla., Columbus, Oh., and Lincoln, Nebr., 1994–95

W. Jackson Rushing, *Native American Art and the New York Avant-Garde: A History of Cultural Primitivism*, Austin (University of Texas Press) 1995

Synchromism and American Color Abstraction, 1910–1925, exhib. cat. by Gail Levin, New York, Whitney Museum of American Art, January–March 1978

Toward a New American Cubism, exhib. cat. by Bruce Weber, New York, Berry-Hill Galleries, May–July 2006

Sharyn Rohlfsen Udall, *Modernist Painting in New Mexico, 1913–1935*, Albuquerque (University of New Mexico Press) 1984

David L. Witt, *Modernists in Taos: From Dasburg to Martin*, Santa Fe, N. Mex. (Red Crane Books) 2002

Individual Artists

Ani Boyajian and Mark Rutkoski, eds., *Stuart Davis: A Catalogue Raisonné*, 3 vols., New Haven, Conn. (Yale University Press) 2007

Ralston Crawford, exhib. cat. by William C. Agee, New York, Robert Miller Gallery, November–December 1983

Stuart Davis, 1892–1964: The Breakthrough Years, 1922–1924, exhib. cat. by William C. Agee, New York, Salander-O'Reilly Galleries, November–December 1987

Stuart Davis: American Painter, exhib. cat. by Lowery S. Sims *et al.*, New York, The Metropolitan Museum of Art, November 1991 – February 1992; San Francisco Museum of Modern Art, March–June 1992

Arthur Dove: A Retrospective, exhib. cat. by Debra Bricker Balken *et al.*, Washington, D.C., The Phillips Collection, September 1997 – January 1998, then traveling

Arthur Dove: Life and Work, with a Catalogue Raisonné, exhib. cat. by Ann Lee Morgan, New York, 1984

The Drawings of Stuart Davis: The Amazing Continuity, exhib. cat. by Karen Wilkin and Lewis Kachur, Chicago, Terra Museum of American Art, December 1992 – February 1993, then traveling

Marsden Hartley, *Somehow a Past: The Autobiography of Marsden Hartley*, ed. Susan Elizabeth Ryan, Cambridge, Mass. (MIT Press) 1998

Marsden Hartley, exhib. cat., ed. Elizabeth Mankin Kornhauser, Hartford, Washington, D.C., and Kansas City, Mo., 2003–04

Marsden Hartley and the West: The Search for an American Modernism, exhib. cat. by Heather Hole, Santa Fe, N. Mex., Georgia O'Keeffe Museum, 2008

Barbara Buhler Lynes, *Georgia O'Keeffe: Catalogue Raisonné*, 2 vols., New Haven, Conn. (Yale University Press in association with the National Gallery of Art, Washington, D.C.) 1999

Georgia O'Keeffe, *Georgia O'Keeffe*, New York (Viking) 1976

Georgia O'Keeffe in New Mexico: Architecture, Katsinam, and the Land, exhib. cat. by Barbara Buhler Lynes and Carolyn Kastner, Montclair, NJ, Denver, Santa Fe, N. Mex., and Phoenix, 2012–14

Randy J. Ploog *et al.*, *Manierre Dawson (1887–1969): A Catalogue Raisonné*, Jacksonville, Fla. (The Three Graces) 2011

Sheldon Reich, *Andrew Dasburg: His Life and Art*, Lewisburg, Pa. (Bucknell University Press) 1989

Morgan Russell, exhib. cat. by Marilyn S. Kushner, Montclair, NJ, Chicago, and Buffalo, 1990

John Storrs, exhib. cat. by Noel S. Frackman, New York, Whitney Museum of American Art, December 1986 – March 1987

John Storrs: Machine-Age Modernist, exhib. cat. by Debra Bricker Balken, Boston, West Palm Beach, Fla., and New York, 2010–11

Max Weber: The Cubist Decade, 1910–1920, exhib. cat. by Percy North, Atlanta, Houston, Tex., Washington, D.C., Buffalo, New York, and Los Angeles, 1992–93

Acknowledgments

Many people helped to shape the vision for *Masterpieces of American Modernism*, and many others subsequently became involved in developing that initial vision into its full, finished, and very elegant form. Jan Vilcek and Marica Vilcek are, of course, at the center of the project—not only because of their passion for art and art collecting, but also because of their lifelong commitment to sharing art with others. Having decided to put their entire collection of artworks on permanent display, the Vilceks knew that they also needed to create a comprehensive illustrated catalogue of their collection, one that would be invaluable to both art historians and the interested general public.

In order to go forward with the creation of this book, we required the support of the Vilcek Foundation's board. Happily, everyone on the board felt instinctively that the foundation needed to create a fully documented record of the Vilcek Collection. I'm very grateful that, along with Jan and Marica, fellow board members Joan Massagué, Peter Ludwig, and Richard Gaddes were all so supportive.

In the months that followed, I relied heavily on the staff of the Vilcek Foundation to handle so many of the details that are crucial to the creation of a book of this sort. I'm very thankful to Brian Cavanaugh, Joyce Li, Seamus McKillop, Ronnie Mewengkang, Phuong Pham, Christopher Rungoo, Anne Schruth, and Violeta Venegas for taking on these responsibilities, even as they were so busy with their own day-to-day work. Peter Libron, who assists the Vilceks personally, also contributed a great deal of his time and attention to various aspects of the project.

We were exceptionally fortunate to have Professor William C. Agee of Hunter College, New York, agree to write the book's main essay. As a distinguished art historian and Americanist, Professor Agee knew exactly what the Vilceks had intended to create with their art collection, and his immediate response to its beauty was matched only by his thoughtful erudition in writing about it. Professor, curator, and art critic Lewis Kachur of Kean University, New Jersey, brought a similar passion and enthusiasm to the task of describing each of the works in the collection. Emily Schuchardt Navratil of Lehman College, City University of New York, meanwhile, was involved with the project from the very first day. She researched and compiled cataloguing information for each of the works, and wrote the timeline and artists' biographies. Finally, I'm grateful to Justin Spring for helping me put my own thoughts in order as I wrote the book's introduction.

Merrell Publishers handled the project of designing, editing, and producing the book with exceptional style and brilliance. I am particularly grateful to Hugh Merrell for taking a personal interest in the book and shepherding it through every step of the editing, design, and publication process. Selina Skipwith and Cat Newton-Haydon both introduced me to Merrell Publishers and gave me advice on the particulars of the book-publishing business. I'm also grateful to Arthur Klebanoff for lending his hand and sharing his expertise in the field of publishing. At Merrell, Nicola Bailey did a truly exceptional job of designing the book; Claire Chandler was a fine project manager; Mark Ralph did a very thorough job as copy editor; Nick Wheldon handled the often very tricky business of obtaining photo clearances and permissions; and Amanda Mackie oversaw the equally complicated work of color reproduction and the printing of the book.

As the book was being written, we had a number of questions that required the expertise of specialists. I'd like to thank Dr. Peter Bolz of the Ethnologisches Museum, Berlin; Catherine Whitney, Chief Curator of the Philbrook Museum of Art in Tulsa, Oklahoma; and Percy North, a leading scholar on the artist Max Weber, for their insights. Several art dealers were also extremely helpful in providing details about specific paintings, including Lily Burke of the Gerald Peters Gallery, New York and Santa Fe, New Mexico; Valerie Carberry of the Valerie Carberry Gallery, Chicago; Tom Parker of Hirschl & Adler Galleries, New York; and Jonathan Boos and the staff at his eponymous gallery in New York. Of all the dealers we consulted, Nat Owings and Laura Widmar, of the Owings Gallery in Santa Fe, were especially helpful, truly going above and beyond the call of duty.

My final thanks go to Joe Coscia, who produced the beautiful photographs of all the objects in the collection.

Rick Kinsel
Executive Director
The Vilcek Foundation

Picture Credits

Index

Page numbers in *italic* refer to the illustrations.

Authors' Biographies

William C. Agee

William C. Agee is the Evelyn Kranes Kossak Professor of Art History at Hunter College, City University of New York. A specialist in modern art in America from 1900 to 1970, with degrees from Princeton and Yale universities, he has worked as a curator at the Museum of Modern Art and the Whitney Museum of American Art, both in New York, and has held museum directorships in Pasadena, California, and Houston, Texas. He is the author of numerous articles, catalogues, and monographs, many of which, including *American Vanguards: Graham, Davis, Gorky, De Kooning, and Their Circle, 1927–1942* (2012), were published in conjunction with exhibitions he helped to organize.

Lewis Kachur

Lewis Kachur is Professor of Art History at Kean University, New Jersey. He received his doctorate from Columbia University, New York, and is a specialist in twentieth-century and contemporary European and American art. He has written numerous articles, catalogue essays, and reviews, and is the author of *The Drawings of Stuart Davis: The Amazing Continuity* (1992, with Karen Wilkin), *Displaying the Marvelous: Marcel Duchamp, Salvador Dalí, and Surrealist Exhibition Installations* (2001), and *Robert Rauschenberg: Transfer Drawings from the 1960s* (2007). His research interests include the history of exhibitions.

Rick Kinsel

Rick Kinsel is Executive Director of the Vilcek Foundation and a member of its board. He began his association with the Vilceks while working with Marica Vilcek in the Cataloguing Department of the Metropolitan Museum of Art in New York. He received his BA from Ohio State University, and his MA, in the History of the Decorative Arts, Design History, and Material Culture, from the Bard Graduate Center, New York. Before joining the Vilcek Foundation in 2000, he spent seven years as Director of Cultural Affairs for Coty, Inc. His professional affiliations include the International Association of Professional Art Advisors, the Association of Grantmakers in the Arts, and the Association of Grantmakers Concerned with Immigrants and Refugees.

Emily Schuchardt Navratil

Emily Schuchardt Navratil is Assistant Curator for the Vilcek and the Vilcek Foundation art collections, a PhD candidate at the Graduate Center, City University of New York, and an adjunct lecturer at Lehman College, CUNY. Her dissertation, "Native American Chic: The Marketing of Native Americans in New York between the World Wars," examines the impact of exhibitions of Native American art on women's fashion and interior design. Her published work includes contributions to *Cézanne and American Modernism* (2009), *Picasso in The Metropolitan Museum of Art* (2010), and *American Vanguards: Graham, Davis, Gorky, De Kooning, and Their Circle, 1927–1942* (2012).

First published 2013 by Merrell Publishers, London
and New York

Merrell Publishers Limited
81 Southwark Street
London SE1 0HX

merrellpublishers.com

A catalogue record for this book is available from the
Library of Congress.

British Library Cataloguing-in-Publication Data:
A catalogue record for this book is available from the
British Library.

ISBN 978-1-8589-4595-8

Produced by Merrell Publishers Limited
Designed by Nicola Bailey
Project-managed by Mark Ralph
Indexed by Vicki Robinson

Printed and bound in Italy

Jacket: Ralston Crawford, *Rockefeller Center* (detail), 1939
(see page 223)

Page 2: Marsden Hartley, *Berlin Series No. 1*, 1913
(see page 57)

NOTE ON TEXT
With one or two exceptions—for example, to allow for
the grouping of similar or related pieces—the works in
the main part of the book are in chronological order by
artist; where two or more works share the same date of
creation, they appear in alphabetical order by title. The
artists themselves are ordered by date of birth and,
where two or more artists were born in the same year,
alphabetically by surname. The dimensions in the
captions indicate height followed by width followed by
depth, unless noted otherwise.